D0893697

kidnapping

kidnapping

douglas gordon

(kɪd'nap/ɪŋg) *v.* to steal, carry off and hold (a child, person etc.),
taken by force or deception, usually for ransom.
[c17: kid + obsolete nap to steal; see NAB] *n.*
the title of a book by douglas gordon.
in conversation with jan debbaut. annotations by francis mckee.
editing by marente bloemheuvel. design by arlette brouwers.
published by the stedelijk van abbemuseum, eindhoven.
distributed by nai publishers, rotterdam.
200 pages. colour and monochrome illustrations throughout.

contents

...by way of an introduction

It was a hot and humid day, June 1st, 1889, when James Gordon (senior) was born. One year and five days later saw the appearance of Janet Lawrie Lamont. They lived separate lives until sometime early this century, and were married on August 22nd, 1919.

Janet Lawrie Lamont, known to friends and family as Jessie, gave birth to seven children over the next 15 years, six of whom survived. The youngest of these offspring was born on January 25th, 1934, and was named, like his father, James Gordon.

Meanwhile, on a cold winter's day, December 8th, 1909, John Wier McDougall dropped into the world. He was almost two years old when, on October 21, 1911, his future wife first drew breath as Jane Jarvie Forrest. It is not clear whether they were known to one another from childhood, but it is sure that, 20 years into John Wier McDougall's life and 18 years into Jane Jarvie Forrest's life, they were married on August 8th, 1929.

Jane Jarvie Forrest, was known to family and friends as Jean, and she gave birth 7 times, like Jessie Gordon, over the next 21 years. The fourth of these seven children was born Mary Clements McDougall, on April 20th, 1942.

The latter events happened, more or less, in and around Glasgow; a city which lay on the banks of the river Clyde, beneath a blanket of industrial smog, barrage balloons and the occasional crack of anti-aircraft gunfire.

Although they lived relatively close to one another, James Gordon did not meet Mary Clements McDougall until sometime in 1962. The swinging sixties; he was 28 and she was almost 20. They were married three years later on July 17, 1965. Soon after this, probably in mid-December 1966, a cold, dark Scottish night was filled with passion and, nine months later, on September 20th, 1966, Mary Clements Gordon, née McDougall, gave birth to Douglas Lamont Gordon.

The first 18 years of his life were less than eventful, or at least that is what he would have us believe; the years of overeating and underachieving, he told me. But what happened after this period is not quite clear. It is known that Douglas Lamont Gordon first visited Vienna in August 1985, and at least once more in the early 1990's. Whilst he is reluctant to discuss anything about these visits, his travelling companions, on the first visit, claim that, on return to Glasgow, he became obsessed by Carol Reed's film *The Third Man* which had been set in post-war Vienna.

But *The Third Man* was merely a vehicle through which he could exercise his preoccupation. The real subject of the obsession, and its relation to this film, must be traced back to a chance meeting in the breakfast lounge of a Vienna hotel. Neither the name nor the address of the hotel are of any relevance to this story, but it is important to say that it advertised itself as a two-star establishment with three-star pretensions. This will give some idea of the clientele and the ambience in which the rendez-vous took place.

It was a hot and humid morning, much like the one on which his grandfather had been born at the beginning of this story, and the breakfast lounge was quite empty. Not that there were a shortage of guests at the hotel, but it was almost 10 o'clock and most people had breakfasted and left already. There were many empty places in which to sit to eat, but most of them had not been cleared of the dirty plates, eggshells and breadcrumbs from the previous sitter. Apart from him there was only one more guest at breakfast and she was sitting at a table-for-two, with the other place unoccupied. So he gathered his cold breakfast buffet and asked, in very bad German, if he could join her.

She was old and she was beautiful.

Her eyes were *so* green. He looked at her clothes (a friend had once told him that the colour of one's eyes is intensified by the reflection from the colour of clothes that we wear) and she thought he was making a pass. He got very embarrassed at this, tried to apologise, she said 'no, it's okay' (she spoke English), and they began to talk to one another. They sat together for a while and she asked his name, what he was doing in Vienna, how long he was visiting and so on. For some reason, unknown, he did not ask her very much. But she told him anyway, or at least she told him something that made her, to him, unforgettable.

She was an actress, mostly on stage, but when she was younger she had played some minor roles for cinema, and sometimes for television (which she did not enjoy). Her first involvement with cinema was as an extra in *The Third Man*. The scene is well known; we are in a public park, in Vienna, and Harry Lime (Orson Welles) steps onto a Ferris wheel with Holly Martin (Joseph Cotton). The Ferris wheel starts to move and they go up to a tremendous height, looking out and onto the park and the people beneath them. They have a discussion about the past, the present, and what future, when Harry Lime says to Holly Martin,

'Look down there. Would you really feel any pity
if one of those dots stopped moving forever?
If I offered you twenty thousand pounds for every
dot that stopped, would you really, old man, tell me
to keep my money, or would you calculate how many
dots you could afford to spare?'

This was 1949, she was 17 years old, and she was one of the dots.

And every time he watches this film and hears Orson Welles say those lines he remembers the two-star breakfast lounge, the crushed eggshells and breadcrumbs, and the fact that he never knew her name and would never see her again.

end.

Douglas Gordon.

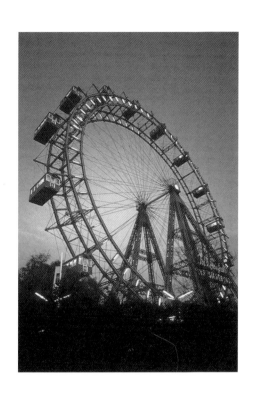

...in conversation: jan debbaut and douglas gordon

The scene is a small tenement flat in the centre of Glasgow. Two men sit talking in a living room littered with books, faxes, CDs, and videotapes. One man is older, in his late forties, a museum director from the Low Countries; the other man is an artist, in his late twenties, and this city is where he lives and where he was born.

The telephone will ring constantly, and they will ignore it. They drink small glasses of whisky.

I know that you studied in Glasgow, then went to live in London, and now you're constantly travelling around, or so it seems. But what happened before that? Were you already involved in artistic activities in Glasgow?

Yes.

So what was the point of going to London?

I went in September, 1988. Three months previous to that I had spent time living in Belfast, killing time between finishing up studies in Glasgow and starting again at the Slade School. I came back to Glasgow in 1990. [1]

So between 1984 and 1988 I went to art school here in Glasgow. The first year was pretty much like a 'foundation' year; most people tried a little bit of painting, a little bit of sculpture, took some photographs, made a film or video, or even tried to make some pottery or textiles. Just a very liberal idea of education.

Was there any awareness of what was going on in the art world?

Not much, in retrospect. In fact, one vivid memory of the early days at Glasgow School of Art was when one of the students, out of about 2000 or so studying there, ran into our classroom saying, 'Hey, there is this really interesting old guy working in Germany – he's like using all these weird materials like fat and felt and bits of old sheep and things, and making amazing drawings. He's called Joseph Beuys.' I remember this quite vividly because everyone received this news quite coolly, as was the way in Glasgow. No-one made a fuss, it just sounded like another story about some crazy artist making some crazy work far away in another country – and hey, we were in Glasgow, so what does it have to do with us? Right! But a few people quietly rushed to the library to try and find some information on Beuys, while pretending to be there to do something else entirely.

1 *Proof*, 1990.

Then, a few weeks later someone else said, 'Yeah, that old guy who wraps himself in old blankets and sleeps with coyotes is having a show down in London, in some gallery or something.' Now, at that time most people who I knew at the art school had never even been to London. We didn't know much about art, or galleries. We didn't know much about people like Beuys, and we certainly didn't know who Anthony d'Offay was. Then, looking back on it all, the show that we had heard about, and didn't see, was the *Plight* installation at d'Offay's. [2] We missed out on that one, I'm afraid. So, in answer to your question, No! I certainly didn't know so much about what was happening in the outside (art) world.

Did you go to London with an idea of getting something specific out of it, or did you go with an open mind?

That was in 1988. The circumstances of my going were a combination of chance and desire. I had no real desire for London, over anywhere else, but I had the chance to go, so...

Who was teaching at the Slade at that time?

A pretty mixed bunch. Stuart Brisley was the squadron leader but I had most contact with Susan Hiller, and Tim Head. And Bruce McLean was always a good person to put all the 'nonsense' into some kind of perspective, when the politics of the place got to be too much. Of course, I had contact with a lot of people, but these were the ones who I talked to most. To tell you the truth, I didn't really enjoy all of my time at the Slade, but I liked being in London a lot. And I kept good connections with whatever was happening in Glasgow, especially at Transmission Gallery. [3]

What was going on in London at that time?

I'm not absolutely sure. My memories of London are very dark – I spent most of my time going to watch films. I mean, I did go to some galleries, but this was not my priority activity. I was 'advised' by some people at the Slade to go and visit the Lisson Gallery in 1988 or 1989, and also to go to d'Offay's; I remember seeing some good shows – John McCracken, Carl Andre, and James Coleman, amongst others, but I wasn't conscious of what was going on with people in my generation, at least not as regards the Goldsmiths crew, or whatever. I really spent most of my time sitting in dark rooms in Hampstead and around King's Cross. In cinemas, that is.

2 Beuys' installation was allegedly devised in response to Anthony d'Offay's frustration at the amount of noise permeating the gallery from his neighbours' premises. The cladding of *Plight* made the ambient noise in the gallery almost imperceptible.

3 Exhibitions and events at Transmission during this period included: *A Conspiracy of Feelings*, a performance by William Clark; *Eventspace 3*, including video work by John Latham, Catherine Elwes, Tina Keane, Lydia Schouten, and Ian Breakwell; *Photographic Works*, photography by David Allen, Clive Jachnik and Gerlinde Salentin; *Cut Out 2* and *Restricted Movement*, performance and installations by Euan Sutherland; and the *Fifth International Festival of Plagiarism*, a group show including Mark Bloch, William Clark, Stuart Home, and Mark Pawson.

So, you spent more time in cinemas and bars than in college...
you found your own interests spontaneously: film, music,
whatever. And out of these interests developed the art that you
made then, and continue to make now.

This seems to me a critical definition of difference between your
generation, and that of the attitudes held by some of the so-
called conceptual generation. You were not forming your
practice in opposition to anything in particular, whereas I would
say that the sophistication of the sixties generation was that they
identified something which they had to be against, had to fight,
and had to construct a new model for art; in opposition to that
which they saw as the established order of things. Now, this is
the attitude that I, and many others, grew up with. But you're
talking in terms of spontaneity, and interests, and I think you're
making art as a natural extension of those interests. This is an
aspect of art making that is not often acknowledged by art
historians. The classic model is for a new generation to adopt
the stance of protagonist. But what I hear you saying is that
people are making work that is more unconscious, more open to
influence in terms of process, context and cultural influence
rather than trying to beat the hell out of the former generation,
in order to define a role, a place, or an identity for yourselves.

Listening to certain words that you are using, and in reference
to the influence of context, I should say that this way of thinking
comes very strongly from the class in which I studied in
Glasgow, in the Environmental Art Department. Looking back
on when I graduated from that department, I feel as though we
(my generation of graduates) were given as much freedom as we
wanted [4], but all of this freedom was under the philosophical
umbrella, or the ethic of the department, which was that an
artist had to be able to understand the context in which the work
was to be seen. It is very simple but it is absolutely critical. The
kind of phraseology that was used in the department was that
'context is 50% of the work', meaning that if you have an idea, it
doesn't matter whether that idea turns into a recognisable piece
of art, or not. It's simply common sense to say that there are
certain things that might be possible to do in a bar that you
would not do when sitting on a bus; there are some ideas which
would work very well on the street, which would be a total
failure in the museum, and vice versa. [5]

And time was an issue here too. You have to choose the right
moment to do the right thing.

Maybe this is the attitude that defines what is interesting in art
being made now.

4 The Environmental Art Department was established in
1985 in the Glasgow School of Art. It replaced the older
Department of Murals and Stained Glass that had, in its
final days, been housing everything that fell beyond the
orthodox categories of the Art School. The new
Department of Environmental Art was led by David
Harding and teachers included Brian Kelly, Stan Bonnar
and Sam Ainsley, now head of the Masters of Fine Art
Course at the School. These teachers, amongst others,
became key influences on the development of
contemporary art in Glasgow. The Department of
Environmental Art, in particular, was the seedbed for a
remarkable generation of artists including Christine
Borland, Toby Webster, Nathan Coley, Martin Boyce, Roddy
Buchanan, Jackie Donachie, David Shrigley, Louise
Scullion, Jonathan Monk, Ross Sinclair, and Craig
Richardson.

5 In a recent article on public art, David Harding recalls
the influences on the formation of the Environmental Art
Department, citing the Artist Placement Group (APG)
founded by John Latham and Barbara Stavini, among
others, to site artists in non-art settings. The maxim 'the
context is half the work', is theirs.
Harding also recalls a quote from the artist Michael Heizer
in 1969 after his move into the deserts of Nevada: 'The
museums and collections are stuffed, the floors are
sagging, but the real space exists.'

It defines a sensitivity to a situation.

But the other thing is that this 'looseness' and lucidity combine to make a different statement in art history.

So it seems like the process of art making is one of spontaneous growth without being fully conscious until after the fact of making a work – at which point you can turn around, look back, and make a conscious construction of intent. That's what is interesting. This could be seen as a reversal of the process of the conceptual generation.

Well, in some ways I suppose this is true. But on the other hand, let me talk about a comment that I heard from Terry Atkinson, lately. He was talking about a difference in attitude between his generation and mine. Now, let's agree that a 'difference' is not only a positive thing, it's a plain fact. So, let's try and identify how the difference is manifest. Now, Terry made a comment that the difference between these generations was in terms of 'dissent'. He said that his generation was very much about 'dissenting' in terms of art-practice, and political culture. [6] Now this issue of dissent was something I thought a lot about in terms of a differentiation between the generations. I think it's absolutely linked to the political climate in which we grew up. Let's agree that the political situation that the artists in the sixties grew into is a markedly different one from that which I have had to suffer for the last eighteen years. Perhaps the sixties was a time for political and social change, a time for building things up, a situation of some liberation (for some people) and so maybe it was a time in which there was some available space for artists, and thinkers in general. A space was available for thinking and so Atkinson's 'dissent' against the previous and contemporary political situation had some space to grow. And the art situation would feel this too, because those same people

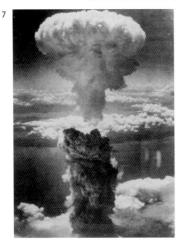

7

were making art with the same attitude. Now, let's compare this to the political situation in Britain when I was growing up, and when I was starting my art education. This was just after the Falklands War, this was during The Miners' Strike, this was at the brink of the collapse of the Trade Union Movement, this was just at the point where no-one really knew what was going to happen in the Cold War relations between the East and West, while we are crossing busy roads in Glasgow with nuclear warheads on lorries bound for the Polaris missile base just 25 miles away from the art school. [7] And let's not forget, this is the

6 In an essay called *Place, Position, Power, Politics* (1994) the artist Martha Rosler sums up this desire for dissent: 'During the "emancipatory" sixties, many artists (...) sought liberation from market forces (...). Such liberation, it was believed, would free artists to interpret – or perhaps to interpret for – the wider society (...) [This] took place in the context of a wide acceptance of the idea of alternative cultural spheres, or countercultures, which was rightly inflected through the late 1960s and early 1970s, largely as a result of the antiwar/youth movement and its alienation from modern technological/institutional power. Many young artists wanted to evade dominant cultural institutions: museums and their ancillary small shops, the commercial galleries on the one hand, and broadcast television on the other. High culture institutions were criticised for fostering individualism, signature, and careerism, and for choosing expression over communication. Television was castigated for empty commercialism.' Rosler concludes that 'The anti-institutional revolt was unsuccessful, and the art world has now completed something of a paradigm shift.'

7 Atomb bomb explosion, Nagasaki, Japan, 1945.

8 The public acknowledgement of AIDS in the early eighties was characterised by the new puritanical mood of Ronald Reagan's America. In a society where the Right had embraced biblical fundamentalists, AIDS was seen as a punishment from God, 'payback' for the perceived decadence of the sixties, the free love movement and the emergent gay culture in the seventies. Just how entrenched these attitudes were can be seen in an editorial by Dr James Fletcher in the *Southern Medical Journal* where he claims: 'A logical conclusion is that AIDS is a self-inflicted disorder for the majority of those who suffer from it. For again, without placing reproach upon certain Haitians or haemophiliacs, we see homosexual men reaping not only expected consequences of sexual promiscuity, suffering even as promiscuous heterosexuals the usual venereal diseases, but other unusual consequences as well. Perhaps, then, homosexuality is not "alternative" behaviour at all, but as the ancient wisdom of the Bible states, most certainly pathologic. Indeed from an empirical medical perspective alone current scientific observation seems to require the conclusion that homosexuality is a pathologic condition.'
The response in Britain, particularly in the tabloid newspapers, was no less severe. The government's reluctant public health campaign was also notorious for its obscure message – television advertisements simply showed an iceberg looming in dark waters.

9 Oliviero Toscani, Benetton advertising campaign using image of AIDS victim, 1992.

10 Margaret Thatcher came to power in 1979. Leading the Conservative Party and winning three elections, she remained Prime Minister throughout the 1980s. At the same time, Scotland's Conservative vote dwindled to (nearly) nothing and Glasgow, in particular, was overwhelmingly voting Labour. Scots felt increasingly isolated as Thatcher set about dismantling the trade union movement's power base, undercutting and closing down

generation that grew into the reality that HIV and AIDS were 'here to stay' and that saw the first public pictures of people dying and dead because of it. [8, 9] This is not the same situation as that of the sixties; I don't remember my friends having a lot of political or metaphorical space available for people to dissent; I do remember seeing political freedoms being shut down on a daily basis.

The highlights of the 'Thatcher Years'.

Totally. And I think that the specific attentions of those political attitudes on education at that time meant that the cultural scene in Britain was... – it was just a wasteland. [10]

Now, who wants to dissent against the wasteland? You couldn't. You can't. There's no point. You had to try and look around and find something positive and try and build on that. And so inevitably what happened was that you didn't find anything positive. Not one thing that was positive. Perhaps, you could find fragments of things which might be able to be put together in an interesting way and to build it into something. [11]
But no one would know exactly what that process would bring about. However, it seemed like a necessity – at least as necessary as the dissent of the sixties.

It's like having to find your way through self-organisation or self-determination rather than participating in a system which was already in place – because the system just wasn't there anymore. At least you couldn't reach it.

I suppose in some ways, in the way I talk about it, the political situation sounds almost post-apocalyptic. And we know that the myth of the apocalypse is that the survivors don't run around waving theses at one another saying 'I told you so!' – they have to start building with whatever materials they have to hand. And for my generation there's no point in hankering after a system that isn't there anymore. [12]

But you must find yourself in a bit of a funny situation these days – because the lifestyle you have, or what people believe, is that of someone who works on aeroplanes and lives off room-service in fancy hotels. Now this picture does not reflect where you're really coming from. Not all artists are chasing after the system, but sometimes the system starts coming to you!

heavy industries and, perhaps sensing she had nothing to lose, using Scotland as a testing ground for controversial new ideas such as the levying of the Poll Tax and nuclear processing at Dounreay. The economic wasteland she created in Scotland was paralleled by a spiritual impoverishment in her vision of a new, materialistic Britain. Her moral grounding was darkly Victorian – she proclaimed her mission saying, 'I am in politics because of the conflict between good and evil, and I believe that in the end good will triumph.' She also declared that there was no such thing as 'society', preferring to focus on smaller cells such as the family, which she perceived in a purely traditional sense, despite the evidence of changing demographics. Paradoxically these negative aspects and her insistence on self-sufficiency have been claimed by some to have had some residual influence on the spirit of various artist-led initiatives that invigorated the scene in Glasgow, London and the British Art World in general. In an extremely odd way, her stress on doing it for yourself echoed the cry of many punk bands in the late seventies, urging everyone to bypass cumbersome institutions and go it alone. However, the debate as to whether the current generation are perceived as 'Thatcher's children', rages on. As Douglas Gordon said in a recent conversation, 'I'd rather be an orphan'.

11 In a brief memoir of her experiences at the Environmental Art Department, Sam Ainsley remembers a piece by Douglas Gordon as a student: 'a performance by Douglas Gordon in one of the ground floor rooms. An enormous wooden beam suspended by heavy ropes hangs from the ceiling; deeply incised with text; sawdust is everywhere. Douglas is working intensely with a range of tools at a bench. There is the live flame of candles and the sound of the tools on the wood. The audience stands around, watching with avid attention, becoming aware of the nature of the activity and its rhythms and rituals. There is a sense of respect for the tools, the activity of using them and those whose lives revolve around the skills of making. Later, he will make an installation with the residue of this performance for the third year exhibition, dedicating it, I think, to his father.'

12 'So where does all this leave you, the young artists just out of art school in Glasgow or Liverpool or Hull? When you're standing at the top of the steps of your college, twenty years of education behind you, is the only way really down? Well, it is if all you are going to do is to retreat to your bedroom/studio for ten years piling up the canvases while you "wait to be discovered". Even if you manage to plough through most of what you imagine might be on the Whitney Independent Study programme reading list it doesn't mean that when the selectors for the British Art Show 1998 (or whenever) come a calling at your studio (which they are unlikely to do anyway) they are going to be bowled over by your work. Why wait for your work to be approved/validated/confirmed by some ex public schoolboy in a sharp suit/jeans'n sneakers? (But maybe you knew him already from prep school). You get out there, do some fucking hot shows and invite them over on your own terms.' Ross Sinclair, 'Bad smells but no sign of the corpse', essay from the exhibition catalogue *Windfall '91*, Glasgow, 1991.

There's an old saying, in Scotland. People talk about the so called 'kale-yard' attitude. It means that you look after your own vegetable patch before you start thinking about creating a garden for other people.

But it also indicates that an artist, coming at things in this way can develop his own criteria, his own media, his own articulation. Your generation has reference to elements that come from outwith traditional art forms. It can avoid the tautological thinking of some previous generation...

Yes. Although, I think I can be tautological when need be.

But let's say that this attitude goes back to the recognition of the importance of 'the context'. And let's try to balance this with the idea of 'inspiration' – which is a concept that I do not like, but I have to accept that some people I know do sometimes wake up in the middle of the night, with a rush of adrenaline, their body covered in perspiration, and they have... an idea!

You speak about it as if it happened to you?

It never did, ... never. I deny it all.

But, anyway, if it did happen to me, and if I did have an idea, then I would have to think hard about where the best place is for this idea. Perhaps it is better to put this idea into a café rather than into the Van Abbemuseum. Then the question becomes one of whether an artist is honest enough to keep some work out of the institution and on the streets. But this shouldn't be such a big deal because it's simple common sense. Is it better for the idea to be in a bar, or in a museum? And then you ask 'better for what?', or 'better for who?'.

Well, I imagine you probably had more access to the bar than the museum anyway?

That was true. Nowadays the problem is in trying to escape from the museum, and find a bar in which there are no artists or curators, so I can have a quiet drink without having to do interviews for publications like this!

But isn't this 'response to context' rather simplistic.

It can be if you want it to be.

On the other hand, it can be very sophisticated, or unstable as a way to work because the context changes – in space and time.

For me, it becomes like trying to understand a language. There's no point trying to say something important while speaking your own language if you are in a foreign country and no-one can understand you. One has to understand the vocabulary of a given situation. And how do you do that? Well, you have to find out how other people live, and act, and behave, and to try to communicate with one another. You do this by becoming one of them. [13] So, there is no such thing as 'other people' anymore; you think like them, and they think like you. It makes communication easier. And this breaks down a lot of so-called barriers between 'art' and 'people'.

If there's no difference between 'artists' and 'people', then there are no barriers to art.

Yes, artists have to participate but at the same time they have to keep the distance of the voyeur. Because you have to be able to register the situation around you.

But voyeurism isn't just for artists, or writers, or thinkers anymore. Voyeurism has become the norm for people living in the world.

It's the same as the way we live with modernism, now. At the beginning of the century modernism was in full flow, but it was writers and artists and so on that recognised this societal change and made it a subject. Nowadays everyone is aware of modernism as a subject, and also as the system in which we live.

So, with voyeurism it's the same; and we need only to look at the cinema to realise that it has become 'accepted' as an integral part of the way the world is.

The term has entered the cultural consciousness. [14]

So, if voyeurism were a necessary position for artists to be able to have an objective view on the world – and you claim that this position has been adopted by culture as a norm – then what position do artists have to occupy now, in order to maintain an objective point of view?

Well, there is more than one issue here. Perhaps the 'objective' is not the point, anymore, if indeed it ever was.

The other thing is that a logical progression from voyeurism would be sadism.

I have heard you say this before, that you are interested in perverting perception.

13 In a well known interview, the Scottish football manager, Bill Shankly, attributed his phenomenal success as manager of Liverpool FC, in the sixties and seventies as being a result of his kinship with the supporters, claiming that there were no barriers between the club and the support: 'People [here] had the same kind of fervour as me. So, I'm one of the people. I'm just one of the people who stands in the Kop. They think the same as I do and I think the same as they do'.

14 One need only look at Hollywood's long obsession with voyeurism. Not only are there many films exclusively about voyeurism: *Rear Window* (Alfred Hitchcock, 1954), *Peeping Tom* (Michael Powell, 1959), *Sliver* (Philip Noyce, 1993), but most films, across every genre, play with the idea of 'what-should-not-be-seen' as an essential part of the narrative, in order to provoke feelings of guilt, fear, or sexual excitement in the viewer.

Well, it's to do with distance. At first you take enough distance to occupy the position of the voyeur, and then you can 'fantasize' with the idea or the image. But this is commonplace, now. So, maybe one needs to take things a bit further. If you take more distance, not just critically, but morally and ethically [15], then you move into the field of sadism – when you can start to manipulate the idea or the image before the audience, or the viewer, get a chance to do it.

15 See Gilles Deleuze's essay *Coldness and Cruelty* (1967), a critical analysis of Leopold von Sacher-Masoch's novel *Venus in Furs*, 1870 (published together by Zone Books, 1991).

So is this your idea of progress? Firstly, artists have to participate in the world, then they have to take a step back (voyeurism), and then, as the world catches up, the artist has to step back again and find another position (sadism); one in which you start torturing people?

Mmmm. Well, ...

Is this what you were trying to do with the *Letters* that you sent to people? [16]

16 See page 94, 95, 164, 165.

I remember receiving two or three of these *Letters*, maybe sometime around 1992, or 1993. It's strange, but I enjoyed thinking about them. I enjoyed the fact that this *Letter* was sent to me by a guy that I didn't know. So, by not knowing the sender, the *Letters* became more about me. On one day the *Letter* could seem very generous, very friendly, very warm. But at other times I hated it. It could seem very aggressive.

In many ways, the *Letters* became like a reflection of the human condition. But they could also be seen to be quite cynical. In terms of your career...

They were never meant to be cynical. And, in retrospect I still don't see them that way. I think they probably jeopardised my career, rather than anything else. But, I am interested in the idea of jeopardising everything all of the time. This may end up not making me a very happy person when (if) I get to be sixty years old but it might at least make my life interesting. So, the idea of jeopardy is very much a part of me, and was a part of the process involved in sending the *Letters*.

Let me tell you a funny story...

I once received a telegram from On Kawara. So, let's say there is a certain way in which On Kawara's work can be read – for example, an existentialist obsession to fix, on a daily basis, your awareness of your own existence, which is a very positive thing. At that time he sent messages by cable because they were the fastest way to communicate. However, in Holland someone had the idea that telegrams were too slow, and so they had a system

whereby the Post Office would call you as soon as the telegram arrived in their place – just to let you know that a telegram would come tomorrow, and to tell you what the message was anyway. [17]

So, On Kawara sends me the telegram saying 'I am still alive'. But the message I get is from the guy at the Post Office who says 'Mr. Debbaut, please sit down, I have a very sad message. Your friend is still alive.' And I said 'Well, isn't that a good message?' But the guy from the Post Office was baffled; he couldn't understand why anyone would send a telegram like that if they were not in some kind of danger, or trouble...

So, here is a perfect example of what you are talking about; the process of an intention completely perverted by the context in which it is presented by somebody else. It becomes a rupture in the system of communication. And I had the same kind of thing with your *Letters*.

When did you first start sending them to people?

In 1991, for a group show in Nevers, France.

The project was that artists were invited to contribute a small work to fit into an 'archive box'. Liam Gillick and Henry Bond were organising the show, and most of the artists invited were from London. Most of them were people who were already known, at least to me, whereas I was totally unknown to them. I thought that this might be an interesting social fact to play with. I sent each of the artists a *Letter*, which stated the simple fact...

'I am aware of who you are & what you do.'

So, the work was playing on a social situation; lack of knowledge on one side, and a position of knowing something, on the other side; even from a peripheral position.

As a critique on the institution of the museum?

Not everyone who received them was working in a museum.

But for those who were, it wasn't so much a questioning of the institution, but more of posing a question to those institution's individuals. My idea was that anyone in a high powered position like that must be surrounded by all sorts of neuroses, paranoia, or even hysteria, and that any human beings who are in a position of making value judgements must run the risk of being wrong sometime. I thought that perhaps this was an interesting social situation, even if a somewhat hidden one.

Maybe some of these people have something to feel a little guilty about, like everyone else in the world.

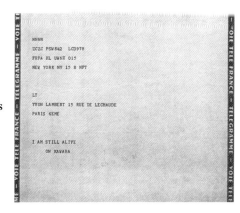

17 On Kawara, *Telegram*, 1972, collection Yvon Lambert, Paris.

And did people reply?

Yes, some people sent back some interesting replies. And some people didn't like the *Letters* at all, and were quite upset by them, I think. So if people ask me if these works were just a cynical exercise in self-promotion, then I always say that they couldn't possibly work out that way. There was always a very real chance of jeopardising a future relationship, rather than cultivating one. But it's important to say that these works, for me, were very critically timed. They were mailed out to people before many of these recipients knew my work, or me. I wanted them to operate as 'real' objects in many ways – not as semi-redundant art souvenirs. I wanted the *Letters* to be read, not necessarily hung on the wall, or safely kept for 'posterity' (whatever that might be). But on this issue of them being 'real' – I know that some people have the impression that the *Letters* were anonymous. They were not. For sure they were unsolicited, but they were always signed, quite clearly. They had an author, who could be identified, and responded to, if that was necessary. And also, on this issue of an identifiable author, or maker; I always sent these things to art-people, so-called, or friends, family, acquaintances. I wasn't interested in choosing names of old women, living in the middle of nowhere, or anything like that. They were not designed as serious intimidations. I tried to send them to people who were under the same umbrella of interests, broadly speaking – whether artists, family, museum people, or whatever.

And what about those 'phone calls' you made? This was around about the same time?

I never made those calls personally. Those works, the *Instructions*, were normally presented, pretty loosely, within the context of an exhibition. [18] And usually within this exhibition there would be a common social situation for the artists and the audience for the exhibition. Let's say that this common social situation might have been a bar, or a café, where the artists, curators, and the visitors to the show might meet. This was a context that interested me. It offered the possibility to be able to use a 'safe' social space, populated by like-minded people, and so a legitimate space to make a piece of work like the *Instructions*. In this way the whole form of the work would not harm anyone, but at the same time it could operate as analogous to a broader social situation.

The form of the work was as follows: I would be invited to participate in a show. I would suggest we make an *Instruction*, and this would begin an interesting process of collaboration – or sharing of responsibility – between the artist, the curator, and

18 See page 104, 105, 116, 117.

the owner of a local bar, or café. I would send an instruction to the curator – he or she would then choose a bar, and a barperson who was willing to participate, and the whole thing would go on from there.

What kind of response did you expect from these works?

In many ways, I had my 'response' before I made the works. These pieces were made because they touched upon areas of my life that I spent a lot of time thinking about, and trying to investigate in any case. The crude example would be that everyone I know has had – or knows someone who has been on the 'wrong' end of – a mysterious phone call, or a strange *Letter*. I thought a lot about these things, and maybe what I was trying to do was to follow the process, pervert it a little bit, and so people might end up being on the 'right' end of the situation, rather than the wrong end.

So, the message is the medium, once again?

Well, perhaps the best thing to say is that the message is the message. People who received the *Letters*, or the calls, had to take them as they found them.

At least, this was the case up until recently, when people might recognise my signature on a *Letter*, or whatever. And then the work became like a souvenir. The message was no longer the message. The message was no longer the medium. The message had become a souvenir, even before it had time to function in the world.

So, I stopped making them.

So, before you stopped the *Letters*, there was a game going on, to do with your recognition of your own status in the system, too. And by the fact of your relative 'anonymity', there is a pretty good chance that a lot of people threw these *Letters* away?

I liked the fact that 95% of people might throw them away. And now that the work is a little better known, maybe those 95% of people might be sitting thinking, 'Did I receive a *Letter* like that?'

And regretting the fact that they might have thrown away a valuable art object.

I never really thought of the *Letters* as possible art objects – they were not made for anyone to 'consume' in any way other than as an idea. They were simply words on a page.

So, now we have the question of conceptual residue, as opposed to material residue.

And this is like the project we made at the Van Abbemuseum, in 1995. I was interested in the way people might start to distrust us, if we actually GAVE them a piece of art, rather than trying to sell it to them. [19] I think this is maybe what I understand when you talk about conceptual residue.

19 *Pocket Telepathy*, 1995.

But this project was quite different.

Well I suppose I was playing with an idea that most people live with – that you don't get something for nothing in this world. This is very Faustian [20], in a funny way. But it also illustrates the way in which people can think in parallel, without even making much of an effort to do so. For example – we gave people something without them knowing it (while their coats and jackets were in the museum cloakroom) – which, by implication, meant that we could also be taking something from them without their knowing it. That was the 'parallel' thought, and I think that most people responded to the stimulus.

The 'game' continued when people discovered what they had been carrying around without knowing: inside the coat pocket was a 35 mm slide. Inside the slide mount was the title of the work, *Pocket Telepathy*, and the image was that of a mind reader. I thought this might be an interesting thing for people to play with – parallel thoughts and residual power.

It reminds me of a story my mother told me when I was young.

She had been going through a period of some bad luck, or ill health, or something, and she couldn't understand why. She began to think that there was some kind of inexplicable reason for the way she was feeling. And then she began to become preoccupied with the idea that someone had put a 'fluence' on her. She remembered an incident that had happened recently, where a young woman had come up to her in the street, out of the blue, and given my mother some wine glasses, as a 'gift'. So, the more my mother thought about it, she reckoned that perhaps these objects had some residual influence on her life. Maybe the glasses had been stolen, and therefore were bringing bad luck on whoever had them. Then, she got rid of the glasses, and everything went back to normal again.

Do you really believe things like this?

Well, even although it's a superstitious story, I always find these things interesting.

20 Faust, a legendary medieval scholar and magician, was said to have sold his soul to the devil (or Mephistopheles) in return for knowledge and power. His myth was based around a real historical figure – Johann Faust (c. 1480 – c. 1539), a vagrant scholar and mountebank – and the folklorist stories that grew up around him were recorded by Luther's disciple, Melancthon, in 1540. In 1587, Johann Spiess published his *Historia von Doktor Johann Faustus*, known across Europe as the 'Faustbook'. This story of Faust inspired writers such as Christopher Marlowe, Johann Wolfgang von Goethe and Thomas Mann. Goethe's *Faust*, in particular, has gained a place in European literature, documenting a more complex version of the devil in the age of enlightenment where evil has become a more subtle force.

You often describe works in a laconic way, tracing reason or intention back to other situations. I wonder if you can point out or trace back what you think was your first mature work?

Well, I used to have some drawings of sharks and birds of prey that were pretty good, but I lost them when I went to secondary school. So, I'd have to say that in retrospect, a lot of the performance works I made, and particularly those in collaboration with Craig Richardson, in Glasgow, are not so different from what I'm doing now. [21]

These performances were very much to do with the sensory perception of objects and action, and in relation to time. Objects and materials were set out next to one another, and usually in a situation or configuration where one would not expect them to be found. The installations were very open, in terms of 'viewing'; people could come and go as they pleased. There was no formal seating or time specified to arrive, stay, or leave. This is close to the way in which I continue to install a lot of work. The space in which the work is placed is open (within reason) and the time that is asked of the viewer is unspecified. I like the basic principle here that visitors could use the work in the sense that they might want to stay 'here' because they don't want to be anywhere else. And maybe if a person stays longer, then some more interesting things can be thought or start to grow...

This situation that you offer – a presentation of what appears to be 'very little' in terms of manipulation, or even with intent...

I see ambiguity as a positive thing; it's about giving the viewers enough space (literally and metaphorically) to come to an individual and shifting conclusion [22], if that's not too much of a contradiction. Perhaps 'democratic' is a better word than 'ambiguity' – perhaps not.

But how do you evaluate a work?

I evaluate one work in relation to another. I try to evaluate a number of works in the sense that I see them as a family.

As regards making the work – I enjoy trying to understand systems or complexes in order to create a meaning and then tear that system down, in order to rebuild it again, and tear it down again, and so on... I like to construct self-destructive systems, or mechanisms, which can only lead towards a multiplicity of meanings [23], a series of contradictory interpretations. I like a conspiracy of circumstances that can help construct a meaning for a work, or that can turn against it at any moment.

21 Douglas Gordon and Craig Richardson, *The Puberty Institution*, 1987.

22 Ambiguity has a long philosophic history stretching back at least as far as the pre-Socratic thinker, Heraclitus. Often nicknamed 'The Obscure' or 'The Riddler', he deliberately couched his thought in ambiguous sentences which left his readers with a kaleidoscopic view of the truth. In *Rhetoric*, Aristotle mentions that it is difficult to punctuate Heraclitus' writings because it is unclear whether a word goes with what follows or with what precedes it. For example at the very beginning of his treatise where he says, 'Of this account which holds forever men prove uncomprehending', it is unclear which word 'forever' goes with. Later, Plato would use the dialogic method to suspend knowledge and to put his audience in the position of 'learning that they know nothing', rather than positing any definitive and authoritative model of knowledge. Also note Gordon's work *Meaning and Location* (1990).

23 'We are used to thinking that the author is so different from all other men, and so transcendent with regard to all languages that, as soon as he speaks, meaning begins to proliferate, to proliferate indefinitely.
The truth is quite the contrary: the author is not an indefinite source of significations which fill a work. The author does not precede the works, he is a certain functional principle by which, in our culture, one limits, excludes, and chooses; in short, by which one impedes the free circulation, the free manipulation, the free composition, decomposition, and recomposition of fiction. In fact, if we are accustomed to presenting the author as a genius, as a perpetual surging of invention, it is because, in reality, we make him function in exactly the opposite fashion (...). The author is therefore the ideological figure by which one marks the manner in which we fear the proliferation of meaning.' Michel Foucault, *What is an Author?*, 1977.

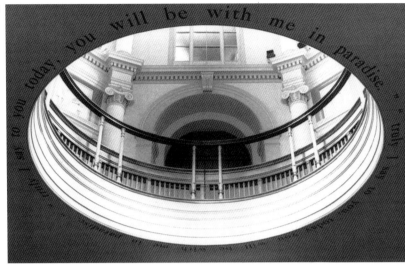

Jeremy Bentham (1748-1832), the London-born lawyer and philosopher, was a leading member of the utilitarian school of thought. Starting from the principle that, 'Nature has placed mankind under the governance of two sovereign masters, pain and pleasure', Bentham argued that human actions should be judged right or wrong depending on whether they maximised pleasure (and minimised pain). To help measure actions in this way, he devised a 'hedonic calculus'.
He is also remembered as the inventor of the panopticon – an architectural creation which placed a viewing tower at the centre of a radiating series of corridors in a prison. In the panopticon, wardens could observe all prisoners at all times from one easy vantage point. The system was much employed in the construction of asylums and prisons in the nineteenth century and is seen as one of the key landmarks in the development of a society of surveillance. In order to demonstrate the efficacy of his panopticon, Bentham acquired a site at Millbank in London, hoping to build a model prison in which he would take prisoners at a fee from the state, giving each one a grant on discharge and paying the exchequer if an ex-inmate reoffended. His panopticon was never built but the government later bought the Millbank site and erected a penitentiary only roughly based on Bentham's design and run by a chaplain-governor, the Reverend Daniel Nihil. Under Nihil's regime, there was a scandal when it was discovered that three small girls, two aged ten and one only seven, had been kept in solitary confinement for twelve months and faced another two years of the same punishment. The public were shocked to hear that when the seven-year-old asked for a doll at bedtime she was refused.
The prison was later used as a depot for prisoners awaiting transportation to the colonies and the central buildings were demolished in 1903. The main site is now occupied by the Tate Gallery.

So, is the work 'functional' for you?

Yes. And I suppose that this pursuit of a 'self-destructive' mechanism becomes manifest to the viewer as ambiguity of meaning – or even of intention, sometimes.

For example?

A piece which few people saw was *Meaning and Location*, in 1990. This was made for an interesting situation at University College, London.

The college was founded by Jeremy Bentham, and the whole ethos of the place comes from his very liberal philosophical roots; this was the first European university to admit Jewish students and women. [24] But because of this liberal history, this secular ethic, there is no theological study, and not one book on theology in the university library (which was something I needed in relation to my project). A further contradiction to the 'liberal' idealism is the architecture of the building – standard neo-classicism. [25]

So, the more I realised the contradictory nature of the place, I thought it might be interesting to make something out of it. I had an idea to install a text into a certain area of the university. This was an area that most people passed by at one time or other in the course of the week, if you wanted to eat in the café or drink in the bar. I was specifically interested in an aperture that had been cut into the ceiling in this area; the aperture was perfectly round and looked up and into the university library, the seat of all knowledge, as it were. I decided to install some words,

The London University building, now University College in Gower Street, was constructed in 1826/1827. John Summerson, the eminent architectural historian, describes in *Georgian London* (1945), saying: 'The plan is shown to contain all the elements – decidedly continental – of the new university idea. There is, of course, no chapel – this pointed omission allowing a great assembly hall to be made the central feature of the building. The wings adjoining the hall comprise suites of museums and libraries (...). In the execution of the design a very unfortunate thing happened. The assembly hall was omitted. But its decastyle portico and the great array of steps leading up to it were retained. The result is that the steps and portico now lead to nothing except a disappointing octagonal lobby with a light-well in the centre; so that the portico is now, in fact, nothing more than a "set piece", and architectural charade'.

Meaning and Location, 1990.

The full gospel text in the King James Version (1611) of the English Bible reads as follows:
'And one of the malefactors which were hanged railed on him, saying, If thou be Christ, save thyself and us.
But the other answering rebuked him, saying, Dost not thou fear God, seeing thou art in the same condemnation?
And we indeed justly; for we receive the due reward of our

and in such a way that they would seem to be in perfect harmony with the space – or at least, this is how it would be perceived at first glance.

So I put a piece of text, which was from the Bible, into this non-clerical building. [26]

What was the text?

The specificity of the text is critical. It comes from the New Testament – Luke 23:43.

'Truly I say to you today you will be with me in paradise'. [27]

So, here we have a biblical text in a staunchly secular environment, which appears to be at one with the architectural environment, but absolutely at odds with the philosophy of the school. Further, the choice of text is one in which there is also a problem as regards origin and translation; depending on which system of translation you adopt, the comma can shift from one side of a word to another. So you can have

'Truly I say to you, today you will be with me in paradise'
or
'Truly I say to you today, you will be with me in paradise'.

I simply installed both of them around the aperture, one text running into the other.

Once again, this promotes a shift in perception. Clearly, the meaning of these texts can differ, depending on the emphasis one creates with the comma. And this text is critical in relation to the Christian belief in life after death; specifically when would life after death take place? [28] And according to my reading at that time, there is no way of knowing where to place the emphasis, because there is no concrete method in translating from Greek Scripture to Hebrew Scripture to German (the first Bibles) and then into English.

The final detail of the work was that, in order to read the text, people would have to look up at the aperture – which of course directed them to look into the university library. This was a library of philosophy, science and art, it is a repository for hundreds of different belief systems; each one of them mediated through books, in which, like the Biblical text, there exists the potential for hundreds of thousands of errors. [29]

So, this work, I think, illustrates what I said earlier, about trying to understand the mechanisms at work in any context; constructing something alongside it, which in itself can collapse, and bring the whole structure down around it.

But, it is important to say that this is not done without some sympathy for the structure.

deeds: but this man hath done nothing amiss.
And he said unto Jesus, Lord, remember me when thou comest into thy kingdom.
And Jesus said unto him, Verily I say unto thee, Today shalt thou be with me in paradise.'
Luke 23:39-43.

28 The Christian concern with the question of life after death may have its roots in the complex Jewish web of myths and theological debate. In his commentary on Saint Luke, G.B. Caird explains: 'Paradise is a Persian word, meaning park or garden, which was taken over, first into Greek, then into Hebrew. In the Septuagint it was used to translate "the Garden of Eden". Then, because of the belief that the day of God would bring a restoration of primeval bliss, Paradise became the name of the future home of the righteous. Finally, this earthly Paradise was distinguished from the heavenly one, of which the Garden of Eden was only an earthly copy. Jewish beliefs about the afterlife were too multifarious to be reduced to a single consistent pattern. At first it was held that the dead waited in the sleep of death in Sheol, the universal graveyard, until the general resurrection and judgement. But later, alongside of this earlier hope, and never quite replacing it, there grew up another belief that the soul of the righteous went at death immediately to heaven. It is this assumption that lies behind the promise of Jesus.' G.B. Caird, *Saint Luke*, 1963.

29 'The impious maintain that nonsense is normal in the Library and that the reasonable (and even humble and pure coherence) is an almost miraculous exception. They speak (I know) of the "feverish Library whose chance volumes are constantly in danger of changing into others and affirm, negate and confuse everything like a delirious divinity". These words, which not only denounce the disorder but exemplify it as well, notoriously prove their authors' abominable taste and desperate ignorance.' Jorge Luis Borges, *The Library of Babel*, 1964. The emergence of the new scientific method in the mid-seventeenth century led to debate on the slippery nature of language. The newly established Royal Society in London tried to promote a clean and pure form of prose, as free of metaphor as possible, in order to clearly and accurately communicate scientific data without any trace of ambiguity. Thomas Sprat, in his *History of the Society* (1667) wrote angrily of 'this vicious abundance of phrase, this trick of metaphors, this volubility of tongue, which makes so great a noise in the World. But I spend words in vain; for the evil is now so inveterate, that it is hard to know whom to blame, or where to begin to reform.'
In *The Imperial Archive: Knowledge and the Fantasy of Empire* (1993), Thomas Richards notes that, 'Most Victorian epistemologies presupposed a superintending unity of knowledge. A comprehensive knowledge of the world was for most of the century the explicit goal of all forms of learning. People began the nineteenth century believing that all the knowledge in the world fell into a great standing order, a category of categories, but, after dozens of Casaubons had failed to make sense of thousands of facts squeezed into library catalogues, biological taxonomies, and philological treatises, they ended it by believing that the order of things was easier said than done. By 1900 not even the librarians at the British Museum seriously believed they would be able to

Would you say that you still use this method of working? It is 'method' based, as opposed to the pursuit of communication through one medium.

Yes. The attitude is the method.

And this, again, is a perversion of Marshall McLuhan's 'the medium is the message'? [30]

Yeah, the message is the medium.

And therefore it's conceptual art.

Well, it's conceptual attitude.

And what's your attitude towards object-making?

I don't know if I have an attitude in this field. I don't see myself as part of the tradition of object-making, or even part of that way of thinking. And this has not got anything to do with the ideology of the deconstruction of the art object – although I'm well aware of how my work has at least a superficial relation to that kind of work produced in the sixties and seventies.

No, I was brought up in a culture, in a house, where there were no objects of any value. Our house was full of utilitarian objects; objects to be used, not thought about. They had a practical value – they cooked food, they boiled water, they allowed you to talk to people in other places, but they had no financial value, no esoteric value, and in no way would they be subject to any kind of speculation – critical or economic. It's even ridiculous to think about my family life in these terms, never mind talking about it. But, it's important for me to say that I'm not looking back on this situation with any resentment or any nostalgia. It's just a simple fact that, in my background, if ideas were discussed, then this was absolutely in the absence of objects. It's not such a bad thing, perhaps. We were never bogged down with aesthetic problems, for instance.

And anyway, now I find myself in the opposite situation. The art world is a system in which many people pursue and collect objects. Some of these objects have a value (economic) and are discussed in the absence of ideas! A total paradox of my experience. I never saw any option to make objects.

But why was this not an option? Surely this must have been something you considered; as a student, you were surrounded by this eighties boom in object making – indeed the whole

chip away at this backlog of knowledge. The great monument to Victorian knowledge, the Oxford English Dictionary, wasn't completed until the late 1920s, by which time the first volumes in the series were already fifty years out of date.'

30 'In a culture like ours, long accustomed to splitting and dividing all things as a means of control, it is sometimes a bit of a shock to be reminded that, in operational and practical fact, the medium is the message. This is merely to say that the personal and social consequences of any medium – that is, on any extension of ourselves – result from the new scale that is introduced into our affairs by each extension of ourselves or by any new technology. The instance of the electric light may prove illuminating in this connection. The electric light is pure information. It is a medium without a message, as it were, unless it is used to spell out some verbal ad or name. This fact, characteristic of all media, means that the "content" of any medium is always another medium. The content of writing is speech, just as the written word is the content of print, and print is the content of the telegraph (...). What we are considering here, however, are the psychic and social consequences of the designs or patterns as they amplify or accelerate existing processes. For the "message" of any medium or technology is the change of scale or pace or pattern that it introduces into human affairs'. Marshall McLuhan, *Understanding Media: The Extensions of Man*, 1964.

generation of artists before you were quite obsessed with the manipulation of objects.

Yeah, sure, if you're thinking about English Sculpture, or whatever was happening down at the Lisson gallery, or whatever. But you must remember that this was certainly not the situation in Glasgow. We were not particularly encouraged, by the art school in general, to look at what was happening in the museum world or in the art world. This was not particularly the case in the Environmental Art Department, but was certainly the feeling that I got from the school at large. I mean, I had no idea about the New British Sculpture people that you were showing in your museum, people like Tony Cragg [31], Richard Deacon, and so on. We didn't get near these guys, or whatever it was that they were doing.

Why not?

Because the 'old folks' in the art school thought that they were challenging tradition, and undermining the culture of the past. So, while the rest of the world was enjoying, or enduring the 'art boom' of the eighties, and the whole world was being flooded with large-scale paintings and sculpture, I, living in Scotland, was totally unaware of it.

People in museums and galleries often say 'forget the eighties', or 'things will never be like that again'. Well, so what? I don't remember them, because I wasn't there. And by the time I went to London, it was already the winter of that boom, and things were starting to go stale pretty quickly.

So, your way of making work, is not in direct opposition to what happened in the eighties?

No, it is neither for nor against whatever happened during those years. That was then, and this is now, and I make work in a way that suits the way that my head works today.

It might change tomorrow.

This is very pragmatic. Is this how you were taught to think at art school?

The peculiar thing is that, although the general art education in Scotland is still very conservative/traditional, we already had experience of 'how to think' at secondary school. This is the supposedly typical Scottish common-sense philosophy of

31 In 1990, Tony Cragg finally appeared in Glasgow (at CCA and Tramway) after a decade of neo-expressionist painting dominated the scene. The primary alternative to this domination was Transmission Gallery's programme from 1983 onwards.

pragmatic thinking and Calvinist ethics and aesthetics. So, it was actually easier to associate with art ideas from the sixties, based upon my school education, than it was to look at whatever was on show at the National Galleries in Edinburgh, or at the art schools in Scotland, or indeed the object makers of the eighties. These shows had just nothing of interest to me. It was more engaging to read about people like Lawrence Weiner, or Dan Graham's early work, or things like Gordon Matta-Clark's *Food* [32, 33, 34], because I could identify aspects of these attitudes with the kind of literature, and movies that I had been encouraged to read and watch as a child and as a teenager.

You seem acutely aware of the art system and some of the relationships it has with the 'larger' political or cultural world. You seem to be able to spot how the hierarchies work. Do you see some of your own works as more important than others?

Of course there is a hierarchy of importance with art ideas, with art works, and so on, and of course this hierarchy is often seen in relation to the scale of presentation of the work – but this is not necessarily always the truth, and not the way I like to think about it. I like to imagine that the relationship with the artwork, the art idea, is just like one's relationships with another human being. This can be wild, or explicit, or discreet or illicit or whatever. Sometimes, a brief kiss and an affair which never got started can mean more than living together with someone for years and years. So, art is like this too. It can be discreet and still mean something.

Discretion has an important place in the world I like to live in.

And discretion implies detail? Do you think you might be obsessed with detail?

For me, this is true. I often like to think that I'm looking at big situations in a macro way. You know, by taking something quite small – and usually this thing is something that is a part of a much larger whole – and allowing it to fill the frame for a time. So, I like to take a detail, and allow it the time and space to become an epic, or a monolith in it's own right.

But it's important to differentiate between detail and precision.

To me, precision alludes much more to a process.

Detail can be part of a discovery through a process of precision.

And also the fact that this discovery of detail, or the focus on that which should not be seen, should not be examined, can completely undermine the larger system in which the detail has

WITH RELATION TO THE VARIOUS MANNERS OF USE:
1. THE ARTIST MAY CONSTRUCT THE PIECE
2. THE PIECE MAY BE FABRICATED
3. THE PIECE NEED NOT TO BE BUILT
EACH BEING EQUAL AND CONSISTENT WITH THE INTENT OF THE ARTIST THE DECISION AS TO CONDITION RESTS WITH THE RECEIVER UPON THE OCCASION OF RECEIVERSHIP

32 Lawrence Weiner, statement by the artist, 1968.

33 Dan Graham, photographic documentation of *Two Correlated Rotations*, 1969, 2 super-8 film projections.

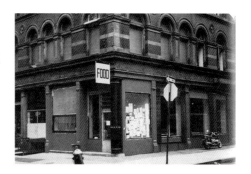

34 Gordon Matta-Clark, *Food*, 1971, restaurant and performance space, Prince Street at Wooster Street, New York.

its natural home. I like the idea that a rupture or a perversion of a large system can occur through the focus on ambiguous detail, and that this can alter the whole fabric of society. Sometimes this can be positive, and sometimes this can be negative. [35]

Maybe I'm interested in this because my family all practised homoeopathy – and as a child I was fascinated by the fact that a tiny amount of herbal influence could cure, or kill, the body. And all of this without the patient being aware of what the doctor was administering. [36]

And do you think that art works in this way? With artists functioning like doctors?

It's funny you should say that, because I remember one of the first times I visited a museum in Germany, possibly in Mönchengladbach, or maybe Stuttgart. And I was looking at this big sprawling piece by Joseph Beuys and my mind was wandering around as I stood there. And I was absentmindedly biting my nails and spitting them into my hand and then quietly dropping them out and onto the floor. This was quite honestly an unintentional action – at first. Then, when I realised what I was doing, I thought it was quite funny – what with the whole Beuys mythology; him and his old toenails, and whatnot. So, it seems that, by homoeopathic accident, I had started to 'intervene' in his work.

Are there actions, performances, or any kind of work of yours that are so discreet as to be unknown at the moment?

Maybe. Maybe not.

35 This fascination with the random positive or negative effects of a tiny detail seem to echo the contemporary outlines of chaos theory. Evolving from meteorological studies, chaos theory can be quickly summed up in the glib shorthand of the Butterfly Effect – the idea that a butterfly stirring the air in Tokyo today can change storm systems a month from now in New York. Physicists have recently used chaos theory to argue that the erratic, unpredictable behaviour of the human mind is a natural consequence of tiny errors or tiny gaps in our knowledge being amplified with more complex systems until they have larger scale effects. The physicist Richard Feynman writes that, 'If water falls over a dam, it splashes. If we stand nearby, every now and then a drop will land on our nose. This appears to be completely random (...). The tiniest irregularities are magnified in falling, so that we get complete randomness (...). Speaking more precisely, given an arbitrary accuracy, no matter how precise, one can find a time long enough that we cannot make predictions valid for that long a time. Now the point is that this length of time is not very large (...). It turns out that in only a very, very tiny time we lose all our information (...). We can no longer predict what is going to happen!' Richard Feynman quoted in James Gleick, *Genius, Richard Feynman and modern physics*, 1992.

36 Homoeopathy is a branch of medicine founded by Samuel Hahnemann, the son of a porcelain painter at the Meissen factory in Saxony. Hahnemann was studying in Edinburgh under the celebrated physician William Cullen when he first began to outline the principles of homoeopathy, later to be published in his work, *The Organon of the Rational Art of Healing* (1810). The basis of homoeopathy can be summed up as follows: 'If a dose of a substance is administered artificially to a patient, the effects of which sufficiently closely simulate the illness from which the patient is known to be suffering, the original illness disappears. This might be described colloquially as treatment by analogy or mimicry. What needs to be done in treating a patient is to observe all the essential details of the illness and then seek out the nearest possible group of substances producing clinical effects which can be found to correspond, and to give the patient suitable immunising doses of these substances. If a smaller, perhaps infinitesimal dose, or series of doses of the same substance is given at repeated intervals, at first nothing is noticed, but presently, gradually a series of effects comes about, much more subtle than those from larger doses, but still completely characteristic of the toxicological effects of that substance. Homoeopaths make use of this knowledge, known as Arndt's law, to heal patients'. Dr Ronald Livingstone, *Homoeopathy*, 1973.

A light on the tape recorder starts to flash, indicating that the tape has run out, and the interview is over, for now. The two men finish up their drinks, leave the flat and head out, onto the city streets...

The scene is a house on the outskirts of a small shipbuilding town in Belgium, somewhere between Antwerp and Ghent. The two men have met again, having eaten a small dinner of eels and potatoes, and drunk white beer. They are relaxed, and begin to talk again. They try to pick up the conversation where they left it, six months before. They drink large glasses of brandy and small cups of coffee. The older man mostly smokes, the younger man mostly talks.

I heard you say once, or perhaps I read it somewhere, that 'art is only an excuse for a conversation'. What do you mean by that?

Well, I mean you've got some art right here on your walls, so let's talk about it. What's that picture over there?

It's a drawing of a man making the shadow of a cat on the wall. It's by Marcel Broodthaers. [37]

So, why did you have this on your wall?

I like the work.

For the fact of possession, or because you thought you'd like to have it as a conversation topic.

When people come to visit me, they often talk about this print, so I suppose that it can be seen as a tool for conversation.

Well, that's what I'm saying; except that you use the word 'tool', and I say 'excuse', which is less eloquent.
So, I think that art is an 'excuse' for a conversation.

What do you mean by 'an excuse'?

Well, it's like when you ask someone to go for a drink, which is just an excuse to ask them to go to dinner, which is just an excuse to ask them to go to the cinema, which is just an excuse to ask them to go to bed with you. And things can move on from there... Sometimes.

Okay, I know what you're saying, but now let me get back to asking you some questions. You travel a lot. When did this start?

I went to Paris when I was seventeen. That was the Summer of 1984. I'd never been outside of Scotland before. I remember arriving in London, getting off the sleeper train at 5:30 in the morning and not knowing where the hell I was...
Anyway, on that trip I went to the Tate Gallery. I was amazed, I'd never been in a place like that before. Sure, there was a lot of great art and so on... but I was more interested by the people

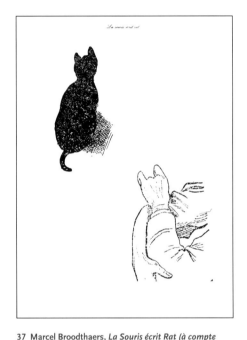

37 Marcel Broodthaers, *La Souris écrit Rat (à compte d'auteur)*, 1974, lithograph, 76,5 x 56,5 cm, edition 150.

who were there. Lots of good-looking girls, and boys, and people seemed to be spending as much time looking at one another, as well as the art. This was the first time I realised this, and it was a very important experience – to see that people do not go to museums just to look at art.

People go to museums to look at other people.

But what about the art?

I had an incredible encounter in the Tate. And with a painting, of all things.

You sound surprised?

It was the largest painting I had ever seen. I was seventeen years old, and it was a huge blue Barnett Newman canvas, and I was astonished. It was really 'the shock of the new'. I remember standing really close to it, at the point where I couldn't see anything, or anyone, else in the room – just this field of blue, saturating my eyes. Then, I turned away from it with my eyes closed, opening them again to look at something else but still seeing the Newman painting. It was as if it had made some kind of a retinal impression. It was really as if I was carrying the image around with me, and this was the first experience I had of the relationship between art and time. I went out of the room for a few minutes, and then went back in order to walk from one end of the painting to the other. I left one end of the blue and looked at my watch. I arrived at the other end of the painting and looked at my watch again. It took a long time. [38]

So, you've spent time in museums. What do you think about them? How do you, as an artist, think museums should be, for other people?

Why do you care what I think?

Museums are constantly told that we should try harder to please people, and that visitors need to be entertained more. I'm interested in your attitude to the museum as an institution. What do you think?

I'm not sure how much a museum should try to please people. If we take it quite literally, and people are 'pleased', then that means that museums are about 'pleasure'. And this is close to entertainment.

That's what they say. 'That's entertainment.'

38 See also Jeanne Siegel's interviews with a series of American artists who discuss the impact Newman's paintings had on their practice, in *Artwords: Discourses on the 60s and 70s* (1985). One of those artists – Robert Murray – analyses the experience of standing in front of a Barnett Newman painting saying: 'It seemed pretty valid, just the way Barney laid it down. His devices were never diagrammatical or decorative, but the format was amazingly logical. The bands within the painting repeated and echoed the rectilinear shape of the canvas just as the color and forming of the bands entered into a dialogue with the open areas of color. It all happens in one arena and when you stand in front of the painting, you are in it. It's not the Impressionist window, it's not the iron-flat Cubist room. It's not mural decoration for the walls – it's more an aura of casually punctuated color you get into through your head and gut. He continued the best aspects of Impressionist color as light and went around the architectural hang-ups of Cubist picture making.'

Entertainment! This is not a museum issue. It should never be discussed in the context of the museum. It's ridiculous. I remember I saw a so-called artist on TV in Scotland saying that going to a museum should be like a trip to the cinema. Well, why? I mean if people want a cinema experience, then the best place they get it is to go to the cinema. If people want a gig experience, then they go to a gig. And a museum offers a different experience to these things. It is not the entertainment industry. It should never be the entertainment industry. [39] The fact that people can be policed by being entertained is no new truth.

Okay, so I'm being the devil's advocate here. Please humour me for five minutes. So, what's wrong with entertainment?

It's because entertainment is primarily to do with the fulfillment of expectation. But surely an aspiration of the museum should be to allow for the unexpected. I mean, my god, there are not so many places left in the world to encounter the unexpected.

But politicians say that people don't want to be 'challenged'?

Well, bluntly, let's assume that people must like the idea of challenge. Because if human beings did not like it, then we wouldn't be sitting here in 1998 and talking about it. Our ancestors would have given up long ago and that would have been the end of it all.

And politicians say that your generation find museums boring.

I don't believe that rubbish. People don't find it boring. Maybe, ironically, some older people find museums boring, or rather depressing because they do not see the museum as a place in which to find a reaffirmation of the society in which they live. But look at how children react in museums. They look at things without prejudice, they have no expectations to be fulfilled. I think that museums should be for children. Yes, keep the middle-aged people out and let the kids in for free!

Do you really believe this? Do you really think that museums should be for children?

My first experiences of museums were in Glasgow, at a beautiful Victorian institution – Kelvingrove Art Gallery and Museum. [40] During the sixties and seventies it was like a model situation. Like thousands of Glaswegian children, I went there on Sundays to look at the stuffed animals on the ground floor, and didn't spend so much time looking at the art upstairs.

39 This issue has been particularly pointed in Glasgow in the 1990s since the city's nine museums and art galleries came under the supervision of a general director, Julian Spalding. Opening a Museum of Modern Art, Spalding published an accompanying book in which he argued that contemporary art was made by the people for the people and, as such, should be accessible to the broad majority of the people. The new museum controversially put this into practice, creating four exhibition spaces based on the elements – earth, air, fire and water. The selection of works was determinedly populist and pointedly anti-conceptualist, denying the work of the current generation of artists working in the city. The museum was an immediate success in terms of visitor figures, although decried across Britain for its emphasis on entertainment rather than art.

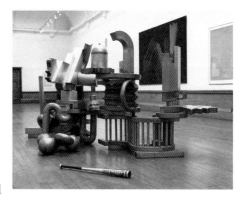

40 *Potential for Violence*, 1993.

Then as I got older, I started spending less time downstairs and a little more upstairs; less time with Tyrannosaurus Rex and more time with Salvador Dali. [41, 42]

And how should these visitors, these children, learn about what they see in the museum?

Not through entertainment. It's about education. And that's not to say that museums need to explain every aspect of an artist's work with diagrams and text and bloody stupid headphones with local celebrities talking rubbish about the way Edgar Degas carved the end on his pencil, or whatever! No way. I hate that. Children, and adults, can educate themselves. All we need is the time, space, and encouragement to do it. [43]

So maybe that's the best time to introduce people to your institution; when they're still small.

Anyway, why are you asking me questions about museums?

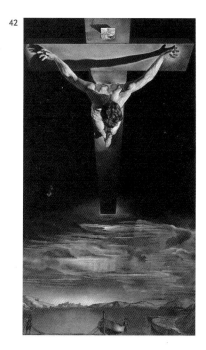

42

41 This is a reference to Glasgow's Kelvingrove Art Gallery, the city's primary museum. For many years the ground floor has presented visitors with a kaleidoscope of British imperial culture – Egyptian mummies vie with African masks and Samurai armour in the shadow of a vast army of taxidermied wildlife. Upstairs, the gallery focuses on Scottish art and European art from the eighteenth and nineteenth centuries. One more recent acquisition has been Salvador Dali's *Crucifixion*, now a tourist landmark in Glasgow, and postcards of which are displayed in many of the region's Catholic homes.

42 Salvador Dali, *Christ of Saint John of the Cross*, 1951, oil on canvas, 205 x 116 cm, collection Kelvingrove Art Gallery and Museum, Glasgow.

43 The origins of the museum have always been rooted in both the pleasure that a collection can give to visitors and the knowledge it can impart. In a memo to Peter the Great in the 1780s, the philosopher Leibniz summed this up while describing the range of works needed for Peter's new cabinet of curiosities: 'Such a cabinet should contain all significant things and rarities created by nature and man. Particularly needed are stones, metals, minerals, wild plants and their artificial copies [that is, products of human cultivation], animals both stuffed and preserved (...). Foreign works to be acquired should include diverse books, instruments, curiosities and rarities (...). In short, all that could enlighten and please the eye.'
Many of the early museum collections were designed both to amaze and to inform. As collections became more rationalised in the eighteenth and nineteenth centuries, their entertainment value was regarded with greater suspicion as it was clearly unscientific. Gradually the arrangement of a museum's collection was designed to tell a story – more often than not the story of evolution – and it has been increasingly clear that the knowledge gained from such collections now depends on their disposition in the gallery space and the museum's guidance of the visitor. Entertainment has resurfaced in these museums but under the guise of education, often ignoring the sensual or irrational pleasures which animated early collections. Seekers of such forbidden fruit often make a pilgrimage to the Pitt Rivers Museum in Oxford where the original arcane and eccentric collections remain stubbornly unreconstructed.

The older man reaches into his jacket pocket and finds that he has no cigarettes left. The bottle of brandy is also empty. They discuss whether to drive into town to get more. They decide to stop talking about museums and they start talking about Marcel Broodthaers. They listen to the Beach Boys' Pet Sounds *as the wind and rain batter against the windows.*

The scene is the interior of a cottage on the shores of a loch, nearby a small village, about two hours drive from Glasgow. The two men sit near a window in the front room of the cottage. They watch rainclouds pass over the loch and break on the hills to the west. Loud cracks emanate from the fireplace as damp logs burn on top of hot coals. The older man drinks coffee and whisky. The younger man drinks wine and brandy. As the skies grow dark they watch moths trying to find a way through closed windows; into the cottage and towards the light.

Is it possible for you to name central themes, central issues that are the basis for development of your work?

I suppose it's to do with perception – or how the mechanics of perception work. It's a broad area, I know, and maybe you wanted a more specific answer than this, but... By looking at something as broad as this mechanism I can make specific investigations into territory to do with memory (or the malfunction of memory), and the ways in which perception breaks up, or breaks down. [44] And it also means that I don't have to be tied down to any one medium. I can skip between film and video, to using text and sound and also to using very personal constructions of materials... to be able to use popular culture as ready-made... to use whatever material seems to be appropriate for the idea. Whatever I perceive to be the best way forward.

But the perception you talk about is not specifically visual?

No, not always.

I think that it's important to point out that you're working with psychological perception.

And even here, I'm more interested in those areas where perception breaks down or the fact that we don't actually know how it works or why it malfunctions, or what aspects of our experience we carry around and are unaware of how they might be shaping our perception.

For instance?

In the work *Something between my mouth and your ear*, I was interested in a hidden influence on my perception of the world; an influence that could have actually had its origins way outside of my 'real' experience but that I was carrying around with me, and that was somehow shaping my reading of the world, and my responses to things. [45]

In an unconscious way?

44 The relationship between perception and memory has spawned a vast literature in the last forty years as new advances are made in neurobiology, psychology, psychiatry and applied artificial intelligence. Works such as *The Man Who Mistook His Wife for a Hat* (1985) by Oliver Sacks and *The Strange, Familiar and Forgotten* (1992) by Israel Rosenfield have offered gripping insights into the nature of memory and the effects of brain malfunctions on both memory and perception. Summing up the importance of memory to the creation of the self, Rosenfield outlines the processes as follows: 'A conscious image (...) whether recognition or recollection, is the consequence of complex neurophysiological interactions; in it the person's past and present experiences are integrated, and the subjective, self-referential quality is of its very essence. The constantly evolving generalisations that emerge are a fundamental characteristic of human psychology. What we call experience, or history, is this endless progressive structuring of events. We rewrite history, we revise our notions of our experiences, by restructuring our thought about people and events in our past (...). Historians constantly rewrite history, reinterpreting (reorganising) the records of the past. So too, when the brain's coherent responses become part of a memory, they are organised anew as part of the structure of consciousness. What makes them memories is that they become part of that structure and thus form part of the sense of self; my sense of self derives from a certainty that my experiences refer back to me, the individual who is having them. Hence the sense of the past, of history, of memory, is in part the creation of the self.'
This role of memory in the formation of the self is described more personally by the surrealist film maker, Luis Buñuel, in his memoirs where he says, 'You have to begin to lose your memory, if only in bits and pieces, to realise that memory is what makes our lives. Life without memory is no life at all (...). Our memory is our coherence, our reason, our feeling, even our action. Without it, we are nothing (...) (I can only wait for the final amnesia, the one that can erase an entire life)'. Luis Buñuel, *My last Breath* (1984).While there has been a recent fascination with the process of memory, literary scholars and historians have reminded us of the longer exploration of memory, stretching back to the Greek philosophers at the very least. Frances Yates, in her landmark work, *The Art of Memory* (1966), outlined the development of memory systems first by Greek orators and later in the Renaissance. Yates explores the links between these systems and the development of Western art, highlighting the need for striking images which would leave an impression on the memory and artists' use of such images in their own work. She also discusses the place of architecture in memory systems – a building's potential to structure a series of memories and its use as a metaphor for the structure of

you, by using the idea that we can be conditioned by culture even when we aren't conscious of receiving any message or any explicit signal. [46]

The formal aspects of the work are to construct a blue room with no artificial light (all light in the space is filtered to the same colour of blue as that in which the room is painted). The only object in the room is a small hi-fi playing a cassette with these songs. I spoke to some people about this work, and what it made them feel, or think; most people said that it wasn't just the memory of a particular track by the Rolling Stones [47] or the Beatles or whatever, but that each song signified a lot more. This is very much Roland Barthes' field of ideas – the principle of the sign and the signifier. [48] I am intrigued by the fact that 2½ minutes of time occupied by a song which was originally released thirty years ago could signify everything from the original moment that it was played, or the original moment that it came into consciousness, right up to the present time. So a 2½ minute period operates as a signifier which has the possibility to occupy a psychological space for over thirty years in my case,

47

memory itself, as in the following passage from Augustine's *Confessions* (4th century): 'I come to the fields and spacious palaces of memory, where are the treasures of innumerable images, brought into it from things of all sorts perceived by the senses. There is stored up, whatever besides we think, either by enlarging or diminishing, or any other way varying those things which the sense hath come to; and whatever else hath been committed and laid up, which forgetfulness hath not yet swallowed up and buried. When I enter there, I require instantly what I will to be brought forth, and something instantly comes: others must be longer sought after, which are fetched, as it were out of some inner receptacle; others rush out in troops, and while one thing is desired and required, they start forth, as who should say, "Is it perchance I?". These I drive away and with the hand of my heart from the face of my remembrance; until what I wish for be unveiled, and appear in sight, out of its secret place.'

45 See page 100-103.

46 It has been believed since the 1960s that prenatal influence on the foetus is possible. Often mothers have been advised to talk to the child in the womb or to 'hothouse' the child by playing classical music to the womb. Recent scientific data seems to confirm these beliefs, indicating the foetus's sensitivity to ambient sounds.

47 The Rolling Stones, 1966 (photograph by Larry Thall).

48 Barthes elaborated the idea that every image may have a literal meaning but could also function on a symbolic level at the same time. He demonstrated this theory in his analysis of popular subjects, advertisements and cultural icons in *Mythologies* (1957) though it may be best summed up in a quotation from his later essay, *Rhetoric of the Image* (1964): 'We have seen that in the image properly speaking, the distinction between the literal message and the symbolic message is operational; we never encounter (at least in advertising) a literal image in a pure state. Even if a totally "naive" image were to be achieved, it would immediately join the sign of naivety and be completed by a third – symbolic – message'.
Barthes goes on to argue that each image is dependent on the various levels of knowledge a viewer brings to it: 'It is as though the image presented itself to the reading of several different people who perfectly well co-exist in a single individual (...). This is the case for the different readings of the image: each sign corresponds to a body of "attitudes" – tourism, housekeeping, knowledge of art – certain of which may obviously be lacking in this or that individual. There is a plurality and a co-existence of lexicons in one and the same person, the number and identity of these lexicons forming in some sort a person's idiolect.'

and longer for other, older people. I'm still amazed by this mechanism of carrying around ideas, signs, and events which will continue to influence an individual's perception many years later. [49]

But in presenting that work – for me those songs couldn't possibly be nostalgic [50], although they may temporarily adopt the disguise of a certain kind of nostalgia for anyone who is in that room, and who is older than me, or my generation. Those people could definitely conjure specific memories of events, or other people, in relation to the sounds that they were hearing. But for me, these sounds shaped my experience in a much more ambiguous way and this is a more interesting area for me.

What was the reason to take perception as a central theme?

In retrospect, I suppose I could guess that it grew out of an interest in detail; how my own perception of one thing was changed by noticing some detail in another place. And how a detail in one event could make a link to another event, in a different space, in a different time. And this seemed to be happening a lot to me, especially when I was in London. Perhaps this was because I had a lot of time to focus on nothing in particular – and so seemingly insignificant details might get noticed, and become significant because I related them to other details that I noticed in other places.
And when we start to talk about details, then we can talk about objects, and the minutiae within an object; to look closer, as if through a macro lens, until the object begins to disintegrate, in a way. And if the object disintegrates, then we have to look at ideas, and if we look at big ideas in detail, then you can see micro ideas – which can be complex and simple, simultaneously, and which can travel through space and time

51, 52

and connect with other details to form new communities of thoughts, ideas and actions. And this is as accurate a diagram as I know for the mechanics of perception. [51, 52]

49 One physiological equivalent of this phenomena is the experience of an acid 'flashback' several weeks after the original LSD trip. Scientists still argue over the cause of this experience – some claiming that a memorable event perceived during the drug trip may be evoked by a *déjà vu* effect, others claiming the brain networks have been altered by the drug, affecting memory. The *Oxford Textbook of Clinical Pharmacology and Drug Therapy* states that, '"Flashback" is a most curious phenomenon', suggesting that science cannot explain the process. Timothy Leary, one of LSD's most fervent supporters, was equally at a loss to explain the flashback phenomenon, but on the drugs effects of the brain's systems, he writes in *Flashbacks* (1983): 'Let's assume that the cortex, the seat of consciousness, is a millionfold network of neurons. A fantastic computing machine. Cultural learning has imposed a few pitifully small programs on the cortex. These programs may activate perhaps one-hundredth of the potential neural connections. All the learned games of life can be seen as programs which select, censor, alert and thus drastically limit the available cortical response. The consciousness-expanding drugs unplug these narrow programs. They unplug the ego, the game machinery, and the mind (that cluster of game concepts). And with the ego and mind unplugged, what is left? (...) What is left is something Western culture knows little about. The open brain. The uncensored cortex, alert and open to a broad sweep of internal and external stimuli hitherto screened out.'

50 The word nostalgia has its roots in the Greek words *nostos* meaning 'return home' and *algos* meaning 'pain', emphasising the painful absence from home rather than a definite return to it. Nostalgia, then, signifies a memory of the past while acknowledging a potentially unbridgeable distance from that memory. The current 'nostalgia boom' industry in America and Britain seems to offer something much more reassuring and saccharine. Often the media memories, packaged for consumption in the nostalgia market, seem to rely on a glib thumbnail sketch of an era, reducing rather than amplifying the period they try to evoke. More interesting, perhaps, are the recent releases of outtakes and bootleg recordings from 'classic' recordings such as the Beach Boys' *Pet Sounds* or the Beatles later albums. These recordings offer a revised history of the recent past, challenging the reductive nature of commercial nostalgia and opening up those works to fresh interpretation and relevance.

51 Fetal arterial system, 1698, by M. Vander Gucht.

52 Pyramidal cortical neurons, Golgi's method, microscopic magnification.

It sounds very esoteric, in the way that you describe it.

It's not.

I got interested in the difference between apparent or explicit detail and hidden detail. I was fascinated by the fact that details which had previously been hidden, or unknown, might be made visible by chance, or by an unintentional action, from another source entirely.

Also, this was a very social time for me and friends in Glasgow. Everyone knew each other pretty well, and on any 'night out' everyone was always telling stories, jokes, talking about work, music, films, football, TV, and everything. But it all seemed to be happening at a million miles an hour – it seemed like a very 'speedy' time. It was one of those situations where people were telling more than one story at the same time, and chipping in jokes to the conversation that was happening at the next table in the pub, or while watching TV (especially). [53] Although this

53 The late eighties and early nineties were the period in which stand-up comedy was hailed as the 'new rock 'n roll', producing a generation of free-associating, amphetamine style comedians such as Ben Alton or Eddie Izzard and, in Scotland, Gerry Sadowitz and Phil Kay, for example. Their rapid-fire delivery was often based on American models, culled from a multitude of television programmes and old films. This was, generally speaking, the first generation of comedians, and audience, to grow up with television and this fact influenced both the humour and the response. The television series' of Reeves and Bob Mortimer, for instance, was composed of rapidly shifting series of allusions to older British comics, television starts of the past, recent media phenomena, self-deprecating gestures and a very British surrealism which harked back to the days of Monty Python and *The Goon Show*. Apart from this context, Glasgow itself tends to produce a fierce form of wit based on a healthy suspicion of anything pretentious or of anything given to grand airs. This kind of humour is often said to have its roots in the struggle to overcome hardship in the city. See note 10 on Margaret Thatcher.

54

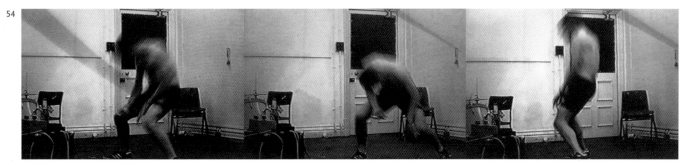

kind of thing has now been 'identified' in administrative areas as multi-tasking, it seemed to me just a way in which a close group of people live their lives and communicate with one another. I thought a lot about this and, I suppose, began to try and incorporate this way of being in my work. I started to encourage unnatural relationships to develop between one detail I might have picked up in the last year, and link it to something I read, heard, or thought about yesterday. I started to play with the notion of the physical or social context influencing the memory of a literary experience, and vice versa. We could go on, and talk about specific examples, but it seems obvious because for my generation this is nothing new at all – we grew up with music using sounds from sampling machines, and the whole culture of 'cross-over', and mixing – especially in music [54, 55] and in the film and video we would see on television.

It's simply the way we live. [56]

But maybe you should give us an example, maybe it's not so simple for other people to understand?

54 Douglas Gordon, David Allen and Jonathan Monk, *Dance Practice*, 1996.

55 Douglas Gordon, David Allen and Jonathan Monk, *Stooges Burn-out*, 1996.

56 By the eighties, video had entered the consumer market, just as the CD format had initiated the re-release of thousands of old albums. Simultaneously, hip-hop had appropriated studio technology to sample quotes from older tracks, collaging them together in music which both acknowledged the past by rewriting it for the present.

Okay, I'll tell you a story. Someone once told me that I should try and read anything by Georges Bataille; anything that I could get my hands on. In retrospect, I suppose they had hoped I might find his writing on society/energy relationships [57], but the first book that I found was *The Story of the Eye*. I began to get very engaged with the various details in the narrative of the book. You know what I mean, I think. It's a very interesting, very stimulating book, but what interested me more was that I began to read this book on a Number 8 Bus which I picked up on Tottenham Court Road and travelled to Bethnal Green where I was living at that time. So, let's say that this was not quite the atmosphere in which the story is set; this was in the East End of London, not the South of France or Spain. Nevertheless, *The Story of the Eye* will always remind me of the vibrations of the bus as we drove past Liverpool Street Station and it started to rain heavily outside just as the main character in 'The Eye' was raping the priest in the church in Seville. I remember wondering if anyone in the bus was reading over my shoulder as we turned onto Bethnal Green Road while Simone (the heroine of the book) was placing bull's testicles underneath her skirt as she watched the next matador dying in the baking heat of the bullring. [58] I remember having to get off the bus and go and buy a bagel because it was all getting too much. But maybe the shape of the bagel had some other significance. Who knows? And then I went home to find my flatmates eating boiled eggs for tea. So, I think you know what I'm trying to say? [59]

59

I got incredibly interested in the way that the mind could synthesise disparate events and details and throw them back at you when you least expected it, much in the same way as the brain can harbour tiny amounts of chemical stimulant and start using them when you're doing something else altogether.

While cultural theorists posited the theory of a postmodern condition, the hip-hop movement was actually creating it in tracks like *The Adventures of Grandmaster Flash on the Wheels of Steel* (1981) in which Grandmaster Flash appropriates 'quotes' from Blondie, Chic and Queen. Like many artists of his generation, Gordon often quotes music, and the culture of cross-over and sampling as a reference. The generation born in the mid-late sixties grew up with the independent label culture of punk rock and new wave music in the seventies, and then the hip-hop and rap scene arrived in Europe from the USA. However, the roots of the sampling culture lie deeper in the work of earlier musicians and producers in Jamaica such as Lee 'Scratch' Perry and King Tubby. If Tubby was the modernist of dub reggae, stretching the form to its limits, Lee Perry was its postmodernist, gathering together an eclectic ragbag of influences which he then proceeded to download into his music. For Perry, in his Black Ark studio, the creation of a context in which to record was vital, as Max Romeo — one of his stars — recalls: 'Black Ark is a studio that if you walk in it was like someone's study. It doesn't look nothing like a studio until you hear it. No one knows what technique Perry used. Because he used those small track tapes and he seemed to get sixteen tracks stuffed into that four-track. It was a marvel — until today, no one knows how he did it. The vibe of the Black Ark studio was like all these people gather around. It start like ten o'clock in the morning. Guys start gathering. There's a kerosene pan on the fire bubbling some dumpling, some jelly roll, some ackee and ting. Everyone throw in something to buy what we need, there might be a guy outside with his guitar, chantin', and Scratch's inside with a spliff, tunin' in to the guy, who doesn't even know Scratch is tunin' to him. The Scratch jus' go out and say "Let's go inside here, and find him a riddim".'
Seeing himself as a local point for influences rather than an originator of 'product' Perry described his music, saying 'It wasn't my work, I'm just an instrument working for the master computer X-I-X. It wasn't I who create the sound, I was just the engineer. I'm the music dolly — it's the music who do it.' Perry is constantly at pains to emphasise that he is not the sole creator of his work and describing the process of collaboration he makes it plain that authorship is not the key issue in his work. It was in this context that the Jamaican 'toaster' tradition flourished in the 1970s, with DJs toasting or rapping over other musicians rhythm track, blurring the boundaries between artist and producer. Discussing his collaboration with King Tubby, Lee Perry makes it clear that such creative relationships could only succeed if the notion of the sole originator was left behind: 'Tubby come to meet me cause him was looking for adventure. I am the only adventurer, because Tubby was there in the beginning, he was looking for that adventure, that makes him act from a baby, from nothing, from a sperm to a baby and he still see the adventure, and recognise the adventure, that this is the adventure, dub's adventure. He was brilliant. I thought he was my student, maybe he thought I was his student, but it makes no matter, I'm not jealous.'

57 Philosopher Nick Land discusses Bataille's theory of energy in his extraordinary text, *The Thirst for Annihilation* (1992), summarising as follows: 'All energy must ultimately be spent pointlessly and unreservedly, the only question being where, when and in whose name this useless

Did you think about this as an area to work in art? Did you think this was new territory?

I didn't think about territory – I just started working with the information I had, the things I found.

Earlier in our conversation you pointed out that your time at art school in Glasgow was characterised by focusing on context all the time. It seems to me a logical development in the sense that what you are doing is to begin recontextualising things.

You could call it recontextualisation, or you could call it synthesis, or perhaps you could call it editing. It's funny, in some ways I'd feel more confident to say that I am a good editor rather than a 'good' artist.

This is only a problem in definition. You could also mention a definition of an artist if you say someone has a special capacity or a special interest in associative thinking and linking things that one normally wouldn't.

I could be happy with that. I can get animated when I am reading a book or watching something on TV and I see, for a split second... I see a detail which I know could be removed from that context and temporarily put in another place, sometimes in connection with something else, sometimes not. I don't think about it as 'art', it's just an interesting thing to do.

Okay, I can see this as a device that connects most of your work; but there is one work that I can't see within this group. Please, tell me about the work using the tightrope walker.

Sometimes, if I'm giving a talk at an art school, I describe my working process as engaging in selective possession, or abduction, taking some object or some sounds or some images and making them do things differently. With the tightrope walker it was very similar in process. This piece was called *Trust Me*; in essence it was me moving into one space and having a look at the architecture, making a slight modification to the architecture and then arranging for someone who normally occupies a completely different context to temporarily move into the one I had newly altered. [60] So in many ways that's not such a different technique as taking a song from 1966 and playing it in 1994 under certain circumstances.

The *Trust Me* work was first made for an exhibition in Portugal, *Walter Benjamin's Briefcase*. One great aspect of this show was that everyone had a huge amount of space to work in.

discharge will occur. Even more crucially, this discharge or terminal consumption – which Bataille calls expenditure (*dépense*) – is the problem of economics, since on the level of the general energy system 'resources' are always in excess and consumption is liable to relapse into a secondary (terrestrial) productivity which Bataille calls 'rational consumption'. The World is thus perpetually choked or poisoned by its own riches, stimulated to develop mechanisms for the elimination of excess: 'It is not necessity but its contrary, "luxury" which poses the fundamental problems of living matter and mankind. In order to solve the problem of excess it is necessary that consumption overspills its rational or reproductive form to achieve a condition of pure or unredeemed loss, passing over into sacrificial ecstasy or "sovereignty".'

58 See Chapter Ten – 'Granero's Eye' – in Georges Bataille's *The Story of the Eye* (1928): 'When we arrived at our places next to Sir Edmund, then in broad sunlight, on Simone's seat, lay a white dish containing two peeled balls, glands the size and shape of eggs, and of a pearly whiteness, faintly bloodshot, like the globe of an eye: they had just been removed from the first bull, a lack-haired creature, into whose body Granero had plunged his sword (...). The events that followed were without transition or connection, not because they weren't actually related, but because my attention was so absent as to remain absolutely dissociated. In just a few seconds: first, Simone bit into one of the raw balls, to my dismay; then Granero advanced towards the bull, waving his scarlet cloth; finally, almost at once, Simone, with a blood-red face and a suffocating lewdness, uncovered her long white thighs up to her moist vulva, into which she slowly and surely fitted the second pale globule – Granero was thrown back by the bull and wedged against the balustrade (...). A shriek of unmeasured horror coincided with a brief orgasm from Simone, who was lifted up from the stone seat only to be flung back with a bleeding nose, under a blinding sun; men instantly rushed over to hall away Granero's body, the right eye dangling from the head.'

59 Film still from *Un Chien Andalou*, 1929, directed by Luis Buñuel and Salvador Dali.

60 *Trust Me*, photographic documentation, 1993, see also page 148, 149.

So, I removed a whole floor of a building in Porto and in its place I installed a tightrope and a vertical rope; the tightrope spanned the room on the plane of where the floor used to be; the vertical rope hung from the roof down to the level where the floor used to be. Then I asked a professional performer from a circus, in Lisbon, to occupy the space where the floor used to be. All of this was seen from below, as the viewers had no access to see anything at the same level as the tightrope walker. The only instruction I gave the walker was that he shouldn't perform anything – no juggling, no fire-eating, or anything like that. I just wanted him to be there; reading newspapers, listening to his portable radio, writing letters, drinking coffee, eating and so on.

Why a tightrope walker?

Only for pragmatic reasons. If I had a head for heights and wasn't afraid to walk about like that, then I would have done it myself. In fact there was no information in the space to say that the guy who was up in the air was not me. The piece was presented very simply. We made a panel to be on a wall outside of the installation; it read '*Trust Me*, an installation by Douglas Gordon'. There was no performance, no entertainment – just someone up there, where they shouldn't be, in a space that shouldn't be that way.

So, there was no 'entertainment'. The work was left open to a wider metaphorical or philosophical implication.

That was the idea; trust me, Mr Debbaut.

Something has just struck me, though. And it's to do with some words you used earlier: 'selective possession', or 'abduction'. If you start to look at what you've been doing over the last few years, from a certain viewpoint one could say that you've been kidnapping music, film, objects, texts and putting them in a space which has wider implications – a space where people do not stand up and applaud, but hopefully go off and think and talk about what they've seen.

These works demand some considerable time from people, and that's a lot to ask from a relationship.

I don't think that applause is part of the relationship.

The title of the work in Portugal was *Trust Me*, which is all about relationships; this is also a text which you have tattooed on your arm, and which I've seen as a photographic work. [61]

61 Other tattoo works by Douglas Gordon are *Tattoo I, Tattoo II, Tattoo (for Reflection), Tattoo (for Doppelganger)*, and *Three Inches (Black)* (see page 96, 97, 84, 85, 126-129). Possibly the ghost of Robert Mitchum in *The Night of the Hunter* (1955) haunts these works. In that film, Mitchum, playing a psychopathic preacher with 'LOVE' and 'HATE' tattooed on his knuckels, engages in a struggle between good and evil for the souls of two innocent children. Directed by Charles Laughton and scripted by James Agee, the film stands as a light, dream-like meditation on evil, powerfully guided by Mitchum's performance.

I suppose I wanted to do something which people would look at and be confronted by a certain paradox, both in the tattoos that I have and also in the tattoos that I have done for other people. I wanted to take the general idea behind a tattoo – which is a very definite statement of intent – and make something indefinite, something which was open to (mis)interpretation, and which might undermine the person whom is wearing it. I prefer undermining to affirmation, in this case.

And at the same time it continues your strategy of bringing a thing from one place to another; in this case you take the issue of confidence, or intent, and remove it from where one might expect to find it.

The notion of confidence seems to me also very present in your work. The longing for testing confidence.

Yes, I enjoy taking a comfortable situation, which is full of unpotential, and making it into something uncomfortable, yet full of potential readings.

I enjoy the idea of jeopardy. We spoke about that issue before.

Ambiguity?

Yes, and ambiguity. I don't really know why this is. I am thirty years old now and I don't like the idea of security. A secure situation? A secure position? Not yet, anyway. And that goes for large degrees in some aspects in my life and very small degrees in other aspects of my life. But insecurity, jeopardy, all these things I think are exciting because they force people to make a decision which may not be what they expected to do. You could say that it is the artists' job to construct the unexpected, to be provocative, in the academic sense. I always liked the way Lawrence Weiner talks about an artist's political duty: to spot the status quo and to go in and do something about it.

Destabilise it?

Yes.

There is one work of yours that I can think of where that is not the case. That's the work which was in the corridor in Eindhoven with the inventory of all the names of the people you remember. There is nothing destabilising about that.

But the *List of Names* is not a fixed point. It's a growing work, always changing. It is not a status quo.

No, it is fluid. But I don't see the relation of that work with the issues you were...

Well, whatever way you might read the *List of Names*, I can only say that it destabilises me. [62] This collection of names represents people that I can remember. But the list is always growing and changing between one installation and the next. The list is a form for a structure which is always collapsing because it cannot support the weight of its own ambition, or its own evolution. I love this contradiction: that a human being could sit down for hours, and days, and weeks, and months, and years, and write down everything that they could recall – and say 'this is what I can remember'. But then if you leave it for only a few minutes and go back to it, there is no way that you could remember the order of those things that had just been recalled. As soon as you step back and recognise the scale of it, the depth of it, and the mass of it, then the system collapses under its own weight. This represents my ideas about memory; an incredible, complex machine, with an amazing power to recall, and an equally unpredictable possibility of failure. [63]

The illustration is complete if you remember what happened when we tried to install this piece at the Van Abbemuseum; I was trying to find one name in particular, because of a spelling mistake that I wanted to correct. You might remember that I couldn't find this particular name of a certain woman, although I knew she was on the list, because I could remember seeing the name, but I just could not remember exactly where it was. So, someone started to help me look, and then another person, and then another, and so on... So, eventually we had six or seven people looking up and down this list of names, everyone trying to locate the same name, everyone saying that they could remember seeing the name, but not knowing the exact whereabouts. Eventually, after an hour or so, it was found by one person much to the disbelief of everyone else who had been looking in the same place.

So, the work is totally destabilising as I experience it.

But let's consider something else. Do you think that your text pieces destabilise you more than another viewer? Perhaps they are jeopardising your status quo more than anyone else's. In particular I'm thinking about the *List of Names*, the *Untitled Text (for someplace other than this)*, and *From God to Nothing*. [64]

Possibly.

They certainly don't quote or 'abduct' other sources. They do have the appearance of something more personal, more autobiographic, in a sense. But that may only be on the surface, just having an appearance...

62 *List of Names*, 1990-ongoing, see also page 119.

63 The experience of joining the *List of Names* is disorientating. It immediately appeals to the ego, elevating the name to the status of art. At the same time, attempting to find your own name among a multitude of others can be a humbling task, serving as a reminder of the sheer scale of information we compete against each day in life and relationships. The democracy of the uniform, non-hierarchical list is also ambivalent, reducing the importance of some, while elevating others. Likewise, the memorial aspect of the list is unsettling as it underlines the nature of consciousness and its relationship to time. Discussing this, Henri Bergson asks, 'What is, for me, the present moment? The essence of time is that it goes by; time already gone by is the past, and we call the present the instant in which it goes by'. Consciousness then is perpetually processing experience, converting it into the 'past' even as it encounters it. The *List of Names*, then, both memorialises each encounter and testifies to its potential to remain alive in the artist's consciousness.

64 See page 75, 77, 150-153.

66

65 *Hysterical*, 1994/95, see also page 64-67.

66 *Trigger Finger*, 1994, see also page 4.

Well? You're being very coy.

I don't want to pin the work down by saying it's personal, autobiographical, or diaristic.

But, isn't everything autobiographical, in a sense. I mean, even the found footage that you use, or those things you borrow, or abduct; they have been chosen, by you, and so your choice will reveal something...

I mean, why choose to use footage of psychiatric malfunction, for instance? [65, 66, 67, 68]

It's an area I was very interested in for a long time, long before I used any material.

Also, I thought that an artist is one of the few people left in the world whose job allows him or her to be able to drag material from the margins of culture and into an institution. Sometimes that act in itself can be an important gesture.

67 *Film Noir (Sleeper)*, 1995, see also page 70-73.

What do you expect from that gesture?

I didn't know exactly what to expect, but I hoped that people might be surprised to find this kind of material, and that it was presented in such a way as to make them start thinking on a long line of questions.

Did you want to shock people?

No. I think that I was always very careful in that area. I have seen a lot of very disturbing material in various archives (official and otherwise) but always chose material which, I thought, would be potent without being shocking.

68 Dr Charcot demonstrating the inducement and treatment of hysteria in a female patient, c. 1880s.

I said once, in another interview, that I wanted people to think when they saw these images – I didn't want people to leave the museum absolutely speechless and so shocked as to be unable to think about what they felt, or to reject what they had seen because it was too disturbing. That just wouldn't be an interesting situation for me. If you shock people so much that they cannot think for themselves anymore, then you might as well have hit them over the head with a hammer...

69 *Fuzzy Logic*, 1995.

Yes, but when you presented those works in Eindhoven, you also showed a film of a dying fly alongside them. Personally, I found this more shocking than the psychiatric images.

I'm glad.

This was an image of something that we see killed every day. We see them dying in corners of rooms at home; we don't care about them. Some of us even tortured these things as part of a 'game' to play when we were children. But seeing something like this in a museum becomes a much more distressing game to play. [69, 70]

That this was an image within a group of films of genuinely distressed human beings made the whole installation more difficult – more potent – more 'up' for discussion. Why do you respond more to the image of the fly than that of the human being? I mean, I'm not the one asking you this question, now.

It's you who are asking yourself.

And the more you ask yourself the question, then the more you watch the image, as if it might provide an answer. But the more you ask, and the more you look, then the more problematic it becomes. The more time you spend, the deeper the trouble. And this issue of 'time' spent looking is one which I have been acutely aware of: that most visitors to galleries or museums spend little time looking at paintings, or sculptures, or even

70 Gordon has made a number of works using images of flies – *Film Noir (Fly)*, as discussed here (see page 72), *Fuzzy Logic*, and *B-Movie*, which projected an image of a fly in life-size. The scale of this work underlines the traditional view of the triviality of a fly's life and makes us aware of our own scale relative to the power of nature, evoking Shakespeare's lines 'We are to the gods as flies to wanton boys, they kill us for their sport.' These works refer us back to a wide array of visual sources from David Cronenberg's film *The Fly*, government issue hygiene films and the insects which littered seventeenth-century still life paintings, adding a touch of reality through their implied worthlessness. His comment here also recalls William Golding's novel *Lord of the Flies* (1954) in which a group of young boys, stranded on an island, quickly revert to a state of savagery.

photographs, but if you put a moving image in front of someone, there seems to be a bind that makes them stay that little bit longer – and this is what makes it interesting to me to use film or video – I ask them to stay a bit longer.

Now, there are several ways that this 'game' can be played out. You can offer people stimulating images in order to initiate thinking, and you can also offer images which appear to be doing nothing, but which, because of the register of time, and that time implies the image will change, then there is a very good chance that people will stay a little longer – if for nothing else than to see if the image does change, or not. [71] In some ways this is like the metaphor of 'hostage taking' again; that I am using some images, on a temporal register, in order to seduce people into spending more time there. Further, if they spend time waiting for an image to change, and perhaps it's not changing very much, then they have to start thinking about something else.

This is a situation that really interests me, and it is one which picks up some criticism. I like the fact that people can go into museums and 'use' work as a way to capture time for themselves. In the same way as I have said, quite strongly, in the past, that 'art is an excuse for a conversation', then I think art is also an excuse to spend time having a dialogue with yourself, and if this is happening in a way which is quite oblique to the work, then so be it. Besides, if this is a way in which people want to use artwork, then it doesn't matter what the intent of the artist is because it will happen anyway.

I want to present ideas such that I think people will not be able to walk out of the museum and say, 'Oh, yeah. I know exactly where he's coming from and I know what that work is about.'

What do you want, then?

I want people to leave and take the ideas to bed with them. And maybe they wake up and they've forgotten about it and won't remember them until the next time they meet. But maybe they will wake up and want to have breakfast with them, and spend some more time with them, and then who knows...

So what you are saying is that the criteria for you to use images is that at least they should be, what you call in structuralism, an open-ended structure.

Maybe. But perhaps it's closer to the Roland Barthes' idea of *punctum*. [72] It's something which does not jump off the page immediately (pictorially speaking), but may hit you the next time you see it, or maybe it happens years later. I was really

71 There is also a relationship here to the notion of the 'subliminal' element to film, in which fast shots, intercut In the main body of a film, work almost imperceptibly in the viewer. Interestingly, William Friedkin, director of *The Exorcist* (1973), used subliminal imaging technique in the dream sequence of that film. Interviewed on this technique, he says: 'The first time I ever saw subliminal editing was in Alain Resnais' wonderful documentary *Night and Fog* where he had these beautiful colour revelling shots of the former killing grounds of the concentration camps in Germany, now overgrown with weeds and restored to nature peacefully. And as these languid shots were going by there would be quick intercuts of black and white footage of the corpses that had been found in these places. That seemed really profound to me when I first saw it, and that was my influence for the use of subliminal shots in *The Exorcist*, the clearest, soundest idea that I had in approaching that diem, was to explore the notion that two different people, Father Merrin and Father Karas, who were in different parts of the world, had had experiences, or memories, or dreams, or nightmares, that had brought about a synthesis between them.'

72 In *Camera Lucida* (1980) Roland Barthes analyses his response to photography, dividing the effect of an image into two categories – the *studium* and the *punctum*. The *studium* he describes as the average effect of any photograph, the social or historical setting of the image, for instance. Of the *punctum* he says, 'The second element will break (or punctuate) the studium. This time it is not I who seek it out (as I invest the field of the studium with my sovereign consciousness). It is this element which rises from scene, shoots out of it like an arrow, and pierces me. A Latin word exists to designate this wound, this prick, this mark made by a pointed instrument. The word suits me all the better in that it also refers to the notion of punctuation, and because the photographs I am speaking of are in effect punctuated, sometimes even speckled with these sensitive points. Precisely these marks, these wounds are so may points. This second element which will disturb the studium I shall therefore call punctum, for punctum is also: sting, speck, cut, little hole – and also a cast of dice. A photograph's punctum is that accident which pricks me (but also bruises me, is poignant to me).'
Later, he goes on to explain how this *punctum* of detail in a photograph can affect him: 'A detail overwhelms the entirety of my reading: it is an intense mutation of my interest, a fulguration. By the mark of something the photograph is no longer "anything whatever". This something has triggered me, has provoked a tiny shock, a satori, the passage of a void (it is of no importance that its referent is insignificant).'

intrigued by this idea of Barthes' and also when he said that you cannot construct a *punctum* within an image. But we can take this idea even a bit further; that you cannot construct a successful or compelling image as something that crawls off the page and straight into your head. You just can't do it. Maybe great images, or great words, happen because there already exists a psychological need in the person who is looking at the picture or reading the book. [73]

Precisely.

It means that you are not an artist interested in offering finalised ideas or images, but you want the active role of the viewer to 'fill in the picture', each in his own way.

But, are you interested in researching the effect?

I think it's too early to start looking for results.

My way of thinking about work is to try and build a family of ideas, a group of works which will relate to one another over a period of time. Sometimes the relationships will be strong between certain works, and sometimes not between others; sometimes a work may appear to contradict another and later there may be some resolution to the dispute between ideas. So, I'm trying to keep the 'family' open for myself, too. I don't think I've made enough work, or allowed enough time to start looking for results, or the effect of the work on other people.

How do you construct a family?

I mean, how do you select, research, and choose to use... for example, some kitschy striptease film that you found in San Francisco, and then a tightrope walker in Portugal, and a list of names that changes from place to place, and a story about a decapitated head? There must be a method, or a sense, of why you choose to excavate certain areas.

There are certain areas of material you use that I would never have known the existence of, so how do you know the existence of them? Do you research, or are you continuously looking for out-of-the-ordinary material, or is it just by accident? You just bump into them?

These are difficult questions. No matter what I say, I could be damned for it.

I mean, of course I'm constantly 'looking' for things. But I don't want to just trawl around the *Mondo Bondage* world and find strange material just for the sake of it. [74] I don't want to be the ringmaster in some kind of virtual freak show. On the other hand, I don't like the idea of 'a method'. It sounds like a

73 Michel Foucault, in his seminal essay *What is an Author?* (1977) posits the view that rather than seeing the author as a solitary 'genius' or sole originator we should view a text or work of art as the result of a series of pressures and influences all set within their specific historical context. Rather than seeing a work as unique to the sensibility of the artist and outside history, Foucault argues, the work should be seen as possible only at a certain moment in time and the notion of the author's originality should be dismissed in favour of a broader reading of the work: 'All discourses, whatever their status, form value, and whatever the treatment to which they will be subjected, would then develop in the anonymity of a murmur. We would no longer hear the questions that have been rehashed for so long "Who really spoke? Is it really he and not someone else? With what authenticity or originality? And what part of his deepest self did he express in his discourse?" Instead, there would be other questions like these: "What are the modes of existence of this discourse? Where has it been used, how can it circulate, and who can appropriate it for himself? What are the places in it where there is room for possible subjects? Who can assume these various subject-functions?" And behind all these questions, we would hear hardly anything but the stirring of an indifference. "What difference does it make who is speaking?".'

74 The 'Mondo' movie emerged as a cinematic sub-genre in the early 1960s with the appearance of an Italian film, *Mondo Cane* (1962), a true life documentary on strange and exotic people from around the world. Voyeuristic and freakish, the film spawned a whole series of imitations such as *Mondo Cane 2, Mondo Infame, Mondo Keyhole, Mondo Bizarro* and *Mondo Trasho*. The films showed a variety of apparently real freakish scenes, such as acts of self-immolation, pygmy sex orgies, a human pincushion, transsexual surgery and bestiality. The genre's origins lie in the travelling freak shows made popular in the earlier part

formula, and this is something that an artist has to try and avoid for himself or herself. There are enough people accusing artists of being formulaic without themselves adopting a formulaic approach. So, I'm not out to find the weirdest possible things you can imagine, and I don't have a method to follow. Perhaps there is a twist here, though. Maybe it's because I don't have a method that means I have to encounter the material that I use. If I did have a method, then there would be nothing to be found.

I don't mean only bizarre material, because I know of works where you're using common images from *Star Trek* [75]**, or the Hitchcock movies which are very available and very well known. But it seems to me that you must have a criteria, or many criterias, for digging into certain areas which have a potential, or which do not. So what's the criterion to use certain material, and not others?**

I'm not sure if I know.

And I'm not sure I would even tell you if I knew.

But this is an interview for people to read and perhaps gain some understanding.

Yes, I know. But sometimes you have to hold some things back, even if only a little.

So, I will put it in a different way. I know you're an addict of football. But I never saw you using any images of football. There must be something that holds you back from using material from a source which I know occupies a lot of your time – as a spectator and as someone who plays the game.

Okay, I'll try to give a little more.

Perhaps my interest is in using material that allows itself to be perverted, or corrupted. Sometimes this can happen because the material has an enormous status, and sometimes because it's 'unknown', or from the underground.

Maybe there are some images which defy this kind of corruption, or perversion of intent – I think that I can't use images of football players, for example. However, I did make a work coming from football culture. It is a piece made in 1991, *Above all else...*, and uses a 'found text' that reads 'WE ARE EVIL'. [76] This is a chant that one group of football supporters would shout towards another group. I read about it in a newspaper article on Millwall Football Club. I was really taken aback when I read the words 'we are evil'; it seemed to me to be much more to do with Nietzsche than the football terraces of East London. [77]

75 See page 134, 135.

76 See page 92, 93.

77 Friedrich Nietzsche saw evil as an essential part of every human's life, deriding the hypocrisy of those who attempted to corral its influence. In *The Gay Science* (1882) for example, he writes 'Examine the lives of the best and most fruitful men and peoples and ask yourself whether a tree, if it is to grow proudly into the sky, can do without bad weather and storms. Whether unkindness and opposition form without whether some sort of hatred, envy, obstinacy, mistrust, severity, greed and violence do not belong to the favouring circumstances without which a great increase even in virtue is hardly possible. The poison which destroys the weaker nature strengthens the stronger – and he does not call it poison, either.'

So, I installed it on the cupola ceiling at the Serpentine Gallery, in London. It was a piece that had already been made, in effect, and just needed someone to spot it and take it from the terraces and put it into an art situation. I was very happy with it, in relation to the architecture of the building, because it messed up the symmetry (physically and metaphorically) of the space and it was probably the last piece to be seen in the exhibition because it was installed right above people's heads. I liked the idea that visitors had been walking around looking at other paintings and sculptures and were unaware of this statement that had been floating above them the whole time.

So, to get back to the motive for perversion, would it be possible to say which areas you don't want to pervert?

No. I wouldn't want to say anything on that because I don't want to rule anything out at the moment.

Is that because of moral issues?

No, because I think that I have to... I still think that I have to challenge everything. And not just in making art, but also in my private life.

Why?

Perhaps I have to challenge the ideas that people have about me. Perhaps I have to challenge the ideas that I have about me.

If I think about what I know of your background, I would say that you could be using your art as a battle against where you're coming from, or the beliefs that you were raised with.

That could be a possibility.

You don't want to say more than this?

No. But I'm quite interested in what you have to say.

I think that you were brought up in a way that your parents wanted for you to be safe, and secure in the world, and that they gave you some morals and values through which to do this. I think that now you are kicking against this kind of security and safety; you're constantly talk about abducting, perverting, changing and corrupting. I want to know why.

Mmmm. Yes, I'd like to know why, too.

So, what has shaving your arms to do with this?

Haha.

Well it's probably a straightforward acknowledgement that on the one hand you can exist as if you are *this person* whereas at the same time you're existing as *the other*, all along, as in the Jekyll and Hyde scenario. This seems to be a very Scottish preoccupation. There is an even more phantastic example of this idea within our literature, which is *The Private Memoirs and Confessions of a Justified Sinner*. It was written by James Hogg in 1824, about sixty or so years before Stevenson's *Dr. Jekyll and Mr. Hyde*. [78] The 'Confessions' also follow a narrative of the coexistence and coincidence of good and bad. [79]

What's the metaphor in the piece where you had one of your arms shaved? [80]

That what seems to be, is probably not.

Because I had to laugh about it when I came to the Tate Gallery to see the show where you presented it. I thought to myself, 'We must have come a long way in the art world when the most famous prize in Great Britain is given to someone who shaves his arms!'

Yeah, imagine what I might have got if I had shaved my legs.

The Nobel Prize is still waiting for you, my dear.

But let's go back again to your construction of a family. I'd still like to try and define those areas where you can sniff out interesting material. Let's talk about the media, as an obvious example.

I like the idea of being able to pick up on details or to see things which have always been there but which no-one else has taken the time or the opportunity to explore properly.

But how do you find it? Put it this way – what stimulates you? Watching television? Or just sitting in a café, or a bar and watching people and listening to things? Or picking up conversations on the street and re-editing them? Or cloistered away in a library, trying to find inspiration in books?

All of these things, I suppose. I just try leaving windows open as much as possible in order to let things fly in and hope they don't fly out again. I am living in a city; I have television, video, the Internet, etc., etc., I live near a library, I have interesting

78 The theme of the *doppelganger* or double runs through James Hogg's work and many of Robert Louis Stevenson's stories and can be traced throughout Scottish literature even up to R.D. Laing's *The Divided Self* (1960) and Irvine Welsh's *Marabou Stork Nightmares* (1996).
In Hogg's *The Private Memoirs and Confessions of a Justified Sinner* (1824), the narrative is divided between an editor and the sinner himself. The book's main character finds himself confronted by a double. Possibly the devil, possibly an hallucination and a strong Calvinist sense of repression hovers over the events recounted. Stevenson's stories and novels reflect a similar obsession with the double, influenced probably by the notorious real life character, Deacon Brodie, an Edinburgh cabinetmaker by day and a robber by night. In *Dr. Jekyll and Mr. Hyde*, Stevenson also draws on contemporary nineteenth-century developments in Scottish forensic psychiatry and even in ostensibly lighter tales such as *Kidnapped* (1886), the young hero David Balfour experiences duality, constantly seeing the orthodox morality of the world inverted around him. The alienation and isolation implicit in the phenomena of the *doppelganger* is outlined eighty years later in *The Divided Self*. Laing's study of schizophrenia, begins with: 'The term schizoid refers to an individual the totality of whose experience is split in two main ways. In the first place, there is a rent in his relation with his world and, in the second, there is a disruption of his relation with himself. Such a person is not able to experience himself "together with" others or "at home" in the world, but on the contrary, he experiences himself in despairing aloneness and isolation. Moreover, he does not experience himself as a complete person but rather as "split" in various ways, perhaps as a mind more or less tenuously linked to a body, as two or more selves, and so on.'
See also page 76-79 and 84-85.

THE PRIVATE MEMOIRS

AND CONFESSIONS

OF A JUSTIFIED SINNER:

WRITTEN BY HIMSELF:

WITH A DETAIL OF CURIOUS TRADITIONARY FACTS, AND
OTHER EVIDENCE, BY THE EDITOR.

LONDON:
PRINTED FOR LONGMAN, HURST, REES, ORME, BROWN,
AND GREEN, PATERNOSTER ROW.

MDCCCXXIV.

79 Title page of first edition of James Hogg, *The Private Memoirs and Confessions of a Justified Sinner*, 1824.

80 See page 162, 163.

friends, I have an interesting family. So, it's all of these things being allowed to influence equally and being encouraged to have a dialogue together within my head.

It's like 'open house', but it happens to be in my head.

This is not entirely true, although I think you are being as honest as you can be. It cannot be 'open house', because although you work in many different media, and the ideas take different form, there is still a thread that maintains a link in all of the work.

I want to press you on this issue. I have an idea of how you might 'define' things for yourself. We know you are very busy, and that you make work as you travel and so on. Is it true to say that sometimes projects take shape in relation to the challenge of having to do something in a place, rather than maybe wanting to do something in a place. It's not traditional studio practice; it's life on the road. [81]

What you say is true, to some extent. But it's not special. It's not a radical way to work. It's a pragmatic way to work in relation to one's desires to keep travelling, and to keep moving. So, I'm not trying to be coy by hiding any information in this respect that you're trying to push me. It's just that 'the way you work' is the way you work, and it's nothing special. Maybe this is why I deny having a method, or a recipe.

But, please, I'm listening to myself saying this, and it sounds bad. It sounds like those artists, the savants, who don't have anything to say and don't have any method or strategy other than the genius that they were born with. I hate this. I don't want it to sound this way.

Of course I have a method, and of course I have a way of working – and this is what you are trying to define. But this practice has been developed over a number of years, so much so that the method of investigation and the process between thinking and realising an idea have become so much part of the way I live my life, that I find it difficult to answer your questions. And this is not to say that I don't question my practice.

I question it every day. I have to question it because that is part of the method that I've evolved.

One of the reasons I keep pressing you on this is because I remember a conversation we had last year, in San Francisco. We were discussing the fact that you were so busy, and at a certain moment I said to you, in a very moralistic way, 'Watch out for yourself in the art world. You can be quite casual about being in demand right now but don't get too tired and slump

81 'Lived time, natural time, cold dank, spooky Alaskan air time, stand in stark contrast to the so-called objective time of clocks and departure times at airports. According to the psychologist David Winnicott, loss of temporality is a feature of the psychotic and deprived individual. In which a person closes the ability to connect the past with the present. The bridging of the present into the past, and into the future, is, says Winnicot, "a crucial dimension of psychic integration and health". So there you have it. Air travel, by scrambling your mind-and-body clock, created the preconditions for psychosis.' John Thackara, *Lost in Space – A Traveller's Tale*, 1997.
'Europe: landing in Amsterdam's Schiphol airport I could already tell I was in a different world. The Dutch women all looked like stewardesses and the Dutch men all looked like game-show hosts. The modern steel corridors through which I wheeled my luggage en route to the trains to downtown smelled contradictorily like the manure spores of the manicured Legolike farm bordering the runway. Waiting for my connecting train to downtown, I fingered a winged name tag I had begged from the airline stewardess as a souvenir for Anna-Louise (HELLO, MY NAME IS... Oh, Miss?). I was even then beginning to understand that when you arrive on the doorstep of Europe, you are given a pair of wings... not for using to fly up into the sky, but rather with which to fly backward in time.' Douglas Coupland, *Shampoo Planet*, 1992.

and drown in the system. I think it is time for you to go back home and develop new works.' And then afterwards I was thinking about the way you work and I thought that I had been wrong to say it; this was a typical institutional way of thinking that could not recognise that you have to be on the road to get fed and inspired and that this is where the work is coming from.

Well, that's how it is for now, for the time being. But it won't always be this way. There will be a time to change things around a bit. Then the work will take on a different form.

Do you already have any idea about what kind of work that could be? Or where the difference could be?

No. And I don't want to know. If I knew how it would change, then I wouldn't bother changing.

I reckon that there are some works that can only be made in a studio scenario – where you have time to construct things because you're not having to run out of the hotel and catch the next train/bus/plane to wherever.

Time to be more systematic?

No, not quite systematic. That's not the word I would use.

I think that being on the road and making art is like being on the road and having a varied diet. After a while you might get sick of trying new things all of the time. You might get overfed. Maybe I'll want to settle somewhere long enough to have a reduced menu. I hope I'll know when the time is right.

Maybe it's already happening?

Well, I am starting to 'create my own images', that is to say that I'm not only working with found things. I feel more comfortable with that idea now, than I have for a long time.

Why would you have felt uncomfortable about that before?

Because I hate the idea of the genius artist whose masterly drawing skills or perfectly crafted objects are there to be admired, revered, worshipped and so on. I don't like that. I'm coming from this Calvinistic culture – 'no idols', 'no icons', 'no decoration'. Then, at school I was taught by artists who were totally involved in the tradition of 'good drawing' – and they were very good at it, too – and I was also, supposedly, a good draughtsman. I remember they told me, as I was leaving school, 'You should never stop your drawing.' But of course, I did.

I had to. And I really haven't done very much of it since. I didn't like the self-consciousness.

I felt much more comfortable in a world where I could move ready-made things around and put objects in relation with other things. But this was not collage, either, it was more this idea of synthesis that we spoke about earlier. It's probably what an events programmer would call 'cross-over', these days.

Isn't that a very postmodern idea, that you use quotes and existing footage and whatever and move it around without trying to put an original into the world?

For me there is no real difference between modernism and postmodernism, because I never really lived through, or endured, either one of them. They are historical terms which are irredeemable for me. [82] If you start looking at a broader historical picture, we can see Samuel Beckett or James Joyce (the modernist writers) as also typically postmodern; they adopted styles, language, narrative from wherever was appropriate. They created the 'new' by adopting the old, or the 'nearby'. They took existing behaviour and modified it through language in order to recontextualise it into something else. It was ready-made. [83]

So, I feel it's quite close to whatever way they were working. And if this is modernism, then that's fine. And if this is postmodernism, then that's fine.

84

I made an unconscious description of Beckett earlier when I mentioned 're-editing or re-mixing conversations picked up on the street.' [84]

When I'm questioning myself on these issues, I come back to this issue of authority. And, in the same way I'm criticising genius, I also have an aversion to authority. Not authorship, per se, but the authority that goes with it.

You know, there are some works that I made which I claimed were using found footage, but it was really material that I had shot myself, or texts that I had written myself. I was happy with the images and texts, but it seemed more convenient for me to hide behind the disguise of found footage, in order that viewers might be able to look at these things, or read these things

82 Hal Foster, one of the most eloquent theorists of postmodernism, reviewed the subject in *The Return of the Real* (1996), saying 'Whatever happened to postmodernism? Not long ago it seemed a grand notion (...) not long ago there was sense of a loose alliance, even a common project, particularly in opposition to rightist positions, which ranged from old attacks on modernism as the source of all evil in our hedonistic society to new defences of particular modernisms that had become official, indeed traditional, the modernisms of the museum and the academy. For this position, postmodernism was "the revenge of the philistines" (the happy phrase of Hilton Kramer), the vulgar kitsch of media hucksters, lower classes, and inferior peoples, a new barbarism to be shunned, like multiculturalism, at all costs. I supported a postmodernism that contested this reactionary cultural politics and advocated artistic practices not only critical of institutional modernism but suggestive of alternative forms – of new ways to practice culture and politics. And we did not lose. In a sense a worse thing happened: treated as a fashion, postmodernism became démodé.'

83 James Joyce's *Finnegans Wake* (1939) is perhaps the best example of this. Using what he termed 'portmanteau words', Joyce constructed a long, dream-like narrative which blended an extraordinary array of stories, fables, myths and sheer gossip into a language at once familiar and alien. The 'prankquean episode' in the book, for instance, illustrates this in its opening lines: 'It was of a night, late, lang time agone, in an auldstance eld, when Adam was delvin and his madameen spinning watersilts when mulk mountynotty man was everybully and the first leal ribberrobber that ever had her ainway everybuddy to his lovesaking eyes and everybilly lived alove with everybiddy else, and Jarl van Hoother had his burnt head high up in his lamphouse, laying cold hands on himself.' It could be said that *Finnegans Wake* advanced the novel in a modernist manner, but approaches culture and language in a postmodern fashion. Samuel Beckett worked alongside Joyce, helping him with much of the editing and research for the work and throughout his own career, he often paid tribute to that experience. While Beckett's own work quoted less obviously, it is clear in something like *Waiting for Godot* that there are numerous references and allusions to Noh theatre traditions, Charlie Chaplin, Buster Keaton and old British music hall routines.

84 Film still from Samuel Beckett's *Film* (Alan Schneider, 1964), showing detail of Buster Keaton's eyelid.

without the authority of the artist, or the prejudice that someone can carry to an idea if they think it has come from an artist.

Do you think this is a personal thing, or is this an attitude of a particular generation?

I think it is a personal thing. But then this depends on one's definition of generation. We are coming towards the end of a millennium where people are already writing the present as the past while it's still happening; it's almost as extreme as the future never being allowed to realise itself as the present, for however brief the present might be. Yeah, the future is past, already. Our ideas of time are all over the place at the moment. And maybe when future people look back at us and find out what happened up until December 30th 1999, then maybe 'my generation' will include that of Beckett, Duchamp, and so on. We don't know how things will look in a hundred years, or from a future perspective. We shouldn't be overly concerned about it either: it's outside our control.

Are you saying that you are part of the same tradition?

I don't know if the best word would be 'tradition' or 'attitude'.

So, let's return to your attitude towards authority – the questions as to what works you actually made, or directed yourself, and the works that you found.

Apart from the difficulties this makes in regard to authorship and authority, it also makes a tremendous difference on how to read these images in terms of morality. I'm starting to question my own reading of the image of the fly, for instance: Why was I more shocked by the dying fly than by these other images of human pathological disease? And why would I be more outraged if I thought that you actually made the image of the fly, rather than using it as a found image? It's ridiculous, I know, but it would make me think that you are a sadist, if you made that image of the fly!

So, when you introduce doubt in the mind of the viewer, as to the authorship of the images, you make the game even more sophisticated. Just when people thought that the work was readable, and manageable, after initial difficulty, then you throw the whole thing up in the air again by introducing another factor. Real or unreal? The moral status is always changing.

You have to look at the idea without the comfort, or cloud, of authority from the artist.

You have to make up your own morals and ethics. [85]

85 'There are no moral phenomena at all, only a moral interpretation of phenomena.' Friedrich Nietzsche, *Beyond Good and Evil*, 1886.

Is that a general statement?

For me, for what I do, yes.

But in terms of art. I mean are you in all possible cases against the authority of the artist or do you make exceptions?

I think in culture, in general, I am against it, because I am against all authority and an artist can definitely be, and behave, just like any other old dictator or authoritarian.

But couldn't authority in art have positive consequences?

Sure. For some people, but not for me. It's not what I like, at all. I don't want to have the voice of the artist telling me anything or interpreting the world for me.

But you are still putting your work out in the public eye. So it's claiming attention. That's authority by an oblique definition.

It has to be in the public because I want an audience.

You like it? You like the audience?

I like the idea of a large audience playing around with these ambiguities.

Okay, but your authority is your decision to make more and more people ambiguous. It's like a message.

I don't see it that way. The way I think about my work is as if I've constructed a room, and I invite people to come inside.
The room does not have very much furniture in it. But it has many doors through which you can enter, or leave. People can leave whenever they want to, and through any door they wish. They can come back in at any time, and through any door they choose. Maybe if they come back in through a different door each time, then they can see the arrangement of furniture in a different way. And maybe they see other people in the room, and perhaps they might leave together and talk about what they saw, or what they thought.

And if I could make a bigger room, with more doors, and have more people, then I would do it. That's my attitude to the idea of an audience.

You could reach a bigger audience by working in another way, with television or by publishing.

Well, this is something I've been thinking about already.
And with writing in particular.

What would be the difference between the existing work and the writing? Would a novel have a different role or function?

Possibly. But, as you know, I've started already. Or, I have been trying to start, over the last few years. I enjoy the economy of means when writing. It makes a change from video players jamming, tapes snapping, and projectors breaking. I like writing because of the precision that is involved. We spoke about this before when we discussed the difference between detail and precision. Details being the things that can be used and precision being the process that allows you to be able to identify the details. So writing is a platform for precision. And I also enjoy the time it takes to read a book, like the performances we spoke about – you can come and go, you can take longer on one page than another, you can turn a page slowly or quickly, you can open and close it at any point. But it takes time.

The older man looks around to find that the fire has almost burnt out. They both look out of the window. It's completely black outside, they can see nothing and hear only the sound of light rain falling on the concrete slabs outside. The younger man says that he'll go to the outhouse and get some more coal and wood for the fire. It's very late now. It's cold and wet. He leaves and returns quickly. The older man is already asleep.

to be continued...

24 Hour Psycho, 1993

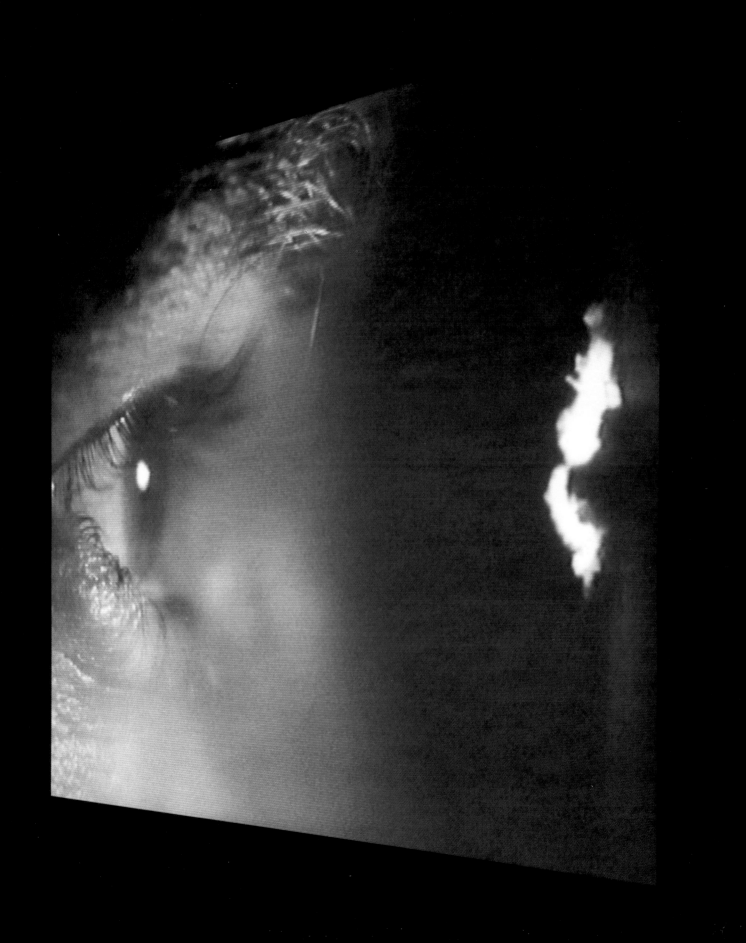

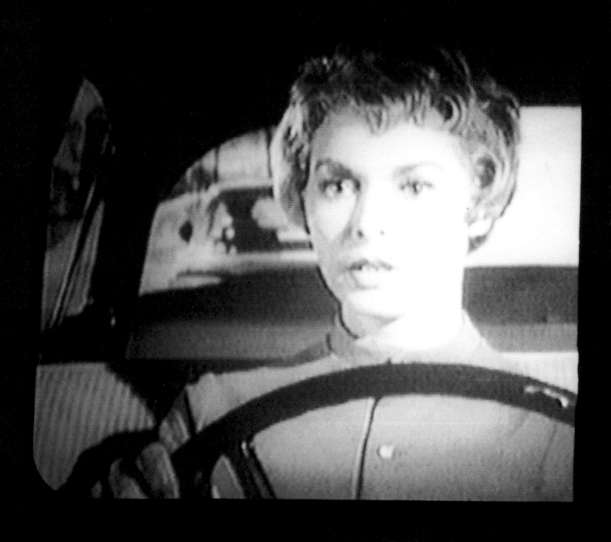

24 Hour Psycho, 1993

24 Hour Psycho, 1993

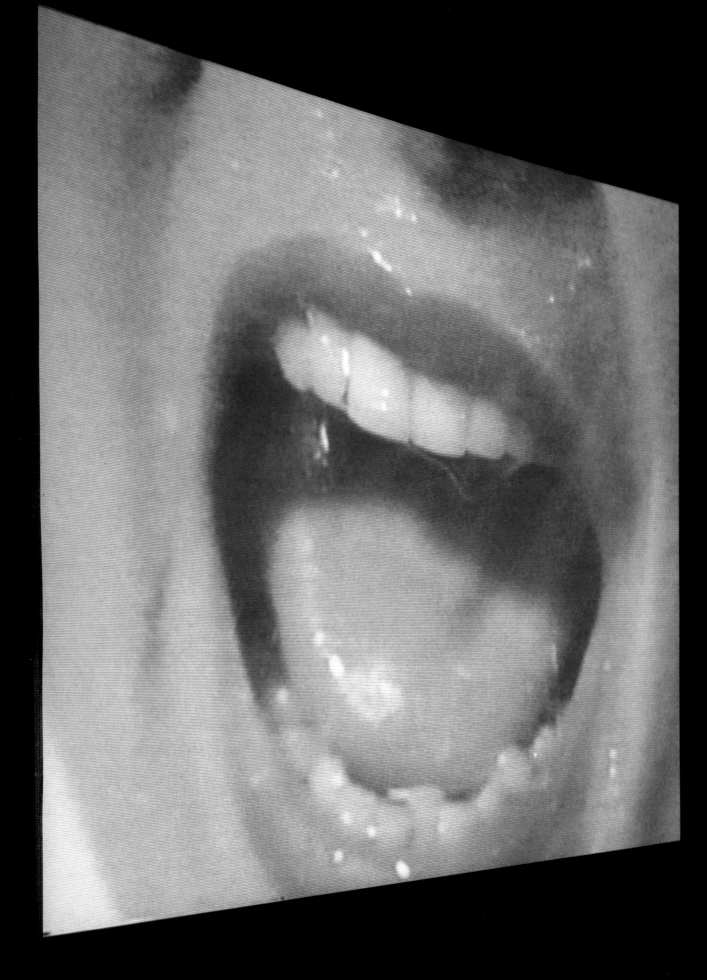

24 Hour Psycho, 1993

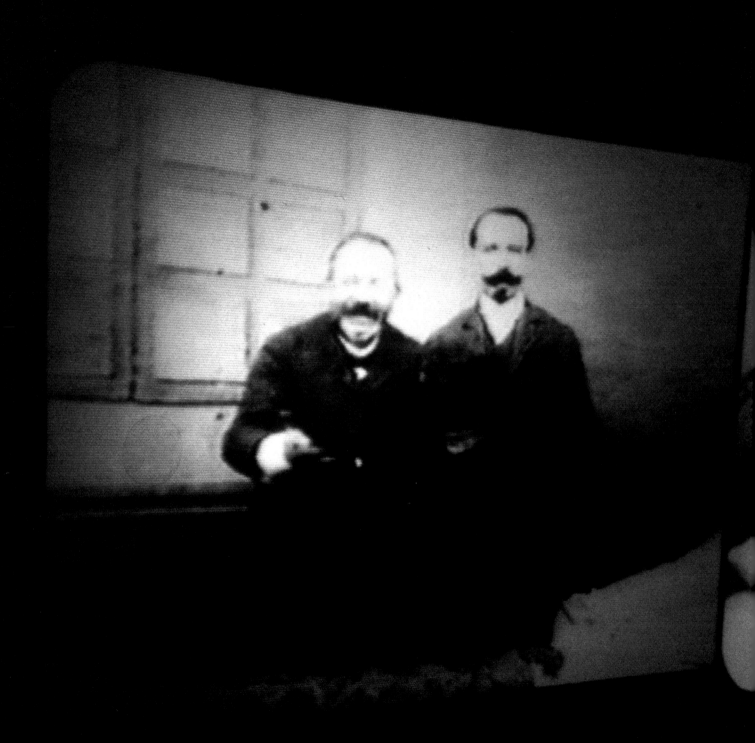

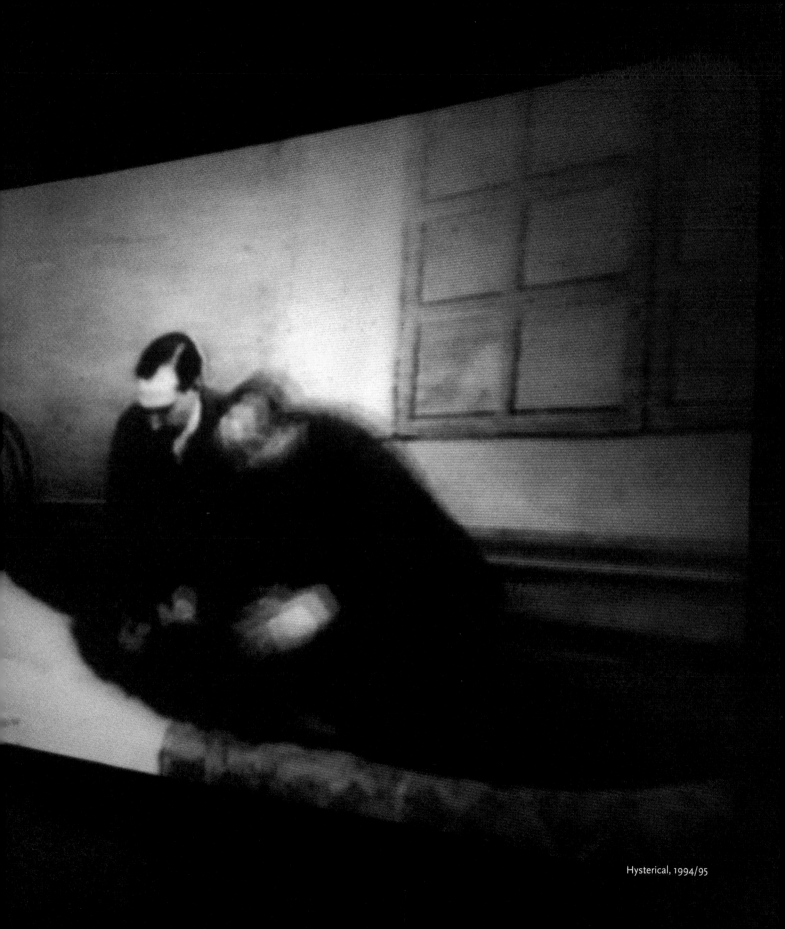

Hysterical, 1994/95

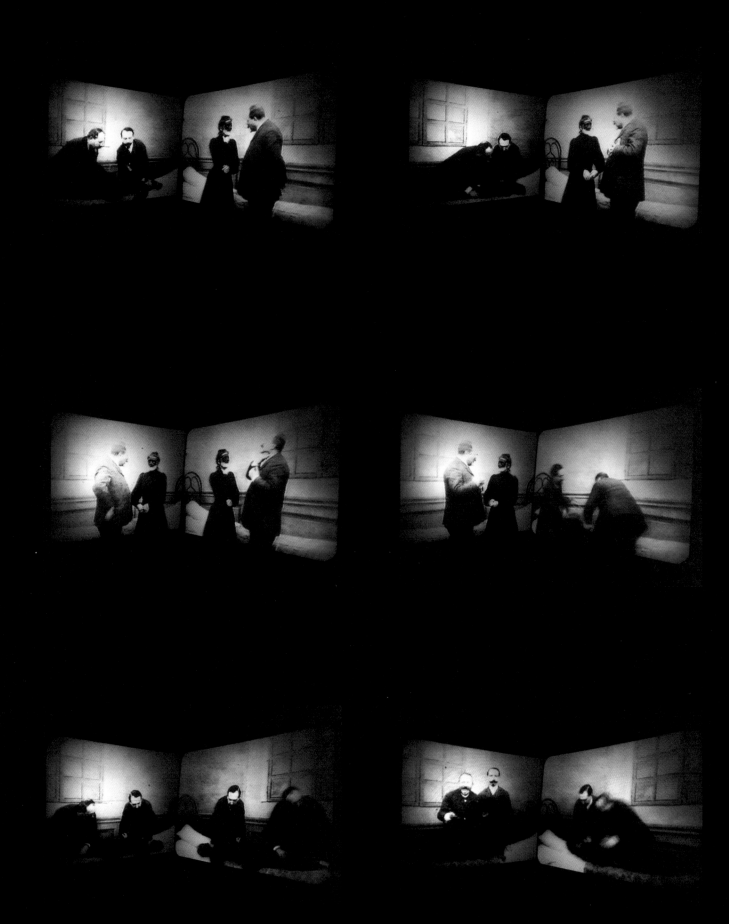

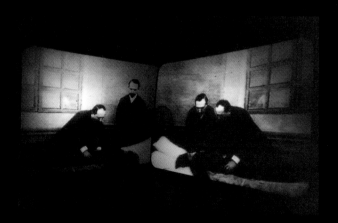

Hysterical, 1994/95

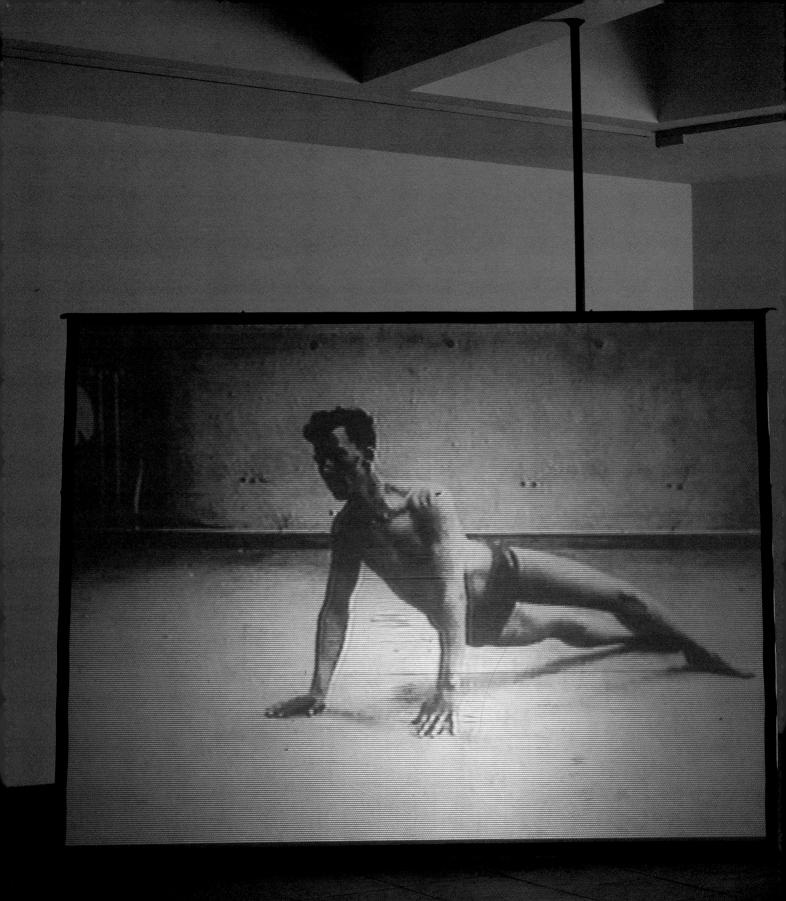

10 ms⁻¹, 1994

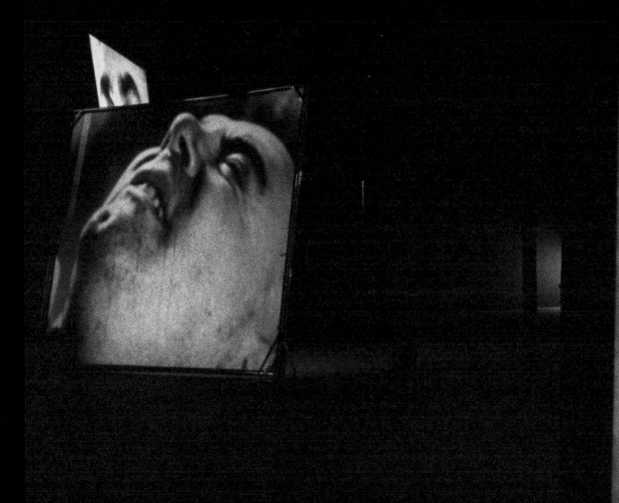

exhibition view Entr'Acte 3, Douglas Gordon, Stedelijk Van Abbemuseum, Eindhoven, 1995
clockwise from top: Film Noir (Fear), Film Noir (Fly), Film Noir (Perspire), Film Noir (Twins)

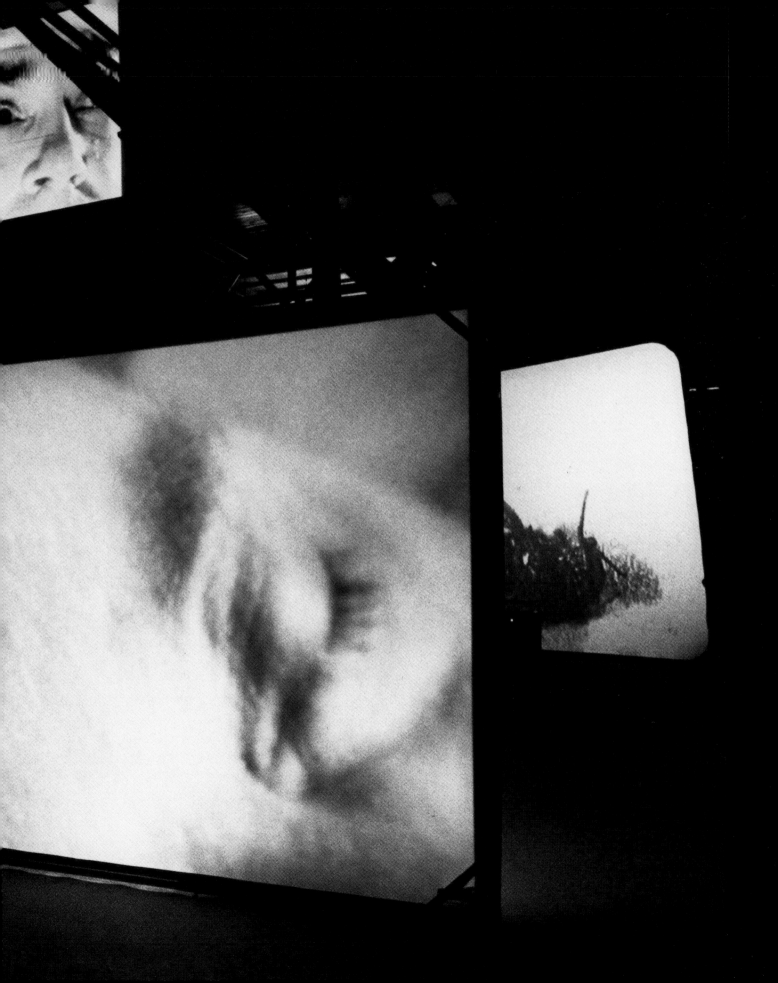

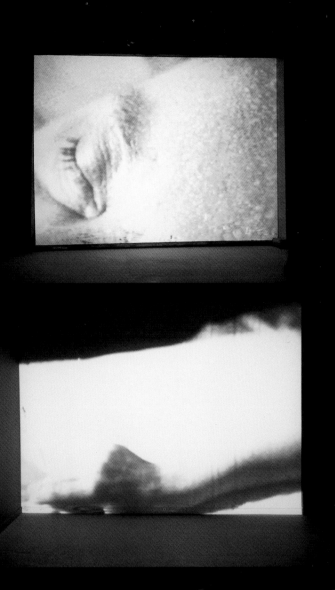

Film Noir (Perspire), 1995

Film Noir (Hand), 1995

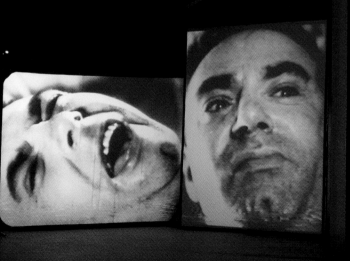

Film Noir (Twins), 1995

A few words on the nature of relationships, 1996

Close your eyes, open your mouth.

...hot is cold, day is night, lost is found, everywhere is nowhere,
something is nothing, pain is pleasure, blindness is sight, hell is
heaven, confinement is freedom, black is white, inside is outside,
famine is surplus, bad is good, nature is synthetic, life is death,
fiction is reality, equilibrium is crisis, doubt is faith, hypocrisy
is honesty, feminine is masculine, open is closed, neglect is
cultivation, laughing is crying, contaminated is pure, blessing is
damnation, construction is demolition, blunt is sharp, sweet is
bitter, satisfaction is frustration, depression is elation, nightmares
are dreams, flying is falling, water is blood, truth is a lie, hate is
love, trust is suspicion, shame is pride, sanity is lunacy, outside
is inside, forward is backward, shit is food, dark is light, right is
wrong, left is right, future is past, old is new, losing is winning,
work is play, attraction is repulsion, screaming is silence, desire is
fulfilment, I am you, you are me, fulfilment
is desire, silence is screaming, repulsion is attraction, play is work,
winning is losing, new is old, past is future, right is left, wrong
is right, light is dark, food is shit, backward is forward, inside is
outside, lunacy is sanity, pride is shame, suspicion is trust, love
is hate, lies are truth, blood is water, falling is flying, dreams are
nightmares, elation is depression, frustration is satisfaction, bitter
is sweet, sharp is blunt, demolition is construction, damnation
is blessing, pure is contaminated, crying is laughing, cultivation
is neglect, closed is open, masculine is feminine, honesty is
hypocrisy, faith is doubt, crisis is equilibrium, reality is fiction,
death is life, synthetic is natural, good is bad, surplus is famine,
outside is inside, white is black, freedom is confinement, heaven
is hell, sight is blindness, pleasure is pain, nothing is something,
nowhere is everywhere, found is lost, night is day, cold is hot...

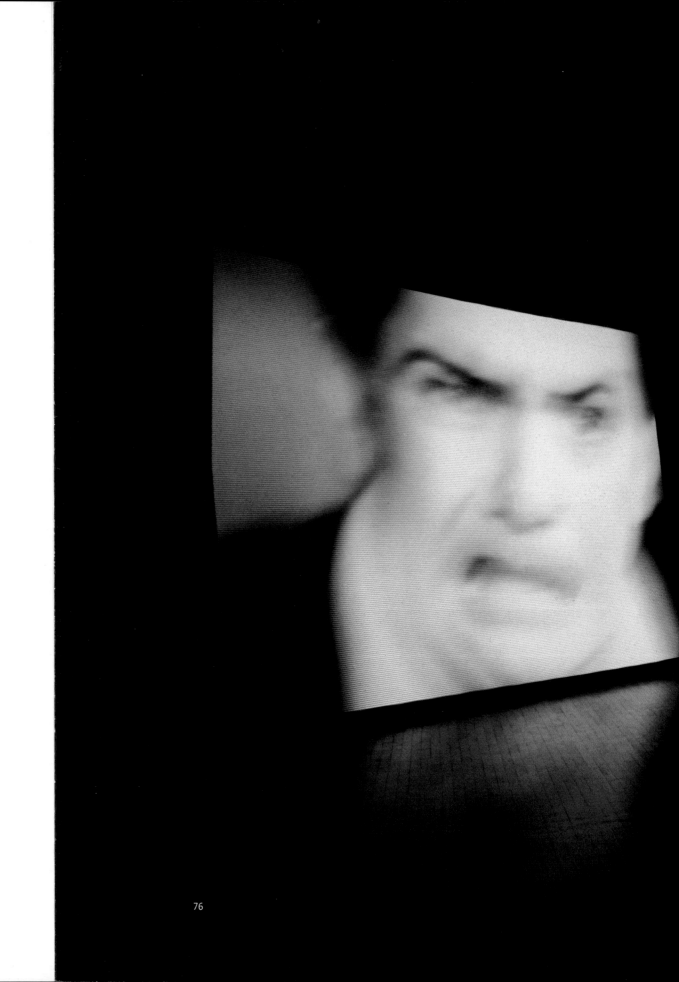

Untitled Text (for someplace other than this), 1996

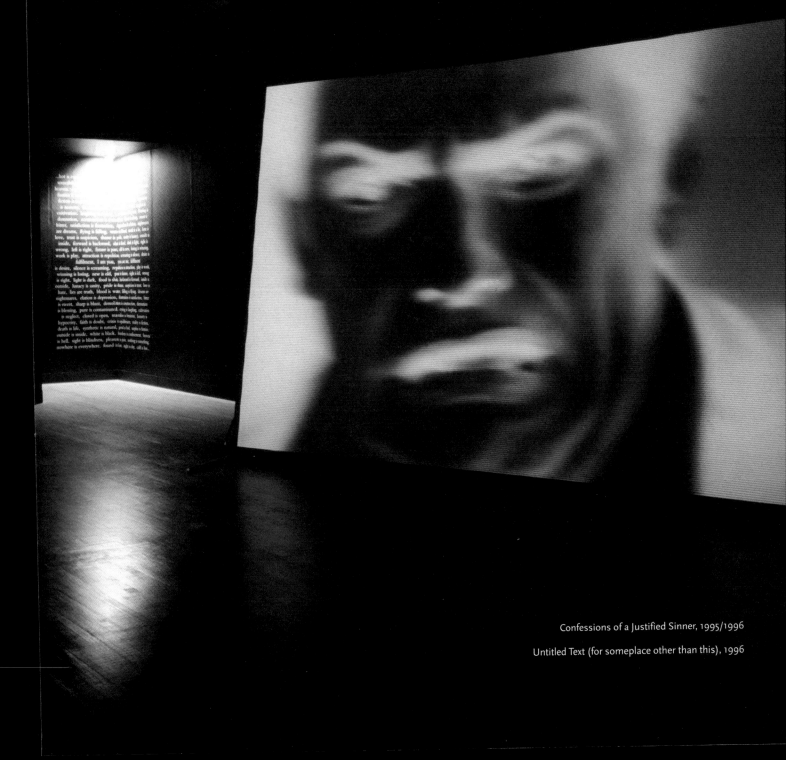

Confessions of a Justified Sinner, 1995/1996

Untitled Text (for someplace other than this), 1996

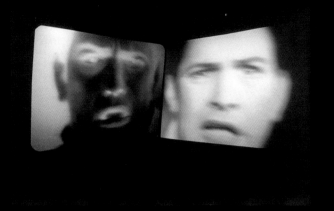
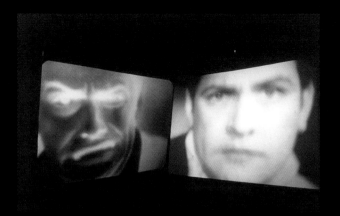
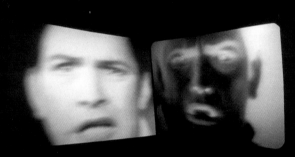
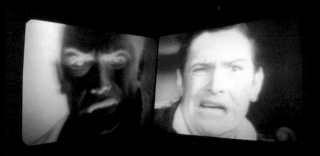
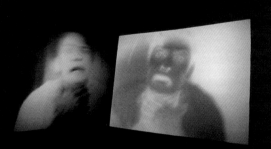
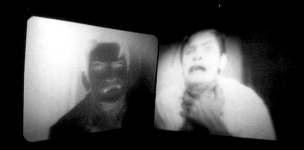

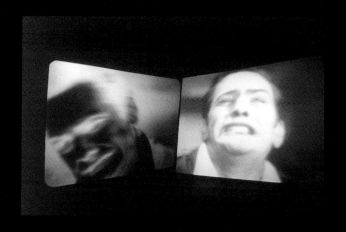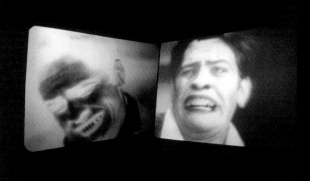
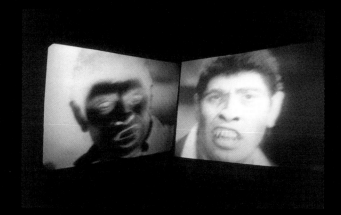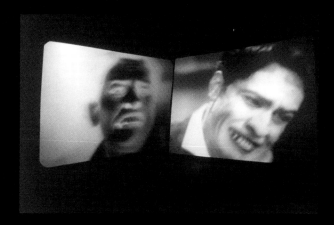

Confessions of a Justified Sinner, 1995/1996

...by way of a statement on the artist's behalf

A letter to Martijn van Nieuwenhuyzen and Leontine Coelewij (curators of the exhibition
Wild Walls, Stedelijk Museum, Amsterdam) from the artist's brother, David Gordon.

Monday, July 17th, 1995.

Dear Martijn & Leontine,

Douglas asked me to write down some ideas about what I thought about his work and to give some opinions as to why I think he is an artist. Apparently this is to be published in a catalogue for an exhibition in a museum, in a city, in a country that I have never visited, so the whole thing feels a little strange.

And so, I'll begin to think about what my brother is doing.

I'm not entirely sure what Douglas is up to. I've never been quite sure. He was always into weird things as far as I can remember. I suppose that's what it's like to be an artist. I remember when we were at school he was always making drawings from images of the Holocaust (which upset my mother) and then he went through a phase of being obsessed by some artist in Vienna who was put in gaol for his obsession with young girls, or something like that. I'm not saying Douglas is into anything like that; at least I hope not.

I think that he likes his work to be like a game for other people to play with. Once he described it to me, at a cousin's wedding (he's always talking about art, no matter where, or when, the occasion) and he said the situation was something like the following; he was the guy who supplied the game board, the dice and the pieces for playing, but that it was entirely up to the people how they wanted to play the game. I suppose that's a good attitude for art – I mean, the harder you work at playing, then the more likely you are to get something out of it.

I think that Douglas is particularly interested in the psychological states of the people who see his work. This is no big surprise to me, because everyone in our family played these games with one another, and we continue to do so. However, I think that Douglas took it all very seriously when he was a child, and in my opinion I think he was too serious. I think Douglas is overly concerned by the psychological details that are implied by using one image, and not another,

or one colour, and not another, or one shape, and not another, or one word, and not another. Like most people, this is an area in which I have no interest at all but it's always amusing for me to see Douglas and his friends (because they are all the same) arguing about whether to use this thing or that thing or this colour or that colour or this word or that word. I remember them arguing in a bar one night over a certain phrase that someone had used to describe someone else's artwork; I cannot even remember what the phrase was, but they were arguing over the issue of whether the phrase used was actually a 'phrase' or a cliché. I mean, everyone in the place was staring at them as they were getting all hot and bothered over nothing. Sometimes these artists really go on too long about nothing, but I suppose there must be something important in it because they do it all the time. Maybe that's what it means to be an artist these days. I don't know.

But back to the psychological, game-playing, fascination; I think the way in which we were brought up by my parents has a lot to do with it. Especially in the way that Douglas behaves. He's the eldest in our family, then there is our sister, myself, and our youngest brother. But because Douglas is the eldest he has assumed, or been given, more sense of responsibility than the rest of us.

I remember one story that Douglas told me about something that happened, between him and my parents, when we were all a lot younger. In fact, the story starts so long ago that our youngest brother was not yet born. I remember, now, that Douglas must have been about twelve, or thirteen, years old when the story originally took form.

Douglas had been given a marijuana joint by some friends at school and he had hidden it underneath his bed, in a room that he shared with our sister. Well, my sister had been poking around, which was not unusual, and she came across this thing and she told our mother. This could have been, or should have been, quite a tense situation, but was a prime

example of our parent's restraint (as regards the physical) and their expertise (as regards the psychological) in the fields of discipline and punishment.

Douglas was called into the kitchen for a talk with Mum & Dad. I should say that if anyone was 'called into the kitchen' in our family, then this was some indication that the situation was grave, if not worse. So, my parents started the conversation quite gently, asking Douglas how things were going at school; had he made any new friends, had he been enjoying lessons, etcetera. Then they asked him if there was anything, anything, that he wanted to talk about, or to ask them. Anything.

'No', he said. Everything was fine.

'Are you sure? I mean, we hope you know that you can talk to us about anything; you know, if you're having problems at school, or with other people, or with girls, or boys, or anything', they said.

'No, everything is fine', he said.

'Are you interested in smoking?', they asked.

'No', he said. He wasn't interested at all.

'Have you started smoking?', they asked.

'No, not at all', he said.

'So, what are you doing with a cigarette hidden underneath your bed?', they asked.

'Oh, how did you find that?', he said.

'We didn't', they said. 'It was your sister who found it, and she told us', they said.

So, at this point Douglas realised that both my parents were unaware of the fact that what had been found was something more serious than a cigarette.

'But I haven't hidden any cigarettes under my bed, or anywhere else', he said.

'OK then', they said. 'What is this?', they asked, producing a small tobacco tin from the drawer in the kitchen table. 'What is this?', they repeated as they slowly opened the lid of the tin to reveal…

'Oh, it's not a cigarette Mum', replied Douglas, truthfully. 'It's a joint.'

'You mean drugs?', they asked.

'Yes,' he said.

At this point anyone could have expected my parents to send Douglas to bed with no supper or, rather, to whip him soundly and forbid him to do anything, with anyone, anytime, anywhere, whatsoever, never, ever, again. But, no. They continued their relaxed conversation and started to ask Douglas about his steadily increasing burden of responsibility as the eldest child in the family.

I mean, what would happen to the family if anything terrible happened to our mother; then Douglas would have to support our father in bringing up the rest of the family. And what would be the case if anything terrible were to happen to our father; then Douglas would have to support our mother in bringing up the rest of the family. And, worse still, what on earth would be the case if anything terrible happened to both our father and our mother; then Douglas would have to be of a sound and able mind and body to be able to raise the family on his own.

'And how do you think you will be able to do that, Douglas?', they asked. 'If you're the type of person who begins to smoke pot at twelve years old?', they continued.

This was just the beginning of the session.

'Apart from all this', they said. 'What kind of behaviour do you expect from your sister, who is just a little younger than you are? I'm sure you can imagine just what she might be doing if she is looking up to her older brother and sees him smoking pot at twelve years old. What do you think she might be doing when she reaches your age? And what about you brother? What kind of behaviour can you expect from your brother, and he is quite a lot younger than you are? I'm not sure if you can imagine just what he might be doing if he is looking up to his older brother and sees him involved in drugs at only twelve years old, How do you think he will be behaving when he reaches your age?', said my mother.

'You have to remember that you are the eldest and that your brother and sister look up to you as a good person and they sometimes cannot see that what you are doing might be wrong. So, if they start to imitate you and your actions, then it's not really their fault, is it?', said my father. 'You have to show them how to behave by example.'

'And what about your cousins?' they both said. 'Don't you think that they might follow your example too? You must remember that some of your cousins are a lot younger than you and that they might look up to you sometimes. How do you think they might behave if they look up to their older cousin and they see him starting to get involved with drugs at the age of twelve. How do you think they might behave when they reach your age?'

'And what if you had to help out with your cousins and aunts and uncles, sometimes, if things went terribly wrong for them? How could you help out if you are the type of person who begins to get involved in this sort of thing at the age of twelve?', they continued.

Douglas told me later that he had gone to bed that evening, after the "talk in the kitchen", with the heaviest burden of guilt he had ever endured. Of course, at first, he could not rest because he was so angry at having been discovered, but much worse, when he began to fall asleep he had the most appalling visions of the dissolution of the family; fatherless children with no support from their junkie brother; motherless babies abandoned by a heartless sibling, too stoned to help out; orphan brothers and orphan sisters surrounded by poverty and squalor as their drug-addled brother squandered the state benefit on more junk to satisfy his uncontrollable appetites. Countless cousins led astray by the sweet perfume of the glowing reefer. Helpless aunts and destitute uncles left to fend for themselves in a world of criminals.

And all of the above because of his teenage hedonism.

I think that stories like this probably say quite a lot about Douglas' work at the moment. He is interested in the oblique, indirect, ways of suggesting this, or that, through an artwork, rather than a direct and confrontational approach like I've seen from some of the people with whom he works. * It's like my parents had always said to us, and they still do, that if a change is going to happen, then it has to happen primarily in the heads and hearts of the people who need to change. I think this is something Douglas thinks too. I know that he imagines his work to be most effective if it gets to work in the time after people have encountered the image, or the object, or the text, or whatever. We spoke about this once, in relation to the work *24 Hour Psycho* which I saw when he presented it at the Tramway in Glasgow. I told him that I thought it looked very impressive, but that it was all a little too slow for me, and that no-one would stay and watch the whole film anyway, so what was the point. He agreed that it would be almost impossible for anyone to watch the entire film, but this is one thing that was interesting to him; that the amount of information presented on his screen over the period of twenty-four hours was too much for most individuals, but that we encounter the same, if not more, detail in our daily lives. He went on to say that he found it interesting to imagine that someone might come to Tramway, on the south side of the city, to watch a little bit of the film, to recognise which part of the narrative they were experiencing, and then leave to go shopping in the west end of the city, or whatever.

He went on to imagine that this 'someone' might suddenly remember what they had seen earlier that day, later that night; perhaps at around 10 o'clock, ordering drinks in a crowded bar with friends, or somewhere else in the city, perhaps very late at night, just as the 'someone' is undressing to go to bed, they may turn their head to the pillow and start to think about what they had seen that day. He said he thought it would be interesting for that 'someone' to imagine what was happening in the gallery right then, at that moment in time when they have no access to the work. He said that the imagination of the person could be said to constitute the work in many ways. 'If you don't have an imaginative audience, then you have nothing to do', he said.

Even although I think that artists talk rubbish a lot of the time, and I include my brother here, I have to agree with some of what he says; in that it can be interesting to structure an event, or an idea, in such a way as to allow it to travel in space and time, outwith the four walls of the gallery and into the sub-conscious space of the viewer.

But now I'm sounding just like him, so I should start to stop.

Lastly, I think it's a pity that I can't go on a little more about Douglas' work. Now that I've given it some time and started to think about it I have a lot more to say about art and artists – some good things and some bad things – but Douglas told me that I had only two thousand words to use for this.

I'm already over the limit now, so I'll have to stop and think that if Douglas likes this he might ask me for some more.

I hope that this is of some use for your catalogue and all the best with the exhibition.

Yours,

David Gordon.

* He tells me that neither one approach is better than the other and that different methods of communication can reach, or appeal to, different audiences. To be honest, I find this attitude far too wishy-washy. I feel that if an artist has something to say, or a way to say it, then they should stand by that decision to the exclusion of all other ways and means, and points of view. I know that Douglas says I am far too extreme in this opinion but I think that he will feel the same one day.

Tattoo (for Reflection), 1997

84

entre-deux, 1996

The work *Unintentional, Sustained, Never-Ending, Always Changing* was shown at Galleria Bonomo, Roma, and Galerie Mot & Van den Boogaard, Bruxelles, 1996. At the beginning of each day, the gallerist would switch on the record player and amplifier, and lift the needle on to the record *Great Tenor Arias*. The record would play through to the end, until the needle became caught in the last groove of the record. The needle would remain in the groove as the record turned, until the end of the day, at which point the gallerist would remove the playing arm and switch off the audio equipment. The procedure would be repeated each day until the end of the exhibition. The work was installed in such a way that visitors to the gallery would hear the sound from various loudspeakers, placed on the floor, outside the room in which the record was playing. The sound produced from the needle catching in the groove was extremely soft, heavy, and repetitive. Visitors to the galleries described the sound as, variously, 'the oars on a rowing boat, being lifted in and out of water...', ' a body being bludgeoned with a heavy object', and 'some sound coming from the body; an amplified heartbeat, or the sound you might imagine in your head after a sudden rush of adrenalin has passed over'.

Unintentional, Sustained, Never-Ending, Always Changing, 1996

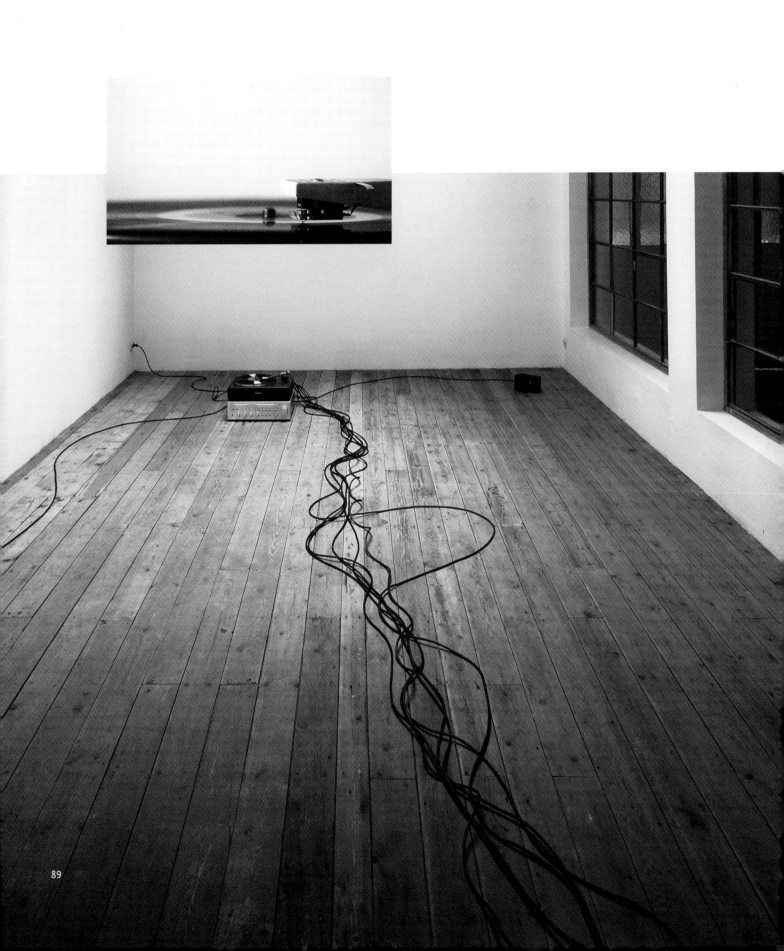

30 Seconds Text, 1996

90

30 seconds text.

In 1905 an experiment was performed in France where a doctor tried to communicate with a condemned man's severed head immediately after the guillotine execution.

"Immediately after the decapitation, the condemned man's eyelids and lips contracted for 5 or 6 seconds...I waited a few seconds and the contractions ceased, the face relaxed, the eyelids closed half-way over the eyeballs so that only the whites of the eyes were visible, exactly like dying or newly deceased people.

At that moment I shouted "Languille" in a loud voice, and I saw that his eyes opened slowly and without twitching, the movements were distinct and clear, the look was not dull and empty, the eyes which were fully alive were indisputably looking at me. After a few seconds, the eyelids closed again, slowly and steadily.

I addressed him again. Once more, the eyelids were raised slowly, without contractions, and two undoubtedly alive eyes looked at me attentively with an expression even more piercing than the first time. Then the eyes shut once again. I made a third attempt. No reaction. The whole episode lasted between twenty-five and thirty seconds."

...on average, it should take between twenty-five and thirty seconds to read the above text.

Notes on the experiment between Dr. Baurieux and the criminal Languille (Montpellier, 1905) taken from the Archives d'Anthropologie Criminelle.

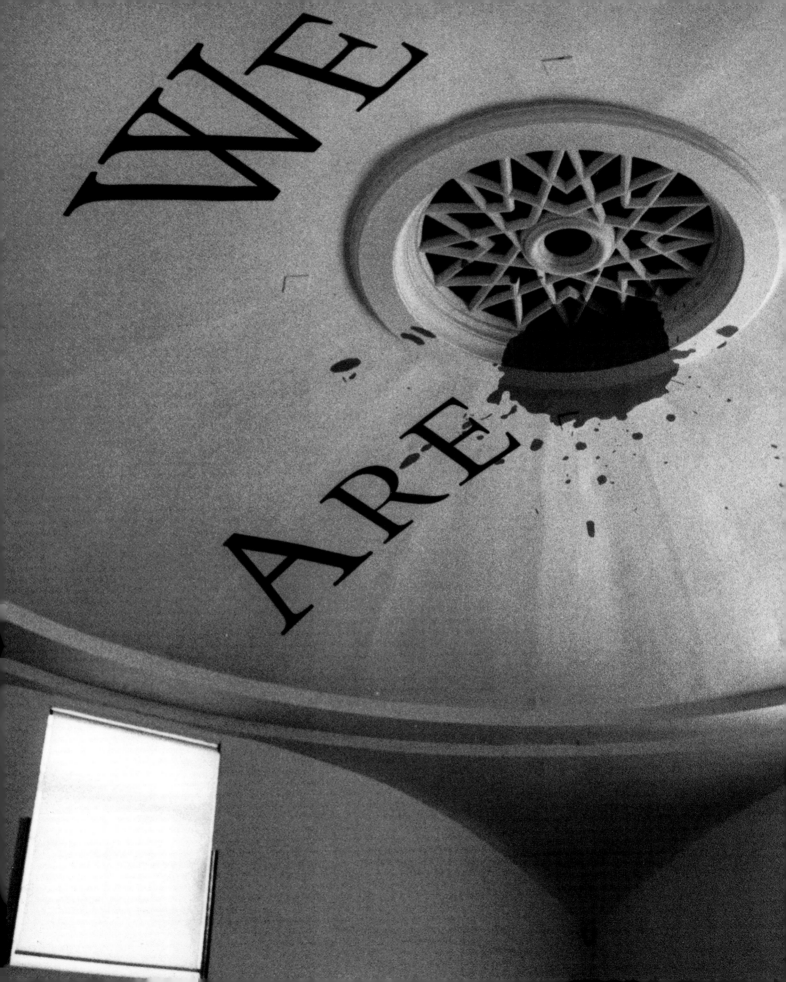

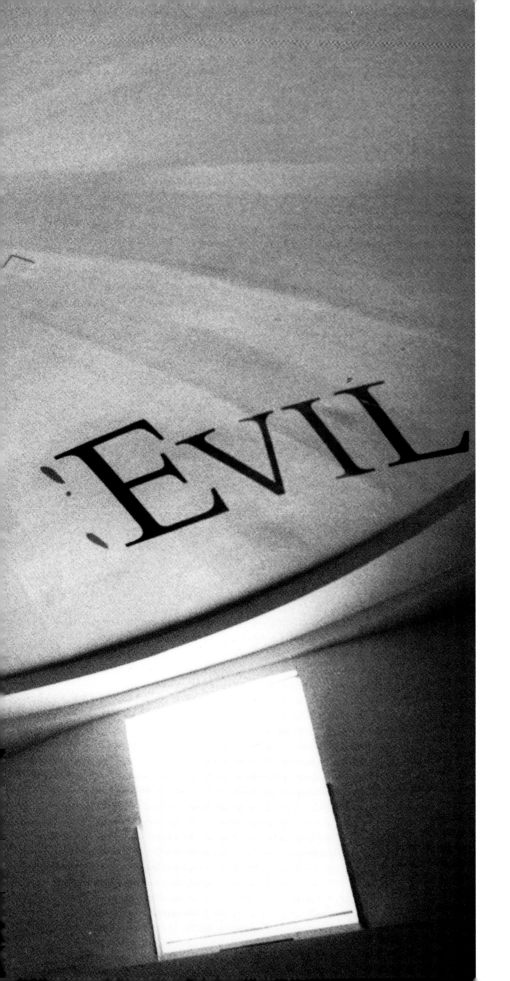

Above all else..., 1991

London, April 6th, 1992.

Dear

I forgive you.

Yours,

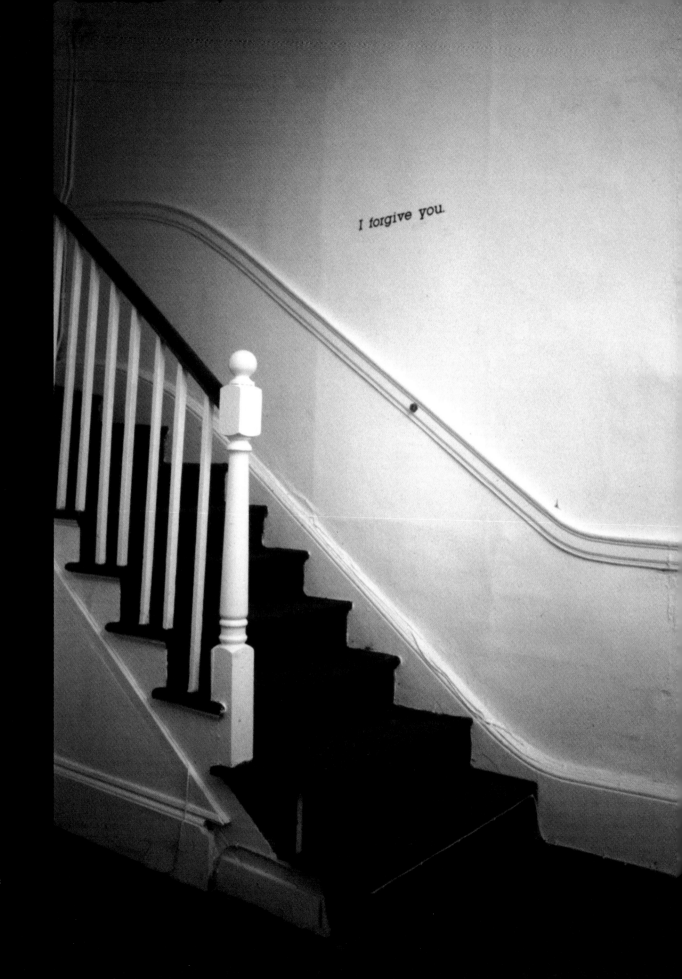

I forgive you.

Letter 5, 1992

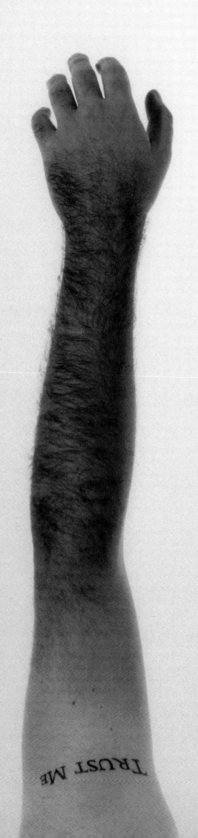

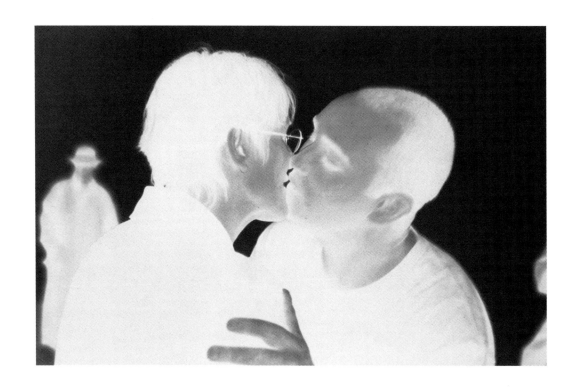

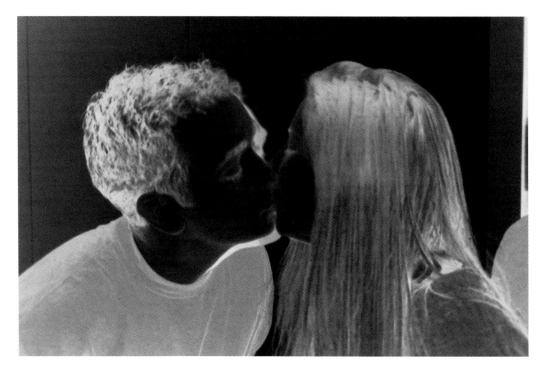

Kissing with Sodium Pentothal, 1994 (detail)

Kissing with Amobarbital, 1995 (detail)

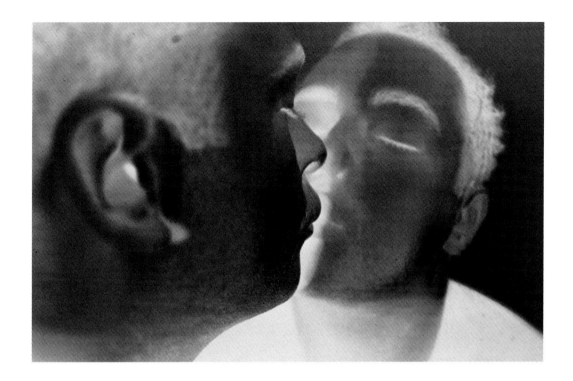

In 1994 and 1995, Douglas Gordon made three works using so-called 'truth drugs' *Kissing with Sodium Pentothal*, *Kissing with Amobarbital*, and *Self Portrait (Kissing with Scopolamine)*. The works are 'documentation of discreet performances' made by the artist at the Lisson Gallery, London, the Van Abbemuseum, Eindhoven, and in his bedroom. The images are projections of negative images of the artist and various others kissing one another. The artist is wearing the various truth drugs on his lips during each 'performance'.

Self-portrait (Kissing with Scopolamine), 1994

Something between my mouth and your ear

30 songs (from Jan – Sept 1966)

May, 1993.
An organisation called Book Works contacted me. They are putting together a series of projects by artists and writers called *The Reading Room*. It sounds interesting. They want me to make something for them.
I say yes, I'll try. We talk about the various cities in which it might be possible to work; London, Oxford, and Glasgow.
I don't want to work in Glasgow, as that is where I live and I suspect people there are bored of seeing too much of me – enough already. I don't want to work in London, as I've done too much there as well, although the British Library would be a good fun place to work, so I visit it, even although I don't think I'll end up making anything there. After this, I decide that I'd like to make something in Oxford.
I've never been there. I don't know anyone, and no-one knows me.

July, 1993.
I make a first visit to look at various sites in Oxford; the Bodleian Library, Green College, the Ashmolean, the Radcliffe Camera and so on. I think Book Works want me to make an installation of text, something like something I might have done before; a critique on knowledge, power, and the literary traditions of the city, I suppose. They haven't actually said this to me, it's just a feeling I get. I don't really want to do this.

August – September, 1993.
I've been travelling a lot, lately. This means I get the chance to read a lot more than is usual. But I am experiencing a strange kind of dislocation when I am in foreign countries and reading my books in English. During this time I'm reading Brett Easton Ellis, Jay McInerney, Donna Tartt and some others from New York. Perhaps it is because of the narratives I am reading , but the voices I hear all around me are strange, and I cannot understand the majority of what is being said (I speak English only), and I feel slightly neurotic.

But the voice in my head, when I'm reading, is familiar even although I don't recognise it completely. This reminds me of something I read a few years ago in a literary journal, *The Edinburgh Review*. An Italian writer, Gianni Celati, was talking about the 'fact' that every time we read a word we hear a voice. We don't know where the voice comes from, but it is there, and it is the key to our interpreting a series of abstract marks on a page, recognising these as letters, which make words, then into some kind of structured sentence, and hopefully towards some kind of sense. It's a nice idea.

And then I start to wonder what kind of voice we hear if we read in a foreign language, or if we read a text by someone from another country. At this point you should try to imagine what is happening in my head; I'm a Glaswegian, reading *American Psycho* by Brett Easton Ellis, on a Korean Air flight, coming back from Japan, and on my way to Portugal.

Anyway, I start to get more interested in the idea of reading as an internal/aural activity.

December, 1993.
Another visit to Oxford. I still can't decide on a site for my work – whatever it might be. But I make a decision that I don't want to tackle any literary or historical aspects of the city. This could be a problem for Book Works. I hope not.

January, 1994.
I've decided that I want to make a work for *The Reading Room* which does not involve any reading (apart from these words you are looking at now). I want to make something using sound; something between my mouth and your ear.

February, 1994.
We decide to work at the Dolphin Gallery. It's small, and it's as neutral a space as one can use in a city like Oxford; no particular history to interfere with the work. Now I know what I want to make.

I'm going to pursue the idea of *The Reading Room* as an internal/aural space, and try to collate a series of sounds that represent this phenomena. I try to think of the first sounds that I might have come across and where I might have heard them. I discuss this with some friends in Glasgow and we end up talking about the time immediately prior to my birth; these would be the months in which I would first encounter any received information. I begin to dig up as much material as I can on events between January and September, 1966. I visit the Mitchell Library in Glasgow and spend some time in the Music and Arts Reading Room where I discover they keep back issues of the Melody Maker, a music paper from the specific time I'm interested in. This is perfect. I begin to compile lists of songs from the 'Pop 50' as it was called in '66. There were some dreadful things in the charts during this time... I decide I have to be thoroughly subjective, which means goodbye to PJ Proby, Jim Reeves, and Tom Jones, among others.

March, 1994.
I send the complete list of songs to Book Works and recommend the various pieces of audio equipment I think we should use. I also suggest that the room in which the songs will be played should be entirely blue.

Douglas Gordon, 1994.

playlist

the kids are alright – the who

roadrunner – junior walker

turn, turn, turn – the byrds

paint it black – the rolling stones

i am a rock – simon & garfunkel

summer in the city – the lovin' spoonful

monday, monday – the mamas & the papas

my generation – the who

god only knows – the beach boys

all or nothing – the small faces

i'm a believer – the monkees

she said – the beatles

here, there, and everywhere – the beatles

8 miles high – the byrds

i want you – bob dylan

19th nervous breakdown – the rolling stones

5d – the byrds

sha la la la lee – the small faces

the sun ain't gonna shine anymore – the walker brothers

wild thing – the troggs

homeward bound – simon & garfunkel

we've gotta get outta this place – the animals

last train to clarksville – the monkees

making time – the creation

i'm only sleeping – the beatles

substitute – the who

sunny afternoon – the kinks

under my thumb – the rolling stones

pretty flamingo – manfred mann

out of time – chris farlowe

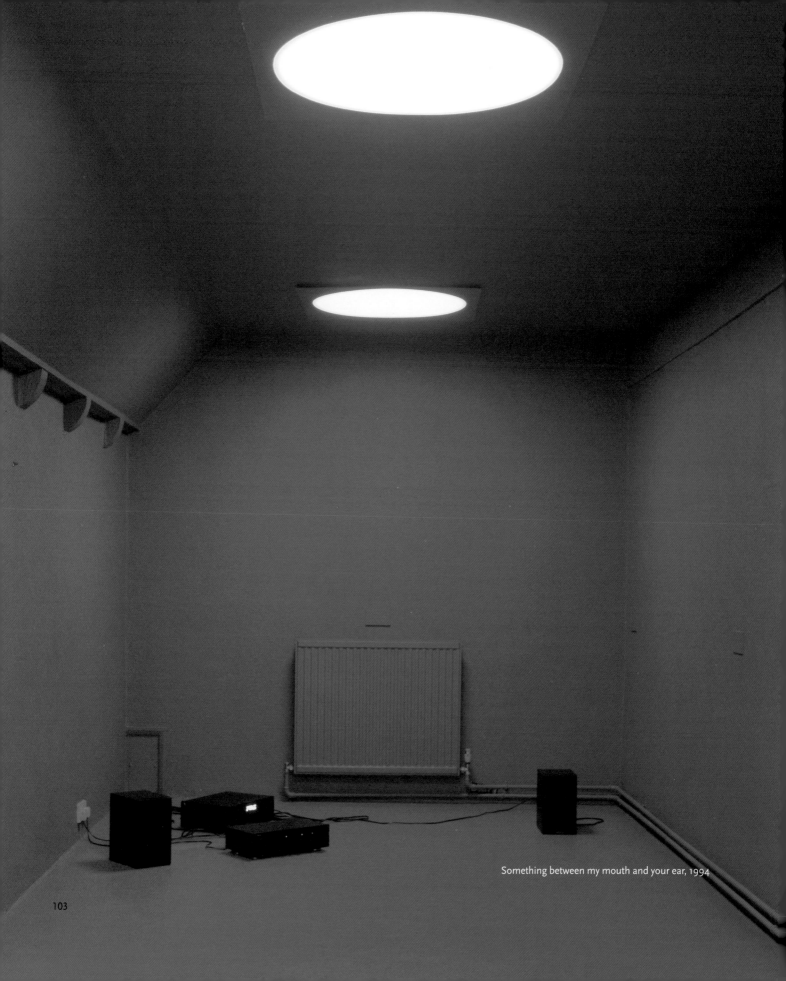

Something between my mouth and your ear, 1994

Instruction. (Number 7)

The *Instructions* were initiated in response to an exhibition curated by Gianni Piacentini, in a café, in Rome, 1991. They continued in Bremen, Connecticut, Copenhagen, Glasgow, Milan, Nice and Paris. The following is an example of the information sent to make a work in Copenhagen. Generally, this information would be formally presented in a gallery; as a facsimile of a certificate of authenticity, including photographs of the event, or a photographic indication of the event. The text would also be installed on a wall in the gallery, for the duration of the exhibition. The typeface used was Bembo, and the installed text would be coloured blue, green, black, or brown – depending on which *Instruction* was shown.

Location; from Galleri Nicolai Wallner, to Café Europa, Copenhagen, March 1994. *Exhibition*; Group show, Galleri Nicolai Wallner. On each day, for the duration of the exhibition, the owner of the gallery, or an assistant, should make at least one telephone call following the instructions below. The time that the calls are made need not correspond to the gallery opening hours. The success of the work depends upon the collaborative relationships between the artist, the curator, the gallery owner, and the café owner.

(1) The gallery owner will call the public telephone in the café or bar. (2) The café owner will answer the call with prior knowledge of the instructions. (3) The gallery (Nicolai Wallner) tells the café owner to choose a customer from the people in the café. This should be someone whom the café owner knows by name. The café owner should call the customer to the telephone, indicating that someone wishes to talk to him/her. (4) The chosen customer will take the telephone and receive a spoken text, the artwork, from the gallery. (5) The text;

I believe in miracles.

(6) There should be no dialogue between the gallery and the café customer. The gallery should disconnect the call immediately after speaking the text. (7) The customers chosen by the café owner can be male or female. (8) The text should also be installed in the gallery for the duration of the exhibition. These instructions should be displayed in the gallery alongside the installed textwork and a photographic document of the café/bar.

Douglas Gordon, 1994.

Words and Pictures, 1996

The following is based on an extract from the instructions for installation that accompany the works *Words and Pictures Part I* and *Words and Pictures Part II*.

The installation is based on the selection of a number of films chosen by the artist, from a list compiled in September 1996; the original list being composed of the titles of all the films shown in cinemas in Glasgow, between December 20th, 1965 and September 20th, 1966; those being the nine months covering Douglas Gordon's conception, gestation, and birth.

The situation should be a room in which films are viewed. The films should be front-projected onto a wall in the room, not on a screen. The walls, ceiling and other architectural particulars (such as columns, alcoves etc.) should be painted blue or white. The area of wall on which the films are projected should be painted white. There is no definitive size for the projection of the films; this should be arranged in harmony with the room, and some indication as to the nature of the size of the projection is available through photographic documentation of the installation.

The seating for visitors to the work is supplied and corresponds to the colour of the room. These should be installed informally, and visitors should feel free to move around as they want.

The audio components for the work are supplied. These should be installed in the most appropriate place, given the context. They should be visible, and not hidden from view.

The video projection and playback components are supplied. These should be installed in the most appropriate place. They should be visible, and not hidden from view.

The room in which the work is to be shown should be without artificial light or daylight, that is to say, as dark as possible.

The following list of films should not be read as a definitive sequence, but as a programme which may vary from one situation to another.

Words and Pictures Part I

Born Free
with Virginia McKenna, Bill Travers.
Directed by James Hill.
USA, 1966.
92 mins. Colour/English.

The Magnificent Seven
with Yul Brynner, Eli Wallach, Steve McQueen,
Charles Bronson, Horst Bucholz.
Directed by John Sturges.
USA, 1960.
123 mins. Colour/English.

Picnic
with William Holden, Kim Novak.
Directed by Joshua Logan.
USA, 1955.
109 mins. Colour/English.

Girls! Girls! Girls!
with Elvis Presley.
Directed by Norman Taurog.
USA, 1962.
98 mins. Colour/English.

The Sound of Music
with Julie Andrews, Christopher Plummer.
Directed by Robert Wise.
USA, 1965.
185 mins. Colour/English.

The Servant
with Dirk Bogard, James Fox, Sarah Miles,
Wendy Craig.
Directed by Joseph Losey.
GB, 1963.
110 mins. Black & White/English.

Torn Curtain
with Paul Newman, Julie Andrews.
Directed by Alfred Hitchcock.
USA, 1966.
122 mins. Colour/English.

Roman Holiday
with Audrey Hepburn, Gregory Peck.
Directed by William Wyler.
USA, 1953.
113 mins. Black & White/English.

Rio Bravo
with John Wayne, Dean Martin.
Directed by Howard Hawks.
USA, 1958.
136 mins. Colour/English.

I'm Alright Jack/Heavens Above *(double bill)*
I'm Alright Jack
with Peter Sellars, Ian Carmichael,
Richard Attenborough.
Directed by John Boulting.
GB, 1963.
Heavens Above
with Peter Sellars, Cecil Parker, Ian Carmichael.
Directed by John Boulting.
GB, 1963.
214 mins. Black & White/English.

Pierrot le Fou
with Jean-Paul Belmondo, Anna Karina.
Directed by Jean-Luc Godard.
France, 1965.
106 mins. Colour/French/English.

Who's Afraid of Virginia Woolf?
with Elizabeth Taylor, Richard Burton.
Directed by Mike Nichols.
USA, 1966.
124 mins. Black & White/English.

West Side Story
with Natalie Wood, Richard Beymer, Rita Moreno.
Directed by Robert Wise.
USA, 1961.
147 mins. Colour/English.

Marnie
with Tippi Hedren, Sean Connery.
Directed by Alfred Hitchcock.
USA, 1964.
124 mins. Colour/English.

Room at the Top
with Simone Signoret, Laurence Harvey.
Directed by Jack Clayton.
GB, 1958.
113 mins. Black & White/English.

The Young Ones/Summer Holiday *(double bill)*
The Young Ones
with Cliff Richard, Robert Morley, Carole Gray,
The Shadows.
Directed by Sidney J. Furie.
GB, 1961.
Summer Holiday
with Cliff Richard, Laurie Peters, David Kossoff,
Ron Moody, The Shadows.
Directed by Peter Yates.
GB, 1962.
207 mins. Colour/English.

The Cincinnatti Kid
with Steve McQueen, Edward G. Robinson,
Ann-Margret, Karl Malden.
Directed by Norman Jewison.
USA, 1965.
98 mins. Colour/English.

Khartoum
with Charlton Heston, Laurence Olivier,
Richard Johnson, Ralph Richardson.
Directed by Basil Dearden.
USA, 1966.
122 mins. Colour/English.

Somebody Up There Likes Me
with Paul Newman, Pier Angeli, Sal Mineo.
Directed by Robert Wise.
USA, 1956.
109 mins. Black & White/English.

Rasputin
with Christopher Lee, Barbara Shelley.
Directed by Don Sharp.
GB, 1966.
92 mins. Colour/English.

House of Wax
with Vincent Price, Frank Lovejoy, Phyllis Kirk,
Carolyn Jones, Charles Bronson.
Directed by Andre de Toth.
USA, 1953.
84 mins. Colour/English.

The Ipcress File
with Michael Caine, Guy Doleman, Sue Lloyd,
Nigel Green.
Directed by Sidney J. Furie.
GB, 1965.
108 mins. Colour/English.

Blue Hawaii
with Elvis Presley, Angela Lansbury.
Directed by Norman Taurog.
USA, 1961.
101 mins. Colour/English.

Help
with The Beatles.
Directed by Richard Lester.
GB, 1965.
101 mins. Colour/English.

Thunderball
with Sean Connery, Claudine Auger, Adolfo Celi,
Luciana Paluzzi.
Directed by Terence Young.
GB, 1961.
124 mins. Colour/English.

What's New Pussycat?
with Peter Sellars, Peter O'Toole, Romy Schneider,
Capucine, Woody Allen, Ursula Andress.
Directed by Clive Donner.
GB, 1965.
104 mins. Colour/English.

Von Ryan's Express
with Frank Sinatra, Trevor Howard.
Directed by Mark Robson.
USA, 1966.
112 mins. Colour/English.

Daleks-Invasion Earth 2150 A.D.
with Peter Cushing, Bernard Cribbins, Ray Brooks,
Jill Curzon.
Directed by Gordon Flemyng.
GB, 1966.
81 mins. Colour/English.

Tom Jones
with Albert Finney, Susannah York, Hugh Griffith.
Directed by Tony Richardson.
GB, 1963.
99 mins. Colour/English.

Spartacus
with Kirk Douglas, Laurence Olivier, Jean Simmons,
Chales Laughton, Peter Ustinov, Tony Curtis.
Directed by Stanley Kubrick.
USA, 1960.
188 mins. Colour/English.

Words and Pictures Part II

The Man Who Shot Liberty Vallance
with James Stewart, John Wayne, Lee Marvin.
Directed by John Ford.
USA, 1962.
118 mins. Black & White/English.

The Nun's Story
with Audrey Hepburn, Peter Finch.
Directed by Fred Zinneman.
USA, 1958.
145 mins. Colour/English.

The Paradine Case
with Gregory Peck, Charles Laughton, Charles Coburn.
Directed by Alfred Hitchcock.
USA, 1947.
109 mins. Black & White/English.

The Wizard of Oz
with Judy Garland, Frank Morgan, Ray Bolger.
Directed by Victor Fleming.
USA, 1939.
98 mins. Colour/English.

Monsieur Hulot's Holiday
with Jacques Tati, Louis Perrault, Nathalie Pascaud.
Directed by Jacques Tati.
France, 1952.
83 mins. Black & White/French.

The L-Shaped Room
with Leslie Caron, Tom Bell.
Directed by Bryan Forbes.
GB, 1962.
120 mins. Black & White/English.

The Nanny
with Bette Davis, Wendy Craig, Jill Bennet.
Directed by Seth Holt.
USA, 1965.
89 mins. Black & White/English.

Robin & The Seven Hoods
with Frank Sinatra, Dean Martin, Sammy Davis Jr.,
Bing Crosby.
Directed by Gordon Douglas.
USA, 1964.
118 mins. Colour/English.

Dracula, Prince of Darkness
with Christopher Lee, Barbara Shelley, Andrew Keir.
Directed by Terence Fisher.
GB, 1965.
87 mins. Colour/English.

Citizen Kane
with Orson Welles, Joseph Cotton, Agnes Moorehead.
Directed by Orson Welles.
USA, 1941.
59 mins. Black & White/English.

Lawrence of Arabia
with Peter O'Toole, Alec Guinness, Anthony Quinn,
Omar Sharif.
Directed by David Lean.
USA, 1957.
217 mins. Colour/English.

From Russia with Love
with Sean Connery, Pedro Armendaritz, Lotte Lenya.
Directed by Terence Young.
GB, 1963.
110 mins. Colour/English.

A Hard Day's Night
with The Beatles.
Directed by Richard Lester.
GB, 1964.
108 mins. Black & White/English.

Mutiny on the Bounty
with Marlon Brando, Trevor Howard, Richard Harris.
Directed by Lewis Milestone.
USA, 1962.
178 mins. Colour/English.

Paris Blues
with Paul Newman, Sydney Poitier, Joanne Woodward,
Louis Armstrong.
Directed by Martin Ritt.
USA, 1961.
94 mins. Black & White/English.

Harper
with Paul Newman, Lauren Bacall, Julie Harris,
Arthur Hill.
Directed by Jack Smight.
USA, 1966.
116 mins. Colour/English.

Darling
with Dirk Bogarde, Laurence Harvey, Julie Christie.
Directed by John Schlesinger.
USA, 1965.
122 mins. Black & White/English.

Alfie
with Michael Caine, Shelley Winters, Millicent Martin,
Julia Foster.
Directed by Lewis Gilbert.
GB, 1965.
109 mins. Colour/English.

Paradise, Hawaiian Style.
with Elvis Presley.
Directed by Michael Moore.
USA, 1961.
91 mins. Colour/English.

Two Way Stretch/Only Two Can Play *(double bill)*
Two Way Stretch
with Peter Sellers, Wilfrid Hyde-White.
Directed by Robert Day.
GB, 1960.
Only Two Can Play
with Peter Sellers, Mai Zetterling,
Richard Attenborough.
Directed by Bryan Forbes.
GB, 1960.
186 mins. Black & White/English.

Jason & The Argonauts
with Todd Armstrong, Nancy Kovack.
Directed by Don Chaffey.
USA, 1963.
100 mins. Colour/English.

Samson and Delilah
with Hedy Lamarr, Victor Mature, Angela Landsbury.
Directed by Cecil B. DeMille.
USA, 1949.
122 mins. Colour/English.

Look Back in Anger
with Richard Burton, Mary Ure, Claire Bloom.
Directed by Gordon L.T. Scott.
USA, 1958.
99 mins. Black & White/English.

Winter Light
with Ingrid Thulin, Gunnar Bjornstrand,
Max Von Sydow.
Directed by Ingmar Bergman.
Sweden, 1963.
80 mins. Black & White/Swedish with English subtitles.

Shoot the Pianist
with Charles Aznavour.
Directed by François Truffaut.
France, 1960.
82 mins. Black & White/French with English subtitles.

High Noon
with Gary Cooper, Grace Kelly.
Directed by Fred Zinnemann.
USA, 1952.
81 mins. Black & White/English.

The Spy Who Came in from the Cold
with Richard Burton, Claire Bloom, Oskar Werner.
Directed by Martin Ritt.
USA, 1962.
118 mins. Black & White/English.

The Plague of the Zombies
with André Morell, Diane Clare.
Directed by John Gilling.
GB, 1966.
87 mins. Colour/English.

Spellbound
with Ingrid Bergman, Gregory Peck.
Directed by Alfred Hitchcock.
US, 1945.
111 mins. Black & White/English.

The Greatest Story Ever Told
with Max Von Sydow, Dorothy McGuire, Claude Rains,
Jose Ferrer, David McCallum, Charlton Heston,
Sydney Poitier, Donald Pleasance, Roddy McDowall,
Gary Raymond, Carrol Baker, Pat Boone, Van Heflin,
Sal Mineo, Shelley Winters, Ed Wynn, John Wayne,
Telly Savalas, Angela Lansbury, Joseph Schildkraut,
Victor Buono,Nehemiah Persoff.
Directed by George Stevens.
US, 1965.
225 mins. Colour/English.

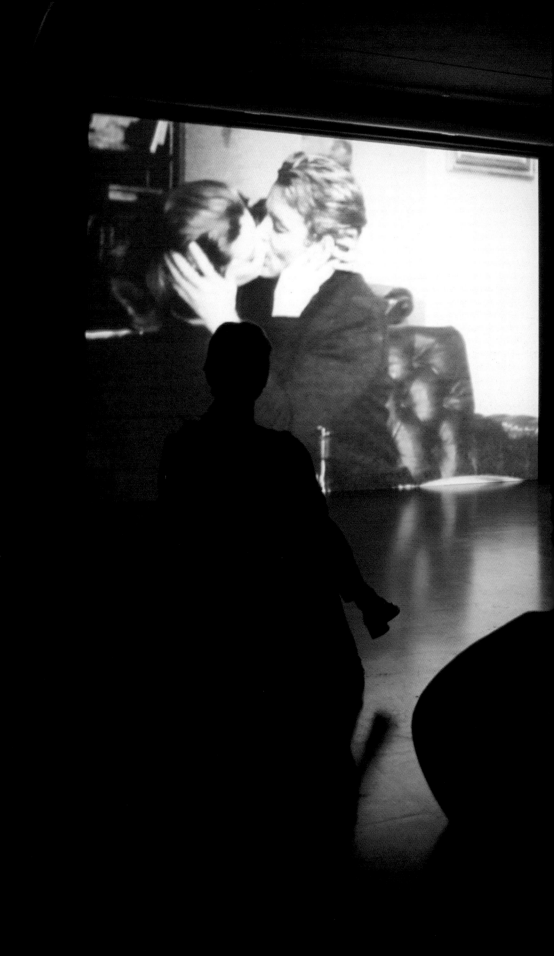

Words and Pictures (Part I), 1996

Cinéma Liberté Bar Lounge, 1996

In early 1996, Douglas Gordon and Rirkrit Tiravanija realised an invitation to make an installation together at the FRAC Languedoc-Roussillon in Montpellier, France.

The space functioned as two rooms; one downstairs and one upstairs. As visitors entered the space, downstairs, they came upon Tiravanija's *Bar Lounge* – where they could enjoy coffee, popcorn, wine, juice, or fresh fruit. A television monitor was installed high above the bar, indicating what was happening upstairs. On leaving the *Bar Lounge*, visitors walked upstairs to Gordon's *Cinéma Liberté*, where a number of films would be screened everyday, throughout the period of the exhibition. A screening programme was available but visitors could request to view a specific film if appropriate. The films selected for the installaton at the FRAC were chosen from a list of movies that had been censored (in part) or had been previously unavailable in France.

Avoir Vingt Ans dans Les Aures, 1972 (René Vautier)

Touchez pas au Grisbi, 1954 (Jacques Becker)

La Jument Verte, 1959, (Claude Autant Lara)

Le Blé en Herbe, 1953 (Claude Autant Lara)

Le Rendez-vous des Quais, 1955 (Paul Carpita)

Bel Ami, 1954 (Lois Daquin)

La Religieuse, 1967 (Jacques Rivette)

Nuit et Brouillard, 1955 (Alain Resnais)

La Neige Etait Sale, 1953 (Luis Saslavski)

Et Dieu Créa la Femme, 1956 (Roger Vadim)

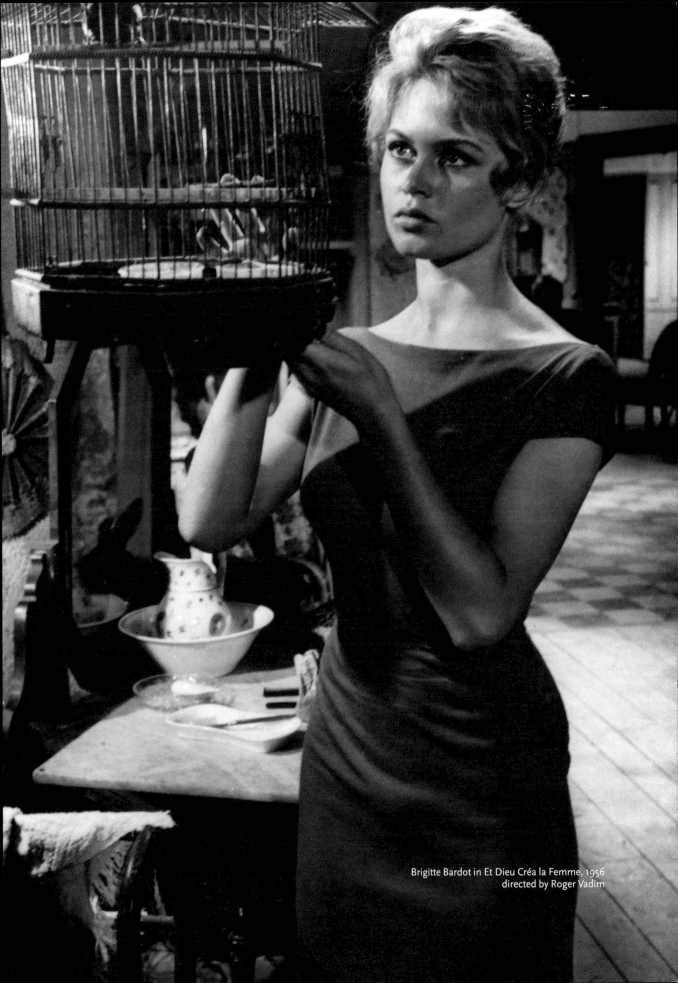

Brigitte Bardot in Et Dieu Créa la Femme, 1956
directed by Roger Vadim

Cinéma Liberté Bar Lounge, 1996

114

Instruction. (Number 3b)

Below are examples of the instructions sent to make works in Paris and Bremen. Generally, this information would be formally presented in a gallery; as a facsimile of a certificate of authenticity, including photographs of the event, or a photographic indication of the event. The text would also be installed on a wall in the gallery, for the duration of the exhibition. The typeface used was Bembo, and the installed text would be coloured blue, green, black, or brown – depending on which *Instruction* was shown.

Location; The internal telephone system at l'ARC, Museum of Modern Art, Paris. *Exhibition*; *Migrateur*, organised by Hans Ulrich Obrist, April 1993. On each day, for the duration of the project, the organiser, or an assistant, should make at least one telephone call following the instructions below.

(1)The organiser should make a call to any number of specific extension telephones within the museum. (2)If possible, the calls should be made internally. However, if this cannot be accommodated at all times, the calls should be relayed in the normal way; from the caller via the switchboard, to a specific internal number. (3)If the calls are made internally; the text should be delivered without addressing the specific individual. The receiver will know that the call has come from within the institution – from a fellow employee. If the calls are made from outwith the institution; the caller should ask for a specific extension number, and the individual in question. (4)The chosen individual will receive a spoken text, the artwork, from the organiser. (5)The text;

From the moment you hear these words, until you kiss someone with green eyes.

(6)There should be no dialogue between the organiser and the receiver. The organiser should disconnect the call immediately after speaking the text. (7)The receivers chosen by the organiser can be male or female.

Douglas Gordon, 1993.

Instruction. (Number 4)

Location; from Galerie Grün, to the Café Grün. Bremen. *Exhibition*; Galerie Gruppe Grün, May 1993. At random times, on random days, during the period of the exhibition, the gallery should make at least one telephone call following the instructions below. The success of the work relies upon the collaborative relationships between the artist and the gallery/ the gallery and the café.

(1)The gallery will make a call to the public telephone at Café Grün. (2)The café owner, or an assistant, will answer the call with prior knowledge of the instructions. (3)The gallery asks the café owner to choose a customer from the clientele in the café. This should be someone whom the café owner can call by name. The owner should call the person to the telephone, indicating that someone wishes to talk to him/her. (4)The chosen customer will take the telephone and receive a spoken text, the artwork, from the gallery. (5)The text;

It's only just begun.

(6)There should be no dialogue between the gallery and the café customer. The gallery should disconnect the call immediately after speaking the text. (7)The customers chosen from Café Grün can be male or female. (8)The text and these instructions should also be installed in the gallery.

Douglas Gordon, 1993.

List of Names, 1990-ongoing

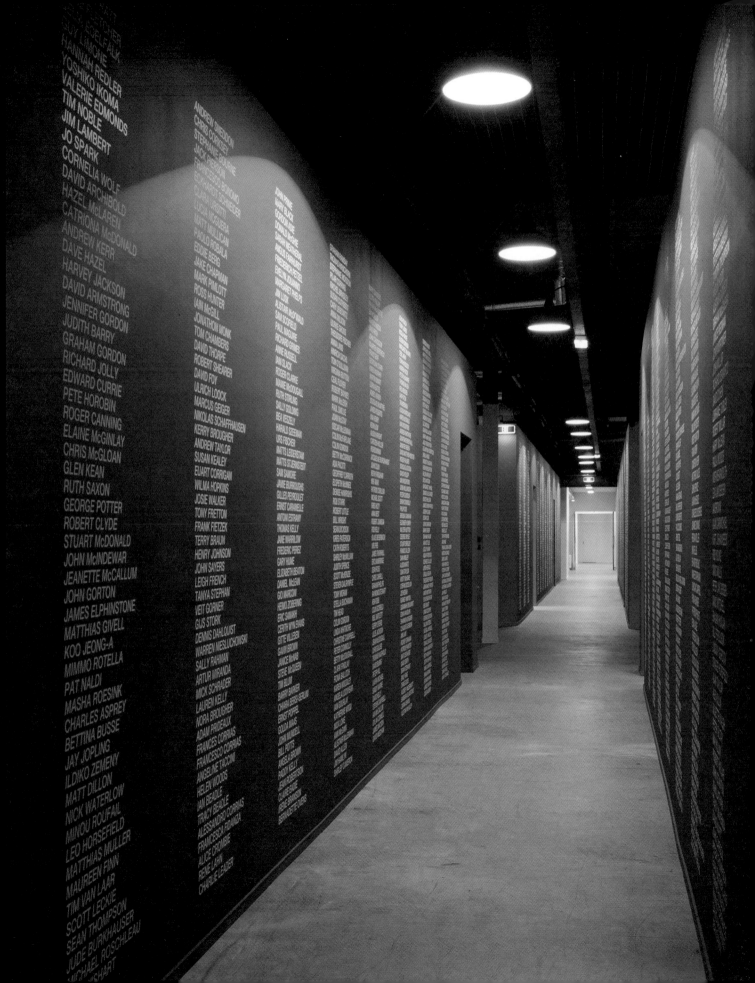

...lost, then found, then lost again;
a true story, after samuel beckett

I first visited Paris in 1980. It should have been a memorable trip, and I suppose it was, is, but there are large periods of the trip that I cannot remember at all. This had little, or nothing, to do with the kind of amnesic state that I desire nowadays (I think this is something to do with my age, but that's something else altogether). The blank spots in Paris were entirely to do with vin rouge, armagnac, and another drink that I couldn't pronounce and have no wish to taste again.

I was very sick. And in the unique way that alcohol-induced vomiting is so different from the retching inspired by the kind of gastric infections I seem to get, from time to time. Vomiting so hard that you begin to feel a pulse throbbing at the back of your throat where the hard palette ends and the soft, fleshy bit begins. And the more you become conscious of this unnatural pulsing the more likely you are to start vomiting again, but this time there is nothing left to throw up; except for the yellow bile that burns your nasal hair as it drips out of your nose because you couldn't negotiate a way for it to come out of your mouth. And as you are worrying about what is coming out of the holes at the top of your body you have completely forgotten to keep control over what is about to happen at the other end. Then things start to get a little bit messy.

I'll never drink again. And you remember the last time you said this.

Anyway, all of this is happening, in the usual way, and it could be in a bar, or in a hotel, or even in someone's house. I can't remember where, but I do remember that my suit was ruined. At least temporarily.

It was a very handsome suit and at least second-hand when I bought it; £2.50 at a jumble-sale in a middle-class suburb outside Glasgow. It was slightly too large for me when I bought it at first but I 'grew into it' over the next few years. Maybe it was more beautiful than handsome; two-piece, worsted wool, one vent and four pockets in the jacket, suspender clips as opposed to brace buttons in the trousers, zip fly, one inch turn-ups and beige satin lining. The cloth was an emerald green, red, yellow and black check (quite loose) over a light green base. Reading this back as I write it I realise this sounds quite awful, but if you could see it you would believe me when I say it was handsome & beautiful. It was made by Hector Powes, Regent Street London.

He would have been appalled if he could have seen what I had done to his suit on that night.

I spent the next day establishing an intimate relationship with an old porcelain toilet bowl in my hotel room whilst my suit lay in a plastic bag in the bath. I wasn't sure what to do about it but the concierge (no description of a jolly, fat, eccentric old woman here) told me to visit la teinturerie not far from the hotel. On checking my English/French dictionary I learned that this was neither a delicatessen, nor a cake shop, but a dry-cleaners.

I still felt fragile, and looked worse, so I put off my visit to the dry-cleaners for another day. By this time the smell from the plastic bag was beyond belief. I decided to put the bag inside another one, and then again, into a third bag. This did the trick.

I spent about 60 seconds at the dry-cleaners; edging in quietly and leaving abruptly, having explained that 'a friend' needed this suit cleaned as soon as possible and that he would call for it, in person, the day after next. All of this in very bad French. The smell in the shop was that of damp wool, warm laundered linen and cleaning chemical, all of this accentuated because of the heat and the steam. Under normal circumstances I find this quite a comforting sensation but right then I was still a little queasy and the shop began to make me feel quite claustrophobic. I thought I started to feel the pulse in the back of my throat again so I left before anything found its way from my stomach into my mouth and onto the floor of the shop. As I was leaving, the man behind the counter gave me a receipt, which I lost within the hour.

I returned four days later, not two, as planned, and tried to explain that I had lost my receipt for the suit. This was not good. La teinturerie explained to me that it was impossible for him to give me anything without a receipt and that I must understand that he was in a very difficult position and perhaps I should go home and look for the receipt again and come back tomorrow when I had found it and everything would be alright, etcetera. The more I tried to explain that the receipt was truly perdue, the more he tried to persuade me to go home and chercher again, and so the more irritated I became. This continued for about ten long minutes. By now the explanations had become arguments and the irritability was becoming plain anger. I decided to leave the shop.

Rather than returning to my hotel to look for the nonexistent receipt I sat in a café across the road and tried to calm myself down a little bit. Three very strong Turkish coffees and a disgusting brandy did not help the situation. But I waited and watched; from where I was sitting I had a full view of the dry-cleaners and could see the man shuffling from the front of the shop to the back and from the back of the shop to the front; folding clothes, dirty and clean, pinning and unpinning receipts onto the lapels of jackets and the back pockets of trousers, pulling some clothes out and putting others in. His routine began to annoy me as I ordered another coffee. Then I began to count the seconds that he spent in the front of the shop and the minutes that he spent in the back of the shop; to-ing and fro-ing, time and again. My mind started to wander towards all of the crappy crime thrillers and police stories that I had watched on TV as a child in the late sixties; big black cars, obvious characters (even to a child), overblown soundtracks, too-vivid colours, prologues, epilogues, and an authoritative male American voice at the end which said 'this was a Quinn Martin production'. I remembered the preparation scenes before a robbery where the crooks, or gangsters, would stake out a bank or a post office or maybe even a casino, depending on the glamour potential of the criminal. They would sit in a café, bar, or car, eat doughnuts, drink coffee and record the time it took for a guard to walk around a building, or a clerk to make a telephone call or whatever. Everyone knows the story.

As I sat there watching and waiting, ordering more coffee, I began to realise what I had to do. It was the only thing I could do.

I opened the door to the shop very quietly, whilst the pressing machine let out a loud blast of steam. This covered the sound of the door brushing against a hair mat on the floor. I saw a pile of clothes, in transparent blue plastic bags, lying on top of one another over the counter of the shop which was about four metres back from the door, which is where I was. I didn't want to move because my boots were heavy and the floor was bare wood, apart from the mat which had been brushed by the door and on which I was now standing, and there was no doubt in my mind that Monsieur la Teinturerie would have heard me trying to be silent. I had to wait until the pressing machine issued another burst of steam. In the thirty seconds that passed between each press from the machine I took a bold step towards the counter. And with every step towards that counter I scanned the pile of clothes wrapped in clear blue plastic; trying to pick out my handsome Hector Powes. By the time the fifth cloud of steam had risen I had been inside the shop for over two

minutes and I was within reach of the pile of clothes. I thought I could see my suit quite clearly. It was neither near the top of the pile, nor near the bottom of the pile. On the sixth burst of steam I lifted those clothes on the top of the heap and carefully, quietly liberated my suit. I stood there, at the counter, for another thirty seconds and on the seventh steam pressing I walked out of the shop, closed the door behind me and went back to the café across the street.

I ordered another brandy and watched the dry-cleaners. After a moment Monsieur la Teinturerie appeared in the front shop, lifted some of the clothes and went about his business as usual. He was none the wiser.

I was very pleased with myself. At least until I got back to my hotel and opened the plastic bag. The first problem was that the suit had not been cleaned, in fact it was quite filthy. The second problem was more serious; this suit was not my handsome Hector Powes. I was crushed.

After a few minutes I tried to look for a positive side to the situation. Although the suit was neither mine, nor clean, at least the dirt was not my vomit. But then again it was not the smell of my urine on the crotch, nor my long grey hairs on the lapels, nor my dry scalp on the collar. But it was a very good suit. Perhaps even better than mine. It was a green fleck on brown, Irish three-ply, wool twist, two-piece, three button, button brace, button fly, tight lapels, no vent, with no turn-ups. I laid it out upon the bed. It looked like it might be a little too long in the leg, a fraction tight around the shoulders and definitely too short in the arm. Perhaps if I walked a certain way it might look okay; which reminds me of a very old joke that is too long and not funny enough to interrupt this story. Maybe later.

I left it there for a while and went out for the evening to meet a friend for dinner. None of this is, or was, important. I returned to the hotel at around midnight and looked at the suit again. I couldn't possibly go back to the dry-cleaners to explain. There was no explanation. I looked at the new suit some more and decided that I liked it and should keep it.

Guilt free, I went to bed.

Next morning I decided to check out of the hotel, out of Paris, out of France, and head back to Glasgow. I folded the new suit into a bag, packed it in my rucksack and set off home.

I forgot about the suit for some time on arrival in Glasgow. I had unpacked, or emptied, my rucksack and put the bag

with the suit in a box on a shelf in a cupboard in the hall outside my bedroom in my house. It must have been there for two or three weeks, until I told someone the story of my raid on the dry-cleaners. This reminded me that I must take the new suit to another dry-cleaners as soon as possible as I had a funeral to attend and this was the only reasonable piece of clothing I had in my wardrobe, even although it was actually in bag, in a box, on a shelf, in a cupboard, at that moment.

Later that night I opened the cupboard, took the box from the shelf, the bag from the box, and suit from the bag. It was desperately dirty. I was about to put the suit back into the bag when I thought that it would be a sensible idea to check if there was anything in the pockets that should be taken out before cleaning. In the top outside pocket, below the lapel, on the jacket, I found a note, or a piece of paper with some handwritten words on. In the first bottom pocket, immediately beneath the top pocket, below the lapel, on the jacket, I found another piece of paper; slightly smaller than the first piece of paper but also with some handwritten words on. In the second bottom pocket, opposite the first bottom pocket, and at a 60-degree angle from the top pocket, which was beneath the lapel, on the jacket, I found nothing at all.

In the inside left pocket, immediately behind the top pocket, below the lapel, I found a third piece of paper; slightly larger than both pieces I had found already and with some handwritten words on. There was no inside right pocket.

In the front left-hand trouser pocket, below the top jacket pocket and the first bottom jacket pocket, I found nothing. In the front right-hand trouser pocket, opposite the left-hand trouser pocket, and below the second bottom jacket pocket, I found a fourth piece of paper. This piece was larger than the first and second pieces of paper but slightly smaller than the third piece (which turned out to be the largest of all). The fourth piece of paper also had some handwritten words on. In the rear left-hand trouser pocket, which cannot easily be described in relation to all the other pockets apart from the rear right-hand pocket (into which I hadn't gone at this point, but which was opposite), I found a very small piece of paper; smaller than all of the others. It had some very small handwritten words on. Lastly, in the rear right-hand trouser pocket, which cannot easily be described in relation to all the other pockets, apart from the rear left-hand trouser pocket (which is opposite), I found two small pieces of paper. They were more or less the same size as one another and were smaller than the first but larger than the fifth. These two small pieces of paper had handwritten words on both sides. I arranged the seven pieces of paper on my bed and started

to read them. On one side of the paper, each piece described the specific relationship between one piece of paper and the next. On the other side of the paper, each piece described the specific relationship between the pockets they had been found in. This was described in the manner that you have just read.

I carefully put these seven pieces of paper into an envelope which I put in a small box in a drawer in the desk in my bedroom. Then I went to bed and thought about the man who had written the notes and had owned the suit.

Then I fell asleep.

Next morning I put the suit into a plastic bag; but by this time the suit was smelling quite dreadful. So I decided to put the bag inside another one, and then again, into a third bag. This did the trick.

I did not want to spend any time at the dry-cleaners; remembering my last escapade. I edged in quietly and left abruptly, having explained that 'a friend' needed this suit cleaned as soon as possible and that he would call for it, in person, the day after next. The smell in the shop was that of damp wool, warm laundered linen and cleaning chemical, all of this accentuated because of the heat and the steam. Under normal circumstances I find this quite a comforting sensation but right then I felt a little uncomfortable with my memories and the shop began to make me feel quite claustrophobic. As I was leaving, the man behind the counter gave me a receipt, which I lost within the hour.

I returned three days later, not two, as planned, and tried to explain that I had lost my receipt for the suit. This was not good. The dry-cleaner explained to me that it was impossible for him to give me anything without a receipt and that I must understand that he was in a very difficult position and perhaps I should go home and look for the receipt again and come back tomorrow when I had found it and everything would be alright, etcetera. The more I tried to explain that the receipt was truly lost, the more he tried to persuade me to go home and look again, and so the more irritated I became. This continued for about ten, long minutes. By now the explanations had become arguments and the irritability was becoming plain anger.

I decided to leave the shop.

Douglas Gordon.

REMEMBER

NOTHING

I

NOTHING

I

I

REMEMBER

NOTHING

NOTHING

REMEMBER

 I

NOTHING

REMEMBER

REMEMBER

REMEMBER

 I

I

NOTHING

Wall Drawing (I remember nothing), 1994

...letter to agnès

Berlin, October 6th, 1997

Dear Agnès,

thank you for the invitation to contribute to an issue of 'point d'ironie'.

I am working on a project just now which might be interesting for the next issue.

The story starts some time ago, when I was about five or six years old. My family lived in Glasgow, and this was in the early 70s. At that time, Glasgow had a reputation of being a violent city with knife-and-razor-wielding gangs terrorising people in the streets; this is the mythology, at least.
I remember that there were stories being told of various people having been attacked with knives and razors and that the police were going to crack down on anyone carrying such offensive weapons. I particularly remember overhearing a story being told to my mother, by one of our neighbours. The story was that someone's son had been arrested in the streets because he had been carrying an object that could be construed as an offensive weapon. It turned that he had been carrying a steel comb, and the handle of such an object was perceived to be dangerous because it was so long and sharp. I remember thinking that this was an amazing thing; that such an innocent object could be seen to have such a potential for violence. So the end of the story, as overheard by me as a child, is that the police would confiscate any knife or sharp object that was three inches or longer.
The measurement of three inches corresponds to an idea that this is the distance that could make a fatal wound in the body; the distance necessary to penetrate a vital organ (the heart in particular).

Even although I heard all of these details as a child, it was one of those stories that one continues to hold on to, and think about for a long time. I kept thinking about it as a teenager, and as an adult, and for some reason, I have been thinking about it a lot, quite recently. I wanted to make something out of these thoughts.

I had an idea that I would like to make a tattoo in relation to this idea of fatal penetration. I wanted someone to have an index finger tattooed completely black. I liked the idea that this could be so simple yet so extreme. I liked the idea that it could be beautiful and ugly at the same time. I liked the idea that the tattoo would be a sign for the distance between the outside world and the vital organs in the body – this could be read quite literally as the distance necessary to reach in and touch someone's heart. This can be read as a metaphor, or as a fact.

I liked the idea that someone would live with this sign for the rest of their life. I liked the idea that people might ask this person what had happened to his finger. I like to think of all the possible conversations he will have when other people ask him 'why?' 'what does it mean?'.

Anyway, I was able to make this work last week. I am showing some photographs of the tattoo for an exhibition at Galerie Yvon Lambert. I also took some photographs of the tattoo being made and I think you might find them interesting for 'point d'ironie'.

Let me know what you think.

Best,

Douglas.

Three Inches (Black), 1997

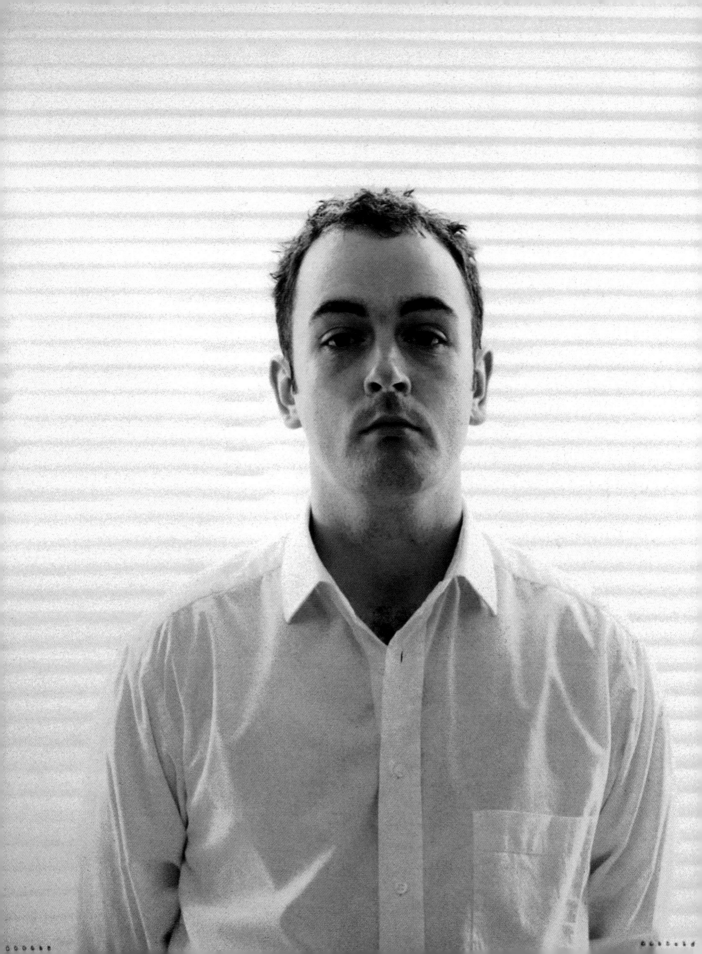

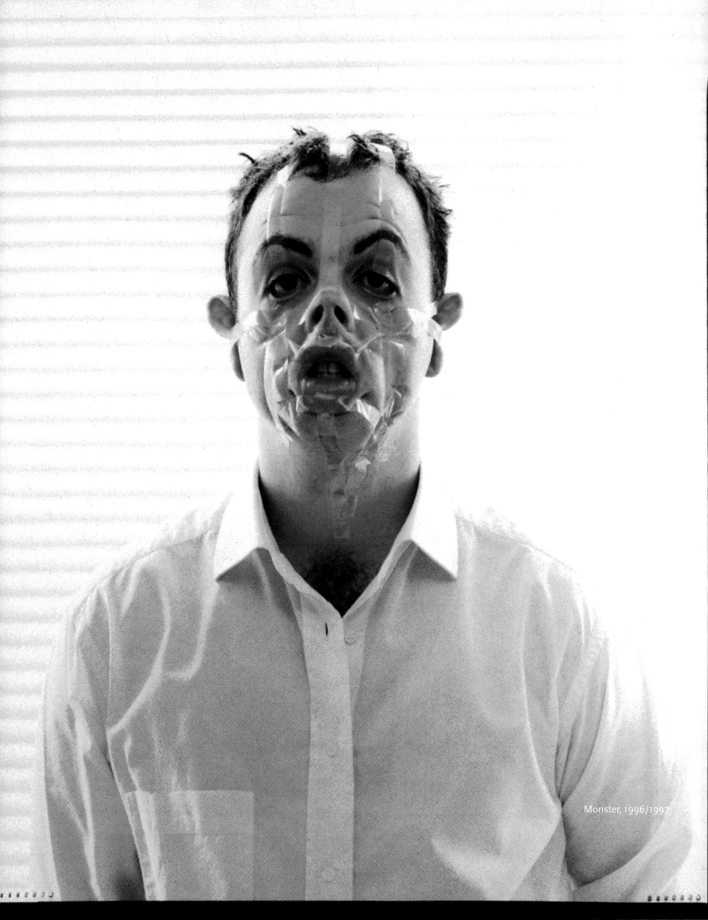

Monster, 1996/1997

Hand and Foot (Left) and Hand and Foot (Right), 1995/1996

Remote Viewing, 13.05.94 (Horror Movie), 1995

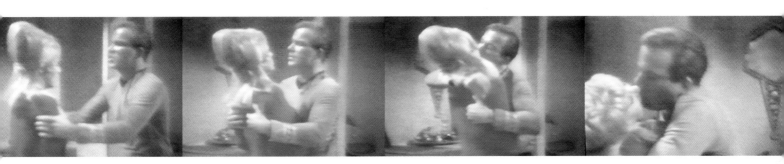

Predictable Incidents in Unfamiliar Surroundings (Party Pack Edition), 1992/5

5 Year Drive-By, 1997, exhibition view Over Night #1, Kunstverein Hannover, 1997

...an apology as a short story/a short story as an apology

A letter to Thierry Pratt (a curator of the *3e Biennale d'art contemporain de Lyon*, 1995) trying to explain...

Saturday, November 4th, 1995.

Dear Thierry,

I'm sorry this proposal is so late despite my promises that I would have everything done in time. For some reason I seem to have hit a run of really bad luck (I think I know why but I'll tell you about it later); everything has been going wrong over the last few months and I have had to sort it all out before getting this idea to you.

The proposal has no title as yet but we'll work something out in time for the opening; I know you've told me countless times, but when is it again?

The work is something of a companion piece to *24 Hour Psycho* but it may appear to be a little more extreme in some ways. I want to work with John Ford's film *The Searchers* which is, I think, the archetypal Hollywood western. The film was made in the mid/late 1950's and it stars John Wayne, Jeffrey Hunter, Vera Miles and Nathalie Wood (although we don't see too much of her in the story).

One of the reasons why I want to use this material is because *The Searchers* was among the first films that I can remember watching as a child. Quite often, when I was younger, and I couldn't sleep at night, my parents would take me out of bed and I would sit with them and watch TV until I fell asleep. Most times I managed to stay awake until the end of the movie so I've grown up with quite a peculiar experience of cinema based on these childhood memories.
I remember watching *Spartacus* (with Kirk Douglas & Tony Curtis), *Von Ryan's Express* (with Frank Sinatra), *The Birdman of Alcatraz*, *Elmer Gantry*, and *The Swimmer* (with Burt Lancaster), and then all the Hitchcock classics like *Rope*, *North by Northwest* and *Strangers on a Train*. As well as all this there were endless westerns; some of which were trashy (even to a child), but others like *Hud* (with Paul Newman), and *One-eyed Jacks* (with Brando and Karl Malden) made a big impression on me, in retrospect.

Of course, the other big westerns that I loved were all the John Wayne films.

I can remember watching *The Searchers* for the first time and feeling that I couldn't understand what was going on (you must remember that this is when I was about six or seven years old); the story seemed too simple.

I mean to say, the narrative here is pretty straightforward;

John Wayne returns home from the Civil War, eventually, and rolls back to his brother and kin like a bad penny. It's all going swell until the Injuns turn up and do the dirty; killing the menfolks, raping the women,

and stealing one of the kids to take back to their camp. Of course, all the pillage & plunder is taking place while John Wayne has conveniently disappeared from the storyline for a few moments to allow the Commanche to finish off what they started and disappear with the stolen child (Wayne's niece).

So, what's to be done; well, old Uncle Ethan (Wayne's character) simply embarks on an epic search for the missing child.

This is the essence of the story; nothing less, and nothing more.

The search lasts five long years.

Now, I remember thinking a lot about this film after I had seen it for the first time; I can remember thinking that five whole years was a very long time, especially in relation to my short life. I also remember asking my father how a film could be made which seemed to be about nothing. He tried to explain to me that the film was not at all about nothing; it was about searching and waiting, and waiting and searching and hoping when all hope has gone and how this was a very important thing in life. I suppose I must have had to accept this, at least for a few years, as I didn't have the faculty (cynicism) to disagree with him.

Then, a few years later I saw the film again; this time with the foreknowledge of the narrative and that the nothingness could be seen to be significant to older people even although what I really wanted was a lot more shooting and killing than the film appeared to contain.

I was then about eight or nine years old and I still was dissatisfied with the film.

I watched *The Searchers* again, in my early teens, and then again quite recently. Now I realise what I thought to be the problem; and it's quite simply a question of time.

How can one film, which lasts only 2 hours, possibly convey the fear, the desperation, the heartache, the real 'searching and waiting and hoping' that my father had tried to explain to me when I was younger?

How can anyone even try to sum up 5 miserable years in only 113 minutes?

Now, it's important to say that this is not a criticism directed at John Ford, nor the motives behind the making the movie. But, for me, it does open up a gap in the way we experience the experience of cinema; and this is the basis of my proposal.

I want to screen the Ford original but at such a speed as to stretch the narrative back to a real time duration. Reconstituting the narrative, as it were.

As far as I can make out, this might be quite tricky on a technical level.

The original film runs for 113 minutes and we need to stretch this to 5 years.

The sums are as follows;

113 minutes of cinema time	:	5 years in real time
so, converting this to days...		
113 minutes of cinema time	:	5 x 365 (days) + 1 (day for a leap year)
	=	1826 days
and, converting this to hours...		
113 minutes of cinema time	:	1826 x 24 (hours)
	=	43824 hours
and, converting this to minutes...		
113 minutes of cinema time	:	43824 x 60 (minutes)
	=	2629440 minutes

so,

113 minutes of cinema time equates to		2629440 minutes in real time.

It follows that,

1 minute of cinema time		2629440 ÷ 113
1 minute of cinema time	:	23269.38 minutes in real time.

and further,

1 second of cinema time	:	23269.38 seconds in real time
	=	387.823 minutes in real time
1 second of cinema time	=	6.46 hours in real time.

I think this will work out in such a way that we can show approx. 1 second of the original film for each day that the exhibition is open to visitors.

So, Thierry, this is as far as we can go for the moment. I'm sure everything will be possible as regards the technical necessities and it would be good for us to talk about this soon.

I look forward to hearing from you.

Amitiés,

Douglas.

It's like a scene in a movie – with Douglas Gordon it's always a scene in a movie. Night has fallen in Los Angeles, there is a new moon visible through high clouds and the air is crisp. It's quiet, with only the hushed hum of distant traffic, and maybe an occasional dog. The camera moves down a dark street, past shadowy houses, and then turns up a driveway into a backyard. The door of a large garage is open and reveals a brightly lit painter's studio, a large, unfinished painting on the back wall. A man sits at a desk in front of a computer screen, typing. A fax comes in, from Douglas. It's headed with an address in Berlin, but he says he's in Glasgow where it's pissing rain and blowing a gale. He wants to know where the essay is. The man drops the fax in a waste bucket and returns his attention to the computer, to send an email to his collaborator: tlawson@muse.calarts.edu to mocarf@earthlink.net.

In a windowless downtown office at the end of the day a man slumps at his desk. Time to check the mail again. He logs on. A message from tlawson: subject: Douglas Gordon: Empire. It's the beginning of an exchange. With Douglas there is always an exchange, always two sides to the story, always an image and always a mirror image. Often there is good and evil, although it is not always clear which is which. Tom and I of course, are both good (mostly) and both Scottish emigres.

A few days before Christmas a package arrived. FedEx from the Lisson Gallery in London. On the customs declaration it said, 'Video: not pornography'. Disappointed, I put it aside for a while. Today I took it up to CalArts to watch what I actually knew to be Douglas's proposal for a public work on Brunswick Street in Glasgow. It's a nice work in itself, a dream-like deconstruction of a scene from Vertigo.

In dreams identities are fluid. People we thought we know pass constantly into others. This dream-like state is the psychic territory in which the apparently realistic film Vertigo takes place. Dream or nightmare? For Douglas Gordon the two are inseparable, like the free-standing film screen he erected in Münster last summer that showed *Song of Bernadette* and *The Exorcist* at the same time, projected from either side of the screen. The saintly young girl and the Satanically possessed adolescent constantly overlapped each other as priests and nuns passed back and forth across them, wrestling for their souls, and the sound of unearthly screams blended with angelic hymns.

The scene begins with Jimmy Stewart walking down a city street towards the camera. He's nattily dressed and seems nervously watchful, maybe even shifty. A number of cars pass, seeming to float. It is then you realise that the film has been slowed down, in the Douglas Gordon manner. Stewart stops and watches a woman walking down the other side of the street. The slow-motion makes his stalking of Kim Novak seem creepier than it does in the movie. She enters a nondescript building with an awning jutting out over the pavement. The camera, taking Stewart's point of view, does a slow pan up the facade, caressing a vertical sign that reads, 'EMPIRE HOTEL'. Novak comes to a

window, opens it and turns back inside. We then see a short take of the hotel front at night, followed by the original scene again, flipped so that Stewart seems to be coming down the street from the other end.

Everything can be reversed in Douglas's art, and often is. The flipping backwards and forwards is relentless. Even although the pace of the action is often glacially slow, the process of reversal, of constant turning back and beginning again from the other side, never stops. The tension is always mounting. Vertigo is just beyond the horizon, or just around the next corner.

Douglas's idea is to take this hotel sign and use it as the basis of a work that would almost blend unnoticed into the streetscape of the city. A vertical neon sign, green light outlining white letters on black, is to be attached high on a wall against a strip of mirror plate. The letters spell the word EMPIRE, but they are reversed, so that the word will seem slightly wrong in the real space of the sign, and clearly legible in the reflective space of the mirror. The lighting around one of the letters is to appear broken, so that its blinking will attract passers-by on Argyle Street to walk into the lane.

Here in America, thousands of miles away from a rainy alley in Glasgow, Empire takes on a faintly nostalgic quality heightened by the old-fashioned lettering and the broken, flashing, letter. Even the neon itself seems from another time, as indeed it is: it's from 1958, when Alfred Hitchcock made his film. The word suggests something Victorian. And we all know now that it is the American empire that dominates the world. American tourists come to Scotland and find it 'quaint'. I like the idea of this (brand-new) old American sign hiding out in Brunswick Lane, buzzing and flashing, slightly disorienting with its reversed lettering and the mirrored surface that (almost) returns it to normal.

Douglas told me that when he first made a presentation of the project at the Mitre Bar a few of the locals questioned the use of the word 'empire'; someone suggested that 'tobacco' might be a better option. Douglas thought that this was positive evidence that his work was going to have strong reverberation with the people of Glasgow, and imagined all sorts of discussion around the legacy of Scottish Mercantilism and the British Empire but then someone mentioned to him that it might be more to do with some memories of the Empire Theatre; some locals mourning its loss, others remembering hating the shows it put on.

After a couple of drinks on a Saturday, the Empire belongs to me.

Thomas Lawson and Russell Ferguson

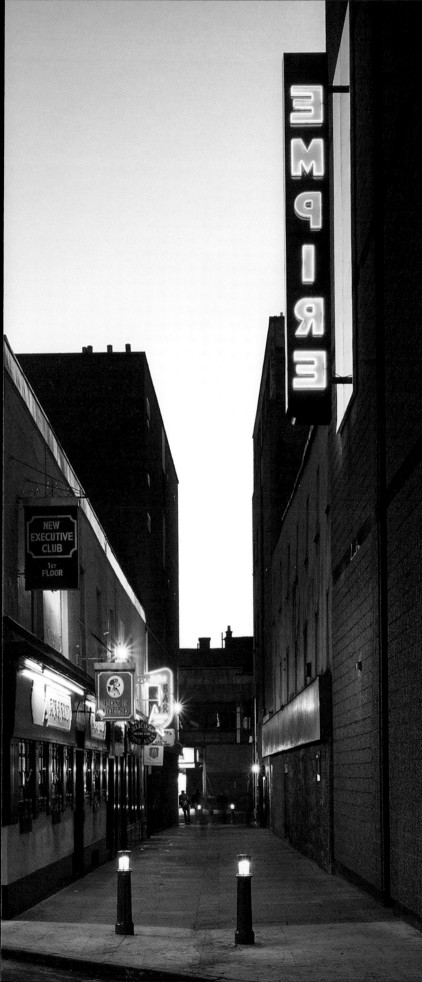

A Souvenir of Non-Existence was made in 1993. The artist sent a letter addressed to Lars Thorwald, a character from the Alfred Hitchcock film *Rear Window*. In the movie, Thorwald is suspected of murdering his wife, who mysteriously disappeared at the beginning of the film. The main characters, played by James Stewart and Grace Kelly, are convinced that Thorwald is guilty, and they attempt to provoke him by sending him a letter with the message 'What have you done with her?'.

Lars Thorwald
2nd Left Rear
125 West 9th Street
Chelsea
New York
USA

Dear Lars,

What have you done with her ?

Yours,

Douglas Gordon

Douglas Gordon.

Lars Thorwald
2nd Left Rear
Chelsea
New York
USA

Return: Douglas Gordon,
Lisson Gallery,
67 Lisson Street,
London NW1
England

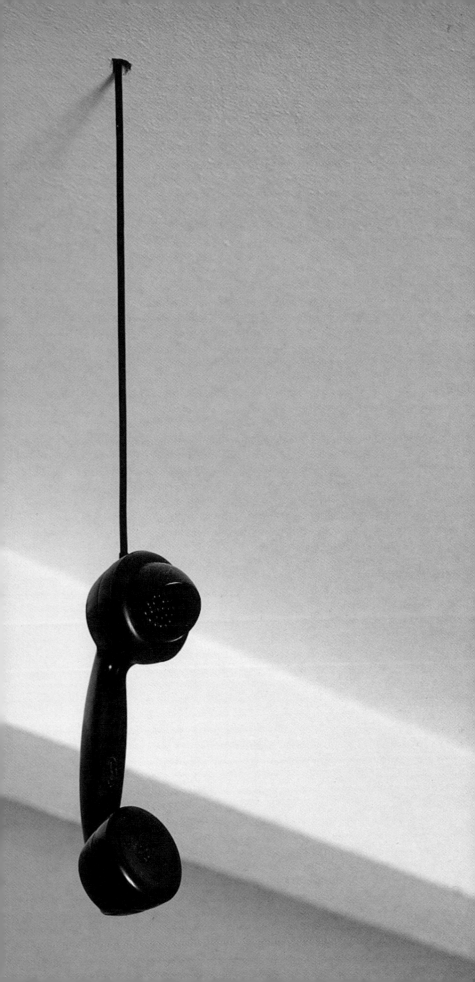

Dead Line in Space, 1997, was made for an exhibition at Villa Minimo, Hannover, curated by the artist Hlynur Hallsson. The exhibition was to be installed in a room directly beneath Douglas Gordon's apartment. The artist drilled a hole through his bedroom floor and out through the ceiling of the apartment below. He took the handset of his telephone 'off the hook', and installed it in the exhibition space below his apartment, the wire leading from the handset, up through the ceiling into his bedroom and onto the main body of the telephone. The exhibition lasted four weeks. The telephone remained 'off the hook' for this period, and there was no contact with the artist.

Dead Line in Space, 1997

Trust Me, 1993, was made in Porto, for the exhibition *Walter Benjamin's Briefcase*, curated by Andrew Renton. The exhibition took place in a large, disued flourmill, on the outskirts of the city. Douglas Gordon proposed to remove the floor and ceiling between levels 3 and 4 of the building, creating one larger space out of two smaller areas. On the plane where the floor and ceiling had previously existed, he installed a circus tightrope from one corner of the room to the other. He also installed a single, short rope hanging from the rafters of the space down to the plane where the floor and ceiling had been. On entering the space, visitors could look up and into the upper level of the building. This upper level was occupied by a tightrope walker, who was employed to be in the space for the duration of the exhibiton.

Trust Me, 1993

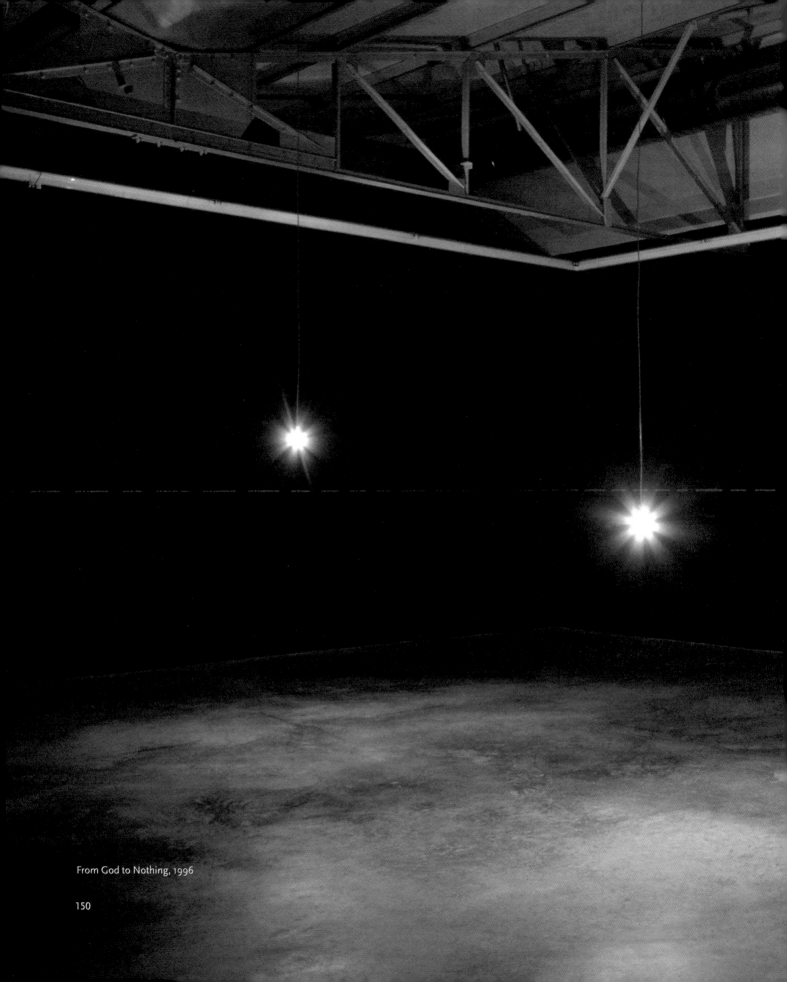

From God to Nothing, 1996

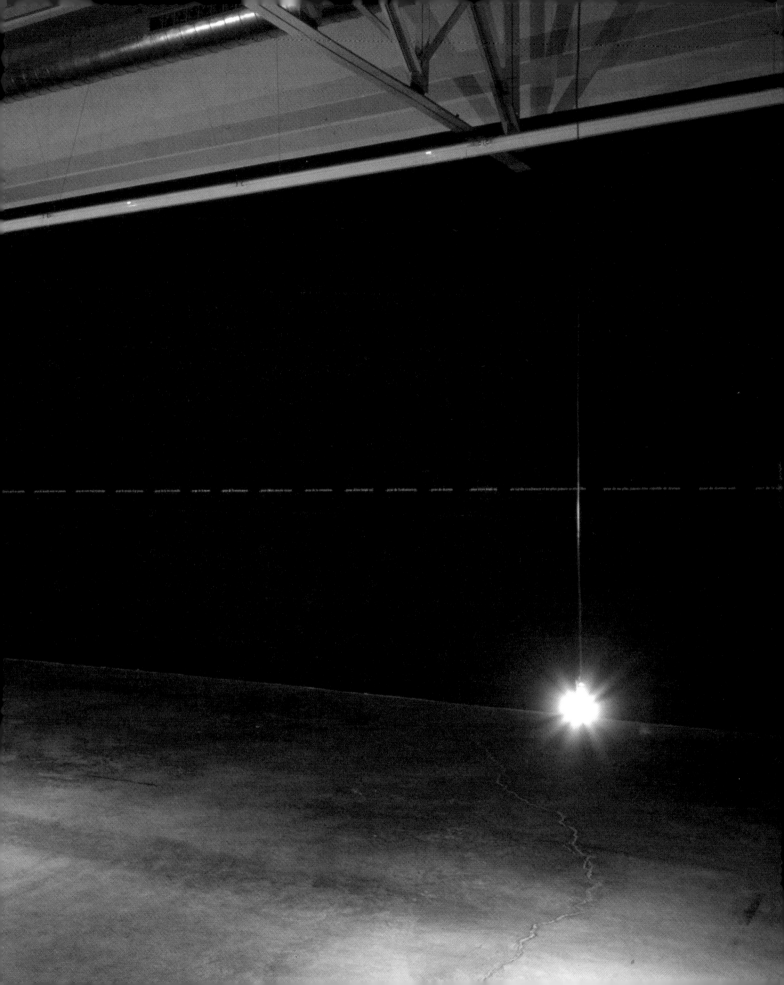

...fear of god. ...fear of the devil. ...fear of jesus. ...fear of judgement. ...fear of purgatory. ...fear of heaven. ...fear of hell. ...fear of friends. ...fear of enemies. ...fear of failure. ...fear of success. ...fear of food. ...fear of wa

...fear of swollen membrane. ...fear of sexual intercourse. ...fear of rape. ...fear of castration. ...fear of masturbation. ...fear of teeth. ...fear of teeth falling out. ...fear of oral penetration. ...fear of anal penetration ...fe

...fear of physical pain. ...fear of disfiguration. ...fear of surgery. ...fear of anaesthesia. ...fear of coma. ...fear of psychological pain. ...fear of seizure. ...fear of dying. ...fear of dying after parents. ...fear of dyi

...fear of exhumation. ...fear of waking up. ...fear of never being able to sleep again. ...fear of sleeping alone. ...fear of loneliness. ...fear of marriage. ...fear of loss of sense of self. ...fear of self-hatred. ...fear of kind

...fear of moving at high speed. ...fear of flying. ...fear of falling. ...fear of drowning. ...fear of the sea. ...fear of fish. ...fear of birds. ...fear of dogs. ...fear of cats. ...fear of spiders. ...fear of flying insects. ...fear of

...fear of urination. ...fear of defecating. ...fear of bodily functions. ...fear of uncleanliness. ...fear of infection. ...fear of aids. ...fear of cancer. ...fear of nature. ...fear of reality. ...fear of loss of reality. ...fear of

...fear of enclosure. ...fear of collapsing buildings. ...fear of technology. ...fear of intellect. ...fear of the supernatural. ...fear of fear. ...fear of inquisition. ...fear of prophesy. ...fear of the future. ...fear of the past. ...

f blood. ...fear of own mother. ...fear of own father. ...fear of own sister. ...fear of own brother. ...fear of own son. ...fear of own daughter. ...fear of own nakedness. ...fear of breasts. ...fear of the vagina. ...fear of the penis.

...fear of women. ...fear of children. ...fear of dwarfs. ...fear of tall people. ...fear of youth. ...fear of the elderly. ...fear of authority. ...fear of movingobjects. ...fear of broken bones. ...fear of being crippled.

ents. ...fear of living too long. ...fear of dying too young. ...fear of everlasting life. ...fear of the dead. ...fear of burial. ...fear of burial, while still alive. ...fear of cremation. ...fear of cremation, while still alive.

of rejection ...fear of tenderness. ...fear of laughter. ...fear of crying. ...fear of deafness. ...fear of the inability to express oneself. ...fear of lying. ...fear of being lied to. ...fear of strangers. ...fear of public spaces.

sects. ...fear of reptiles. ...fear of the dark. ...fear of suffocation. ...fear of gas. ...fear of electricity. ...fear of telephones. ...fear of televisions. ...fear of knives. ...fear of smoke. ...fear of fire. ...fear of bathing.

..fear of poverty. ...fear of white. ...fear of black. ...fear of fog. ...fear of thunder. ...fear of lightening. ...fear of bright light. ...fear of bright colour. ...fear of fame. ...fear of anonymity. ...fear of open spaces.

present. ...fear of time passing. ...fear of the end of the world. ...fear of the truth. ...fear of knowledge. ...fear of solipsism. ...fear of nothing.

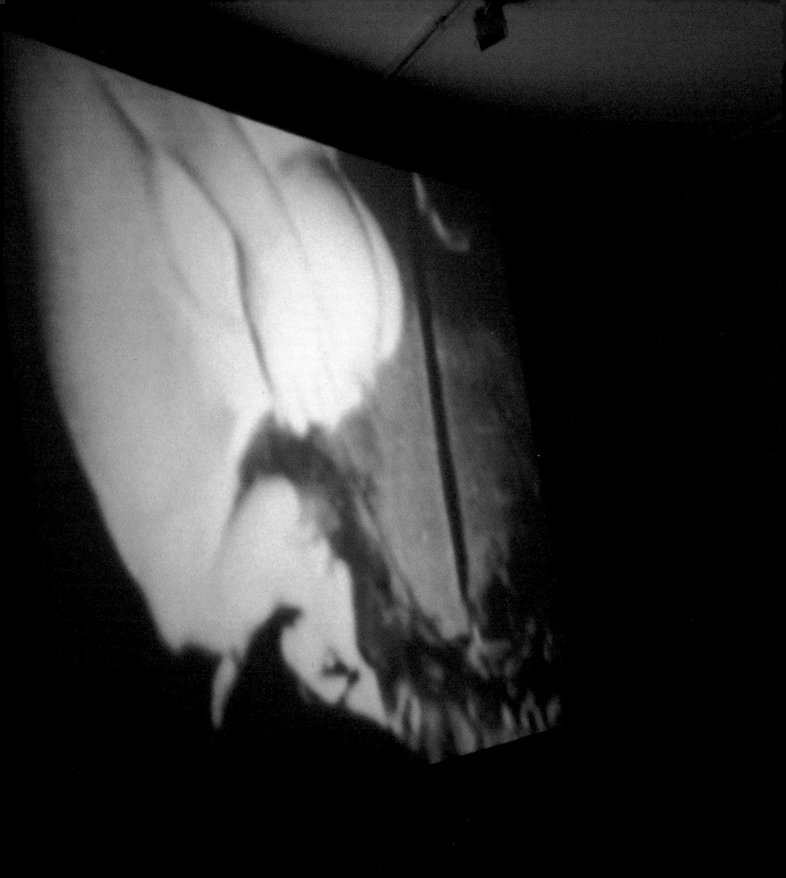

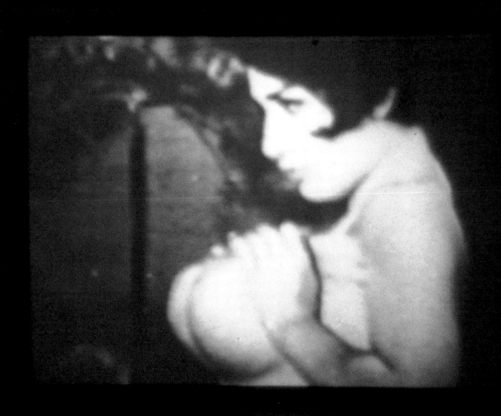

Black and White (Babylon), 1996

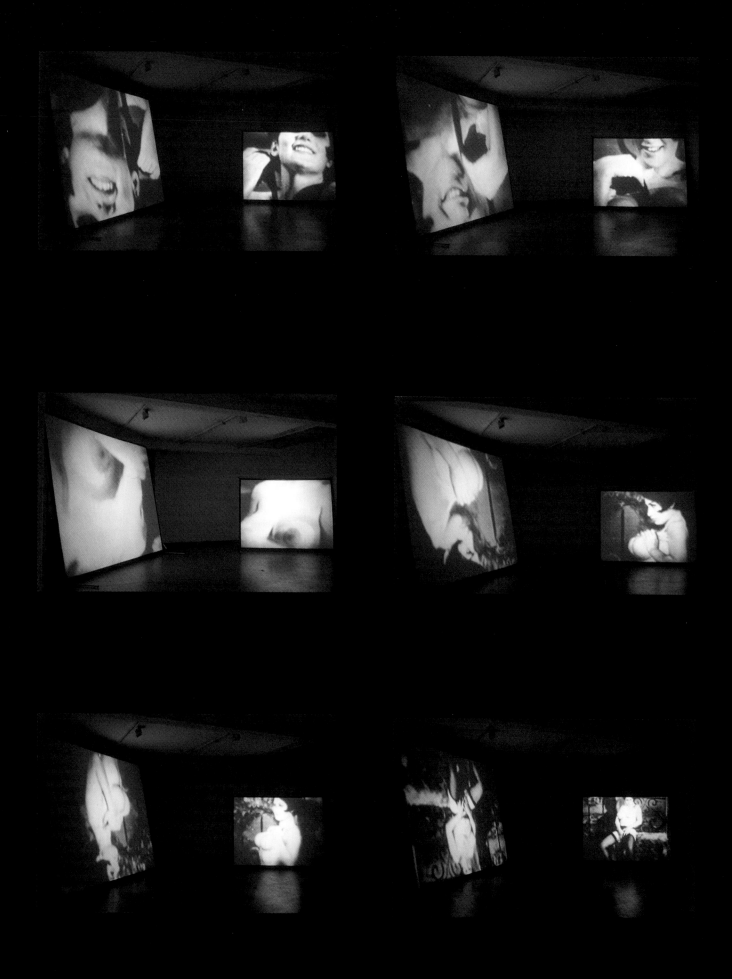

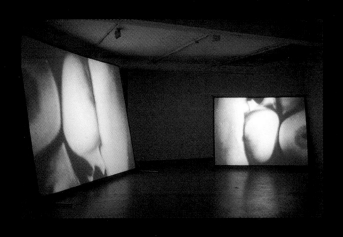

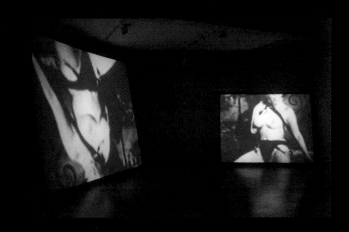

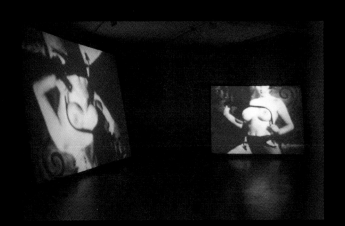

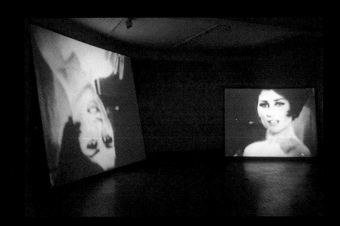

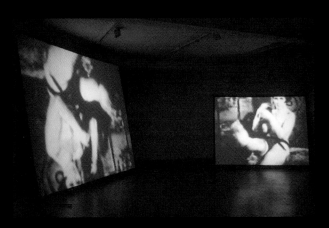

Black and White (Babylon), 1996

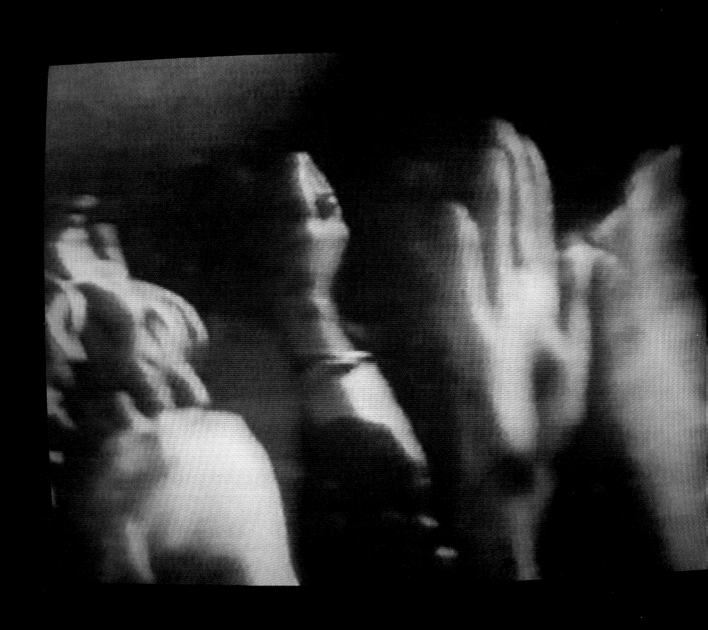

Bootleg (Stoned), 1996

Bootleg (Bigmouth), 1996

Bootleg (Cramped), 1995

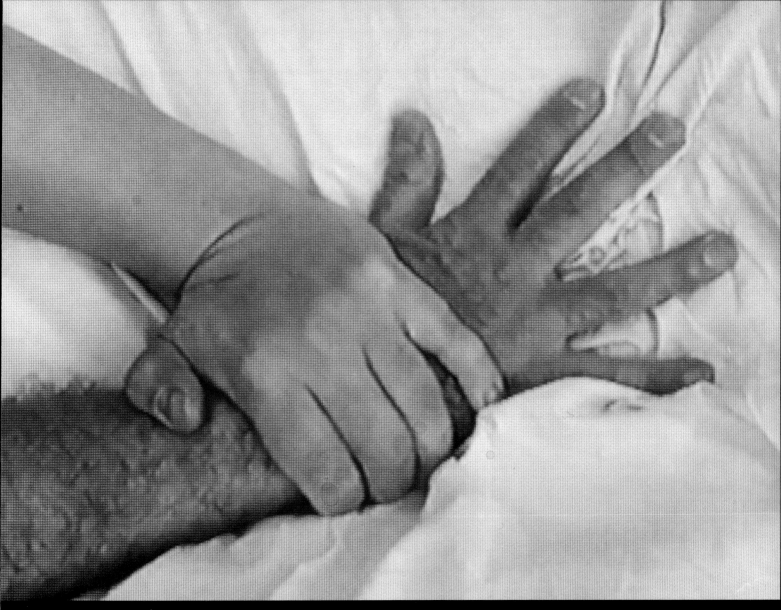

Wednesday, 20th March, 1991.

I am aware of who you

Douglas Gordon

are & what you do.

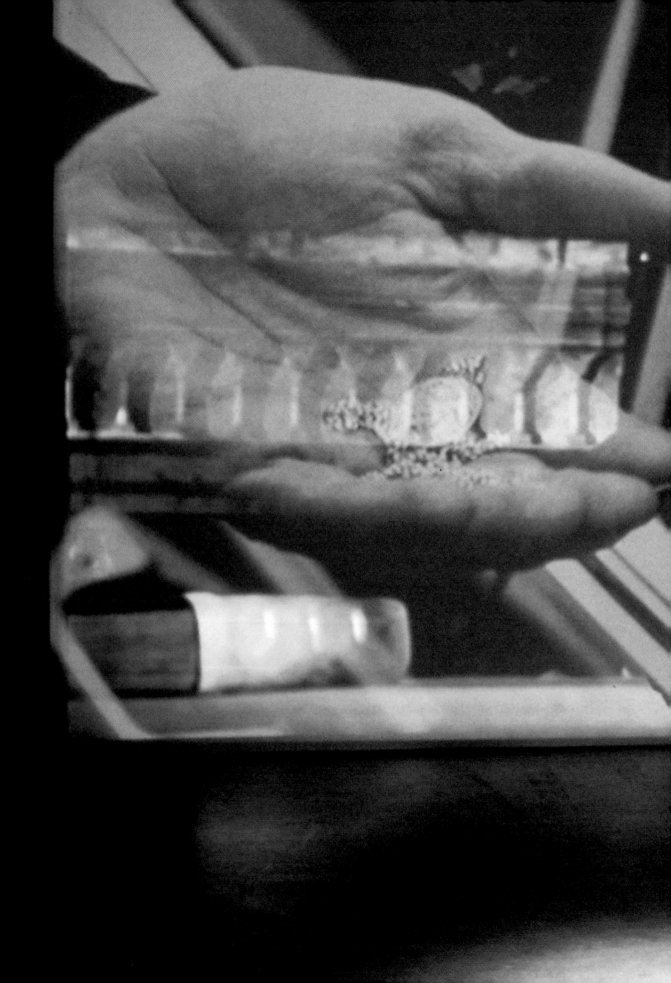

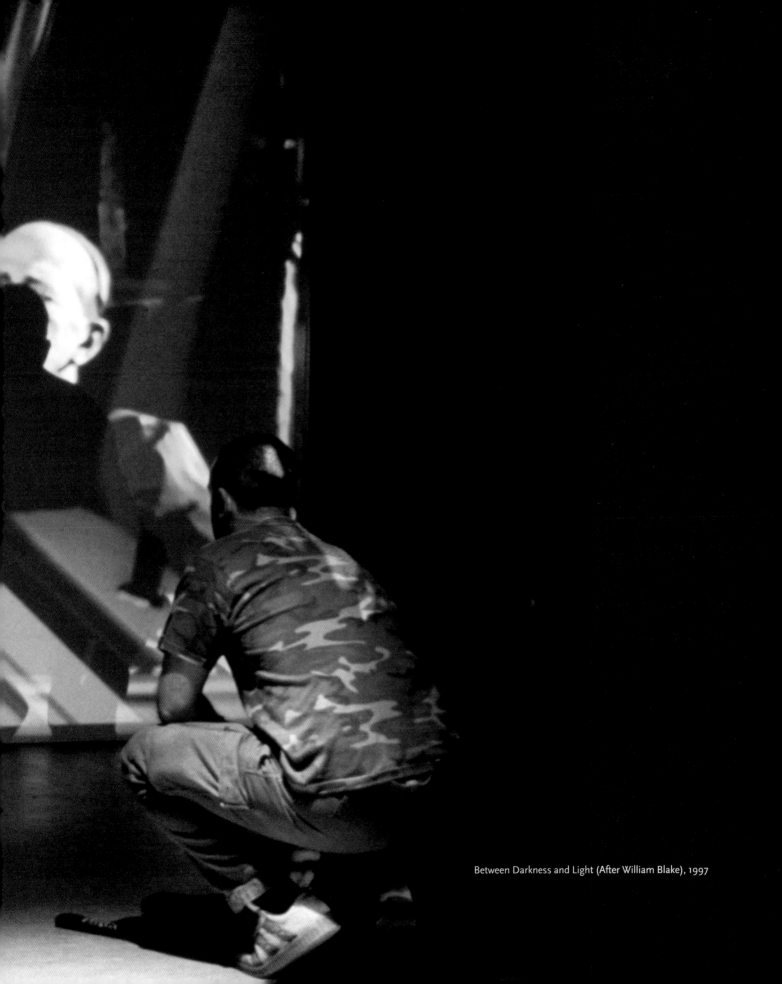

Between Darkness and Light (After William Blake), 1997

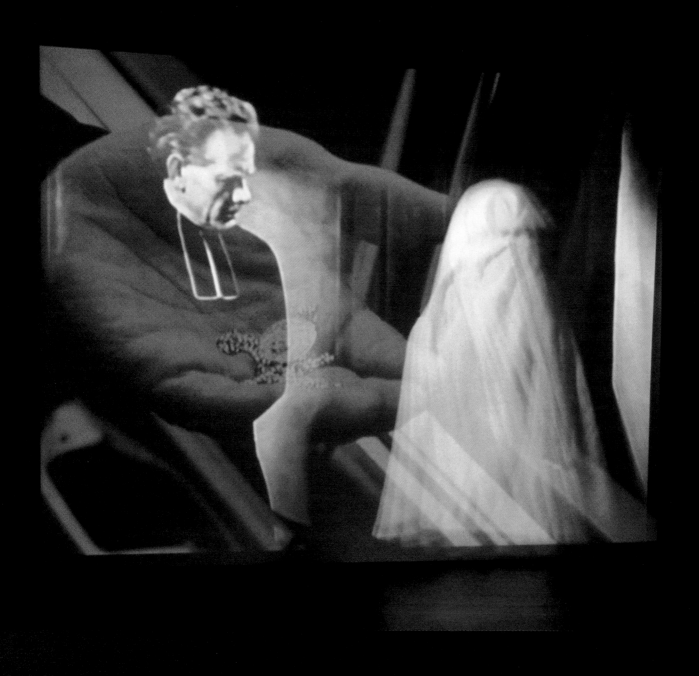

Between Darkness and Light (After William Blake), 1997

Between Darkness and Light (After William Blake), 1997

...in conversation (continued)

The scene is a sunny evening in a small room in an Eindhoven house. The light is beautiful but fading fast. The two men have not been in conversation since the meeting at the cottage, almost one year ago. Neither of them can remember exactly how the first conversation started, or how the last conversation ended. It won't matter much. The older man checks to see if he has enough cigarettes to keep him going through the evening. They drink good red wine and eat cheese. The older man lights his first cigarette and pours a large glass of brandy for the younger man.

So, this is our last meeting, Douglas. I've been thinking about our exchanges over the last few times, and I think there are some things that you've not been telling me.

Maybe what we need to do is to talk about a particular work of yours in more detail; how you came to an idea, how the idea progressed, and how the work was made, and so on. Maybe we need to discuss it like the 'a to z' of an artwork.

Which work do you want me to talk about?

Well, what about the piece that many people saw in Münster?
[86] **Let's talk about it from the very beginning. How did it come about? Was it a pure response to the situation, or did the idea come first, or what?**

86 See page 166-171, 176.

I think it was probably a bit of one, and a bit of the other. But not a 'pure' response, or a 'pure' idea.

Maybe I should describe the whole situation, although some elements may not seem relevant, but they go together, in providing a backdrop, or a context for the evolution of the work.

My first visit to Münster was quite an unexpected visit. The organizers contacted me while I was in Rome making an exhibition, and asked me to come directly to Münster after the opening in Italy. So I flew to Düsseldorf, met the Münster team, and we drove together, to the city. I hadn't had any time to prepare anything, or to do any research with a view to making work, but during that trip we had already begun to discuss the possibility of showing the *5 Year Drive-By* project that I am trying to make – and still trying to make. [87] With this work in mind, we started looking specifically for car park spaces that might be available to use for a big projection, you know – garage spaces, underground, multi-story spaces and so on. It turned out to be

87 *5 Year Drive-By* was initially presented at the *3me Biennale d'art contemporain de Lyon*, 1995, as 'Proposal for a public artwork; reconstituting John Ford's "The Searchers" '. In this work, Gordon has proposed to slow down the John Ford original film from approximately two hours to five years. The work *5 Year Drive-By* was also presented as a large-scale proposal, *Overnight #1*, at Kunstverein Hannover in 1997. See page 136-139.

one of the most miserable days imaginable. It was absolutely pissing down in Münster. And I mean for 24 hours. The only shelter that we got while walking around was to go into these car parks which were, of course, totally choked with exhaust fumes and pollution and so it became clear pretty quickly that we weren't going to find an appropriate place for that film project in Münster. I was quite depressed about the situation and then, by chance we were driving along a road and Kasper König said: 'Oh, maybe you'd like to see the underground space which Joseph Beuys tried to work in. That might be interesting.'

So we went into this space, which is a pedestrian underpass, and as soon as I went in I realized... it was stinking, with urine and shit in the corners, litter everywhere and graffiti all over the walls, and god knows what else all over the place...
So, I thought, yes! This is probably the worst possible space for any art work that you could have in this city – no-one else will want it so it's perfect for me. And I liked the fact that it already had a history with the Münster sculpture project with old Joseph, and whatever...

You were aware of that Joseph Beuys' piece? [88]

Yes, very much. I mean we've spoken a little about Beuys before now – in our first conversation, I think. I was, and still feel, very connected with his work. So, when I was thinking about this specific story in relation to what I might do, I was very aware of the fact that he had not succeeded, entirely, in what he had wanted to do in the underpass. So, in some sense my project for Münster had a kind of competitive element to it – but this was a very private issue, of course. Where Beuys failed to occupy the whole space, for technical reasons, I thought it might be interesting for me to try to take on the whole space in a way that he couldn't... to occupy the whole space in a non-physical way.

So these are some elements that sparked off the idea.

You mention Beuys' failure. This was something you wanted to avoid, it seems. But what do you mean by a 'failure'?

I'm only talking about a physical failure. I'm not even sure what is the true story of what went on with Beuys in Münster, but this is the story I heard: I think Beuys' original proposal was to fill the whole underpass with fat, or tallow, but he couldn't physically do it. So that was why he ended up making the smaller pieces – in the gap between the underpass and the road overhead. So, in my view, the failure was not conceptual but physical, because the material he wanted to use couldn't do the job. But because of this story and the actual size of the space,

88 In 1977 Joseph Beuys was invited to participate in the first Münster sculpture exhibition organised by Kasper König and Klaus Bussmann. Beuys chose the underpass – a soulless, brutal piece of urban architecture. In it he cast the 'dead angle' of the underpass in tallow (the work was finally titled *Tallow*), cut the mould into five pieces and eventually displayed them in the courtyard of the museum. At that time, many of Beuys' works were concerned with healing and, in *Süddeutsche Zeitung*, Laszlo Gloser argued that Beuys had chosen the site because he saw it as a wound or a fissure in the fabric of society which revealed an underlying malaise.

I thought that a physical occupation would be uninteresting, whereas a psychological game might be played out to some better effect.

That was my first visit to the underpass in Münster.

Then, I went back to Glasgow to work on various ideas in response to these experiences and to try and allow the space to 'inspire' some kind of idea.

But I had some real problems around this time. I mean, anytime I described the space that I wanted to use in Münster, then people would say, 'Ahh, yes, the old Beuys' space.' It was almost like the ghost of Joseph Beuys was so present that it couldn't allow the space to be used at all.

After some time of knocking my head against a wall, I tried to relax a little, and just get on with whatever I wanted. I stopped focusing on the situation in Münster, which pissed off the organizers of the project, but just kept trying to work 'as usual' to see whether anything might come up.

So, if we keep the story going, then we have to interrupt a little and go backwards for another two years. This is back to where the work was 'born', so to speak.

It's now 1995 and I was involved in a project in Paris at the Centre Pompidou – this was during the time of the big winter strike, in December.

I had gone to Paris expecting to have three or four weeks of hard work and a lot of fun, of course. But it was a total nightmare. One disaster after another. There was no public transport – no buses, no metro, no taxis. No way to move around the city at all. And it was bloody freezing weather, 15° below zero, it was windy, it was cloudy, the streets were full of smog. I ended up staying in an apartment with no TV, no phone, no clock, no nothing. The only entertainment I had were some books that I had taken with me – the short stories of Edgar Allen Poe,
J.D. Salinger's *Catcher in the Rye*, and for some light relief on a night out I went to see Larry Clark's *Kids*, which was playing at a local cinema.

What a laugh, right? I don't think so.

I was pretty near suicidal by the end of that trip. So, after ten days of misery, and on the day that I was supposed to have my opening at the Pompidou, the director decided he would close the building because of the strike. I couldn't believe it. After all this rubbish, I didn't even get to have a party!

So what's the point of this story?

I'm getting to it. I'm getting to it.

So, the director closed up the shop on that day, which meant I couldn't have an opening. But Christine van Assche, the curator, tried to organize a party somewhere else, just to make some kind of announcement that I had been working there – or to stop me taking a swing at her director, or whatever. But then Christine asked me if I could make something 'special' for the party – like an installation of some sort. So, there was a little bit of money to hire projection equipment and whatever and I decided maybe I would try to experiment with an idea that had been at the back of my mind for some time. So I got some cash and I went shopping. I wanted to buy videotapes of films which I had been thinking about – films which told stories about good and evil. Originally, I was thinking about *The Exorcist* and a film about Jesus called *King of Kings*. I had even seen both films in a department store, about two days before, but when I went back to buy them for the party, I couldn't find the *King of Kings* anywhere. So I ran around some other shops, trying to find it, but it was impossible. I thought that this was the inevitable final chapter of my tragic stay in Paris. Then, just by accident, I was looking through the religious section of another video store and I saw a tape called *The Song of Bernadette*. I had never heard of this film before. So, I took it off the shelf and read the blurb on the back cover – telling the story of Bernadette Soubirous. I had

89 *The Exorcist* (1973) documents the possession of a young girl on the threshold of puberty and the attempts to exorcise her of the devil by two Catholic priests driven to doubt their own faith in God. In a recent book on the making of the film, Mark Kermode points out that the film appeared shortly after a controversial address by Pope Paul VI on 15 November 1972, in which he stated that 'Evil is not merely a lack of something, but an effective agent, a living spiritual being, perverted and perverting. A terrible reality (...). So we know that this dark and disturbing spirit really exists and that he still acts with treacherous cunning; he is the secret enemy that sows errors and misfortunes in human history. The question of the Devil, and the influence he can exert on individual persons as well as communities (...) is a very important chapter of Catholic doctrine which is given little attention today, though it should be studied again.' The film's release provoked an unprecedented outcry in America with reports of members of the audience being driven to hysteria and suicide. The evangelist Billy Graham claimed there was an evil in the actual celluloid of the film. William Friedkin, director of *The Exorcist*, fuelled the controversy by announcing that there seemed to be a curse on the film crew during the shoot and that the sounds of a real exorcism of a young boy, performed in the Vatican, had been mixed into the soundtrack. While the film is now regarded as a classic, the controversy surrounding it has never totally died away and in Britain it has never been granted a video release.

90 *Between Darkness and Light (After William Blake)*, 1997, see also page 166-171.

never even heard this story before. I couldn't believe it. I was standing in this shop in the middle of Paris with a copy of *The Exorcist* in my left hand and *The Song of Bernadette* in my right hand. And it looked to me like they were both the same – they were both the same old story. [89, 90]

So you had never heard of this film before? You had never even heard the story of Bernadette?

No! It was really like a miracle. Or pure chance, or whatever.

You're really telling me that you had never heard about the miracle at Lourdes?

No, honestly. I never knew. I don't know anything about that aspect of Catholicism. I mean, I knew about Lourdes as a place where lots of Catholic pilgrims would go, for some reason or other, but I never knew why, exactly, and I had never heard of Bernadette Soubirous. I wasn't even sure of where Lourdes was on a map. [91]

So, what happened then?

What happened? I have no idea what happened. If you grow up in the culture that I come from, especially in the West of Scotland, if you're not Catholic then no one allows you to know the story of Lourdes and all the other stuff. [92] So this was a real revelation to me. There I was, pissed off, in the Bastille, with these two videotapes. Brilliant. The same old story – a young, pretty girl, pubescent, having a bit of a 'difficult' time at home, one possessed by evil, one overwhelmed by good.

All this is thanks to the French unions who went on strike!

Yeah, *vive la révolution!* Up the workers!

So in the end I played around with the tapes at the party, in a café, and then never thought much more about it. It wasn't a serious thing at all, so when I say I played around with the tapes, I really mean that I was just messing around with material in the way that anyone might in that situation. Then, I went back to Glasgow, left the tapes behind in Paris, and forgot about it.

And so how did it come to be in Münster?

Well, as I told you I was really struggling with the project because I kept stumbling over the Joseph Beuys historical issue. I was almost at the point where I thought I would have to find another space in the town, or simply quit the project altogether.

At last I forced myself to stop thinking about Beuys, and start thinking about what the space could mean in metaphorical terms. If it wasn't an underpass then what else could it be? And I imagined that it might be seen as a conduit between one part of the city and another. So then it could be a conduit between one representation of the city and another – and the underpass literally directs you from the castle to the university and the church.

From castle to cathedral... the earthly power and the divine.

91 *The Song of Bernadette* (1943) is a film based on a Franz Werfel novel recounting the life of Saint Bernadette of Lourdes. Bernadette, a French peasant girl, claimed to have eighteen visions of the Virgin Mary at a small grotto just outside the town of Lourdes at the foot of the Pyrenees in 1858. Two years later, at the age of twenty, she became a nun. In 1933, the Catholic Church declared her to be a saint and the grotto where she experienced her visions is now a shrine and major pilgrimage centre and tourist site. Many visitors to the shrine claimed to have been miraculously cured of severe illness.

92 The Catholic population of Scotland has always remained guarded to a degree, perhaps because of the severity of the Reformation in Scotland and also because of the stigma attached to Irish (and Catholic) immigrants flooding into Scotland in the nineteenth century. While the Catholic population is now well integrated into the mainstream of Scottish life, the Catholic Church retains a separate education system, an issue which occasionally stimulates political friction.

So I thought about it more. I tried to evolve this idea that the underpass was a conduit. It was neither in the city nor out of it. It was present in the minds of the people in the city but it wasn't visible. It wasn't visible but it hadn't disappeared. It was literally and metaphorically an 'in-between' state.

And scary too. Because it was a typical kind of place where you might get mugged at night.

Yes. And I was interested in that kind of contradiction in urban architecture, that places built for safety can become the most dangerous sites in the city. A paradox between the function and the reality. But at the same time, I had been evolving these ideas of what the underpass could be because I was reading a little about the history of Münster. [93] And when you're living in Münster, or spending some time there, you really don't need to read about the history so much because it's still alive. The city that you walk around in doesn't seem so different from the one that you read about in the guidebooks. I've never seen so many nuns and priests, anywhere, in my experience. This was the most intense concentration of religious power probably, outside of the Vatican. Or so it seemed to me. Even the hotels had crucifixes on the walls above your bed. My God! I tried to take my crucifix off the wall while I was living in one hotel – but it was impossible. It had been made with rounded edges so that you couldn't even get a grip on the thing in order to try and prise it off the wall!

Anyway, the fact that the whole area is so Catholic meant that I could probably work with certain religious mythologies and beliefs... At least in this situation it seemed like people would be able to understand what I might try to do. Now, bear in mind my idea of the underpass as an in-between place, or state of mind, and then think about what this would mean under some kind of religious ideology – at least a Catholic belief system.

I started to think about the underpass as some sort of purgatory, an *espace de purgatoire*. It's neither in the city nor out of it. It is neither in heaven nor in hell. I began to think that it might be interesting to try and stop people passing through it as quickly as they might have done normally. If I could find a way to make people hang around there for some time, then it would become a space for thinking, reflecting, and waiting to see what might happen next.

It was like a perfect model of purgatory. [94]

So, what did happen next?

93 Münster is a town of many legends and stories, often linked to the political and religious struggle in the region of Westphalia throughout the centuries. Especially interesting in relation to Gordon's work is the fact that Münster was taken over and ruled by the Anabaptists in 1534: 'the movement originated in the ferment of religious and social distress of that same century which had already produced the Reformation and the Peasant's War. It (...) rejected the whole spiritual and secular order as the work of the devil and turned its efforts to establishing the "true kingdom of the Father" (...). The "golden city of Münster" was singled out to be the capital of the Kingdom of Justice. And so Anabaptists from Westphalia, Holland and Friesia came to Münster (...) and announced that all the ungodly who refused to be baptised anew, had to be driven from the town or slain. Baptism, death or expulsion!' Joseph Bergenthal, *Münster; Curiosities and Treasures*, (1995). The author goes on to state that the Anabaptists were amongst the first of the sects who claimed complete atonement from all sins, past and future, once they had been 'born again' through a new baptism. Their Kingdom did not last long – less than two years – before they were expelled by Prince Bishop Franz von Waldeck who tortured the leaders and hung their bodies to rot in cages on the tower of the Church of St. Lambert. This relates directly to another of Gordon's well-documented preoccupations, the novel *The Private Memoirs and Confessions of a Justified Sinner* (1824), by James Hogg, where the hero/victim is a member of a religious family whose beliefs are alleged to have grown out of those held by the Anabaptists of Münster: 'that no sin can affect the salvation of an elect person'.

94 In Christian belief, the souls of the dead are divided between Heaven, Hell and Purgatory. The iconography of Heaven and Hell is based on descriptions taken from the *Book of Revelations* while the concept of Purgatory was of a state in which souls are purified after death to make them fit for heaven. This concept was adopted by the Catholic Church in the sixth century and was rejected by Protestants during the reformation, who held that souls either go directly to Heaven or Hell or sleep until the Last Judgement. The most famous exposition of the three states beyond death is Dante Alighieri's *The Divine Comedy* in which various spirits guide the author towards salvation.

Well, I just kept thinking. And somehow I remembered this event that had happened in Paris years before. I remembered the experiment with the two films, and I just thought, right! This is the most appropriate work that I could make for that space at that time.

But you're starting to talk about 'a work' already – and that implies a form. Surely, at this point in your story the work still has no form, therefore it's still an idea. So, the idea is that this material is the best possible way to move forward at this time?

Yes, and once I had decided to pursue the idea of using the material then I had to start thinking about the form, how people might approach the work, where I could install a screen, and so on. I mean, the form of the work – certainly in my case – is rarely spoken about, or rarely discussed. And this is strange for me, because the form and the context in which the work is seen are very important in establishing a relationship by which the viewer can start thinking about what they are experiencing. Once the idea moves out of your head and into your hands, things start to change. A lot.

But even before you start thinking about screens and what not, you have the form of the space – a public space – to deal with. There is already a question about public sculpture, which is a very complex issue, as you know, but then to have an idea to put a movie into a place like that seems really crazy to me.

It didn't feel so crazy to me. I was well aware that this was a public space, and that it would have problems, and so on, but I tried to treat it in pretty much the same way that I would treat a gallery space, or a museum space. This is not to say that I'm contradicting what we spoke about earlier – that there are some ideas more appropriate to the street as opposed to the museum, or vice versa. It's not a contradiction – it's just that I try to have the same attitude in approaching these different kinds of spaces – whether that be a white cube, or a stinking underpass. I think when we talked before, I mentioned that if I am using text or a slowed down film, or whatever, in a museum, I like to think that it will be read as outside of 'the academy' and outside of 'the bedroom'. I've always liked this idea that one could conflate these two contextual extremes in a museum or in a gallery – and I felt as if I could do this also in the underpass. It's an in-between space. It's public but it's hidden – so it can be private, in a way. So the films are not being seen in the cinema and they are not being seen purely publicly either because you have got to make a decision to go down some steps and enter into the underpass. It's not so public, after all.

It's not 'in your face', that interests me, it's 'inside your head'.

Okay. But now, what about the actual format it took. Because that is another very crazy step – to mix two movies together in such a way. Did this happen by accident or was it deliberate? Did you think of the effect it might have?

In a way, I suppose.

I think I was just reflecting on how one synthesizes and then separates details from one moment to the next. I was just lying in bed one night thinking about what had happened during the day and trying to make some sense of all the things that I'd heard, all the things that I'd seen, all the people that I'd spoken to in that day, and realizing that usually when one is on the telephone having a conversation, or an argument, you're also typing on your computer or watching the TV and listening to some music, and trying to eat and drink, and think about what to do later that evening, or tomorrow, or next week, and so on. I was fascinated by how this mess of information and experience can be synthesized into something else. And when you try and decipher it at the end of the day or at the end of the week, then maybe the images you saw on TV have been read in relation to the records that you were listening to, which have been heard in relation to the conversation you had, etc. But I thought that maybe this was too much material to present as an art idea so if I simplified it by only allowing two things to mix together, then maybe this would get me to the point where you can make sense of even the most chaotic images or pictures which formally and aesthetically are battling with each other. And if you can make sense of it, then it becomes a beautiful metaphor for what is happening in the films themselves. While one film is representing good and one film is representing evil, the fact is that they can coexist quite easily together – on a physical and conceptual level.

I suppose it might make some sense, here, to say what actually happened.

I think it's about time to...

Well, I simply played the two films at the same time, together, and on the same picture plane. They were not manipulated in any sense – there was no alteration to the speed, or the sound, or the form. They just inhabited the same picture plane, which was a transparent screen in the middle of the underpass, and were played and rewound and played again and rewound and so on and so on.

And on an aesthetic level?

For me the point was that they would co-exist in terms of meaning. In the beginning the aesthetic wasn't very important for me, but when I actually installed the works...

Did you test it in the studio?

No.

You thought it had the potential to do something and then just went for it?

Yes. There was no rehearsal, no dummy-run, or anything like that. And actually what happened during the installation began to disturb me because I started to see incredible images and sounds mixing with one another – spilling from one film onto the other, as it were. It was almost as if the whole thing had been choreographed to be seen as a conspiracy of sound and image in direct relation to one another, between one film and the other, which was absolutely not in the script. Absolutely unexpected.

So you sensed the potential, from a conceptual point of view. But aesthetically you're counting on pure luck, in a way. It really becomes chaos without intention.

I just started with a very strong conviction that if you put almost any two films together, most people would try and make some sense of whatever it was that they were looking at or listening to. I was trying to play with the idea that we can make sense of things, even non-things, or non-sense, like Alfred Jarry or Dadaist poetry, or whatever.

A persons' desire is to try and make sense of things.

But for me, as a visitor to the space, to try and discover the relationship between the aesthetics and the meaning, you are asking a lot. I went into a very dark space, which had a strange atmosphere, as you described, and at first... nobody was with me, no-one told me anything. I had not one clue as to what was happening. I had no idea which two films were being shown. I didn't even understand the space. It was like two different projections from two sides on one screen. Then one couldn't see shapes or people walking behind you. It was very disorienting. Only after a while, once my eyes were used to the darkness and the flickering of the projector, I noticed that one could actually walk through the space.

So through all this confusion one immediately tries to make sense of things, tries to get a grip on what's going on, and for me that meant looking at aesthetics. The first thing one analyses is what kind of aesthetics I am looking at.

Because when you are disoriented, most people use sight as the primary sense in order to find out where they are, and what's happening around them. [95]

It took me a while. I mean for somebody of my generation, my first thought, based on the aesthetic, was that you had made – newly made – a kind of hippie, fluid happening from the sixties or some kind of disco, or something like that. And the next step, if I remember well, was in trying to get a grip on the construction of the space. I suddenly became aware that there might be a second projection at the back. I realized that I was actually looking at two separate things being shown together. But then I still didn't know which movies you were using, if indeed they were movies – by you, or by someone else. Eventually, after spending more time in the place I recognized pieces from *The Exorcist*. And that's where the process of making sense really started for me, because then I could sort of glean a meaning from your choice of *The Exorcist* and from there on derive what the opposite might be, what the other film might be. But this is a long process – and I mean 'long' in terms of time spent on an artwork.

Yes, but there are two ways to look at it. Either I'm asking people to give it time, or I'm giving people time out from something else instead. It depends upon how you want to look at it. But what the time allows, or demands, is that the process of 'discovery' or making sense, or making meaning, is left open for the individual. The reason to leave it so open is because I like the idea that if people put one step in front of the other to make meanings then they might end up going in completely the wrong direction from what I could have thought they would. There's nothing wrong with that. It's just a different way of reading. However, some people were complaining to me that they couldn't understand the story anymore, from the original movies. Well, why do you have to understand the story? Why not make a new one? Every five minutes you are getting such a bizarre combination of images and sounds that it's easy to just let another narrative evolve by itself anyway.

And so what's the new meaning being generated?

The work functions as a mechanism to show that there is no new meaning. Or that all interpretations are new meanings. Or that each meaning, new and old, is as valid as the other.

95 In *The Vision Machine* (1994) Paul Virilio describes the act of seeing in this way: 'There is no such thing as "fixed sight", (...) the physiology of sight depends on the eye's movements, which are simultaneously incessant and unconscious (motility) and constant and conscious (mobility) (...) the most instinctive, least-controlled glance is first a sort of circling of the property, a complete scanning of the visual field that ends in the eye's choice of an object.'

The other way in which the work could be interpreted is a much more moral or ethical illustration about the existence of good and evil. Are they, like the question of narrative meaning or reading, just as valid as one another? Do they exist separately or are they dependent on one another?

Well?

Actually I wouldn't want to give away too much of where I stand in relation to these questions.

Why?

People wouldn't be able to 'use' the work for themselves anymore. People wouldn't be able to use it for conversation or questions if I said 'this is my view, and I'm using the artwork, or the artworld, in order to propagate my view', it's boring. It's boring for me, and it's boring for everyone else to see art like that. And so I also don't want to say whether the work is a model for interpretation, or an illustration of a belief, or a mechanical exercise in deconstructing narrative, or whatever.

Hmmm.

I think there is something strange in this way that you talk about your work. We've been talking now for about two years, and I've been thinking about what elements or attitudes that might be seen as 'characteristic' to your practice. It's not so easy to find any one thing, partly because the area of activity is so broad – we've talked about film, video, text, audio, and then all these other things that are even more difficult to classify – so it's not easy to try and find a characteristic that will cover the area without reducing the practice in any way.

Well, I suppose...

No, please, let me finish this.

After two years of talking and thinking I see that you put art in the world without a fixed meaning or a fixed format or even a fixed status. And you always talk about this in terms of freedom – or space – for the viewer or reader or listener to be able to make up their own minds. And we also spoke about your attitudes to the institution of the museum. I remember in that conversation you couldn't believe we were spending time talking about the museum situation, but it was important to reveal the way you think about your own work and the context that most of it seems to be appearing in. You used terms that were very social, even socialist, in your comments about the museum.

This is all very idealistic and laudable. But you also talk about 'specifics' all of the time – this is the dialectic that you have with yourself. This is how the work is made – in relation to specific shows, specific invitations and specific conditions. There is even a slightly competitive edge to the way in which you approach ideas and contexts. So, one attitude is at odds with the other.

But in the end you seem to suggest that neither you, nor the viewer controls the work, but the context.

Maybe.

I like the idea that circumstances can conspire *for* an artwork. This means that they can also conspire *against* an artwork. Meaning can be made interesting or banal, depending on what surrounds the work. And that is the risk. So, for now in Münster the circumstances were right to conspire positively for the work but there is no doubt that in another time and another place then the opposite could happen.

There is also the point that if a work is discreet, then the residual effect can be powerful. I believe that there is a residual effect from the presence of a work even when the work is thrown away. I can imagine that people, certainly within the next five or ten years, will walk through this underpass in Münster and remember that something strange or special happened here.

So you agree that this is a general characteristic of the work?

I think so. Although I'm getting a bit lost in the details here.

Good. Okay, then. I have two final questions. The first is about your paintings. They don't fit this characteristic; they are made, they have a fixed aesthetic, they are put out in the world and are left on their own.

I never thought of them like that...

You don't have to answer, you know, we can leave this issue out of the book. You don't have to talk about this...

No, it's okay.

I think you're hesitating with this question because you're hesitating about the position of the paintings in the 'whole' of the work so far. [96, 97, 98]

Well..., no...

96 *Painting No 73 Carl Andre (series)*, 1991.

97 *Painting No 106 Christo (series)*, 1991.

The hesitation isn't anything other than an indication that leads to my second question. And this brings us back to the title of the book, *Kidnapping*. I think you're afraid to be kidnapped by your own work.

Well, yes, I don't want to be fixed. I don't want to be taken hostage by the work. This is true.

Doesn't this make you a control freak?

(laughs)

It's a serious question.

I know! I know it's serious. But I don't know... I mean, I don't know if I am or not. The whole thing is about allowing...

I think I know what it is. Let me try to explain it.

The paintings have a fixed aesthetic. They are objects in the world, they can be dated, and they have 'authority' in so far as *you* made them. Now, what happens with these works? They are bought from you, taken from you, and you lose control of the conditions in which they are seen. They are bought by museums and collectors and they are 'kidnapped' by the audience and by art history. I think this is why you are hesitating in answering my question.

I don't know.

It's not a question in relation to quality of work, or quality of ideas. Far from it, in fact. I think the paintings are very important, because they occupy a special position in your practice. But in relation to your other works, it's very interesting. I mean, you are an artist who will spend an extraordinary amount of time thinking about, responding to, modifying and creating conditions under which the other works can exist or not. This means that if the circumstances change, or don't suit you, then you can 'claim' the work back for yourself again. Not only are you kidnapping, in the historical sense of the ready-made, but you're also re-claiming your own work and ideas.

Uhhh, I don't know what you mean. I think maybe...

I began to think about this issue because you are always mentioning *opposites* and you have a very dialectic way of thinking and talking. So, I listen to the main subject that you talk about and reverse it. You talk about self-determination and

98 *Painting No 74 Carl Andre (series)*, 1991.

and providing a context that gives freedom to the viewer. So let's reverse your arguments, or attitudes. Let's say that you don't respond to the context and that you don't allow the circumstances to conspire. Let's say that you actually determine the context and that you influence the circumstances. Let's imagine that the freedom you suggest for the reader is something that actually doesn't deny authorship, but protects it for you. You can deny the traditional position of the author, and it's authority, but you are still an artist. You are still the one who has the power to put work, or ideas, from the studio, or bedroom, into the world. And by denying authority then you never really let go in such a way that you always can get the work, the idea, back for yourself. You remain in control.

In a way, yes, but... I mean my...

Which brings us way back to one of the first conversations we ever had, way before this book was even conceived. We argued about the institution of the museum in relation to the artwork, and I insisted on art being institutionalized because the institution can take art away from you and put it in the world – without your control.

This then brings us back to the old conceptual generation, the first conceptual generation, and the attitude to attack the institution, or to deny the institution. We're back where we started. But now from a more interesting point of view, through the work. It seems to me that you are not so much about freedom and openess as you might think. It seems much more about control.

I feel as though I have just been found out.

You have. That is why I wanted to make the book! You're a control freak.

I thought I had disguised it heavily enough, but...

But then the next, final question is: Do you actually want to share the work with the audience?

You know... Maybe, but this is like an absolute reversal of... I can't remember any of my smart answers right now. I mean of course I would argue that I am not a control freak... I can't argue from the position that you've just come from..., at least I can't argue that I am not a control freak because...

Well...? Maybe we should stop the book here?

This is a most beautiful end to a book. Maybe we should leave it here, with an unanswered question: Do you actually want to share the work with the audience?

But I feel...

We are back at the beginning. At the beginning you had all the answers and now you don't have any answers. And that is the perfect loop. It can all begin again.

I feel like I've just been discovered, or unmasked, or something.

So, then we should stop and leave it open... It's an open end. And we are back at the first stage of our conversation two years ago where we tried to suss each other out.

Like cops and robbers.

Now we have explained all the work and it's still not clear. There's no further explanation.

That's a good way to end it.
Let's talk about films or something, so I can feel a bit better.
Have you seen *Heat*, with Robert DeNiro and Al Pacino?

I think this is the end, Douglas.

A telephone rings. The older man stands up and walks across the room to answer the call. The younger man sits still, not talking, not moving, but thinking. The older man has a long conversation on the telephone. The younger man continues thinking, not moving, not talking, sitting still. But the dialogue has been interrupted, maybe for ever.

fade to black...

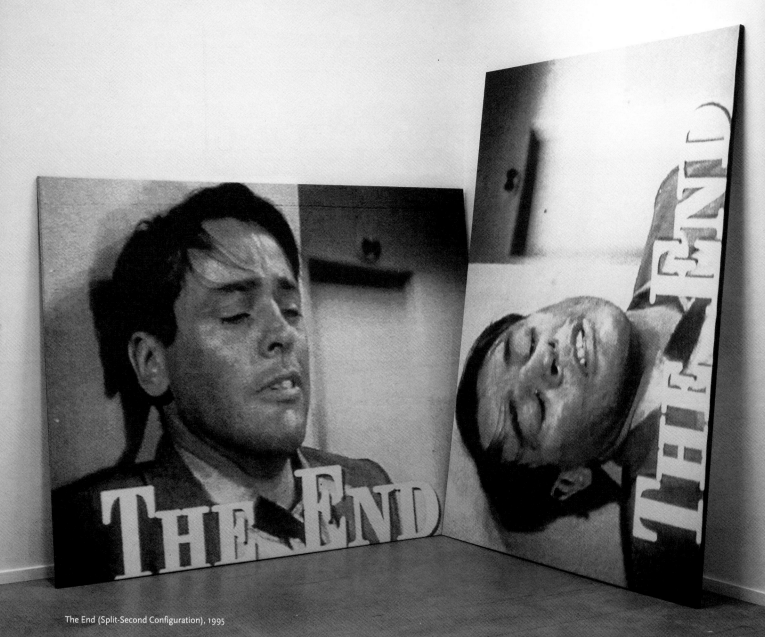

The End (Split-Second Configuration), 1995

list of works

Foot (Left and Right)); Van Loon collection, Amsterdam (Hand and Foot (Left)); Stedelijk Museum, Amsterdam (Hand and Foot (Right))

Remote Viewing, 13.05.94 (Horror Movie), 1995
video installation (colour), single screen (300 x 400 cm), radio, red walls
duration 00.13.28.00 loop
collection Stedelijk Museum, Amsterdam
exhibition view *Wild Walls*, Stedelijk Museum, Amsterdam, 1995

Predictable Incidents in Unfamiliar Surroundings (Party Pack Edition), 1992/1995
video installation (colour), videoprojector, player, VHS tape, beer, mastered on VHS from television broadcast
dimensions variable
duration variable
edition 5
exhibition view *Chez l'un, CHEZ L'AUTRE (1 and 2)*, Galerie Anton Weller, Paris, 1995

5 Year Drive-By, 1995
video installation (colour), wall projection (dimensions variable), image generated from commercially available VHS-copy
duration 5 years
exhibition view *Over Night #1*, Hannover Kunstverein, 1997

...an apology as a short story/a short story as an apology, 1995
letter sent to curator at Biennale de Lyon, from the artist, by way of an apology for a late project proposal
originally published in exhibition catalogue *3e Biennale d'art contemporain de Lyon: installation, cinéma, vidéo, informatique*, Lyon, 1995

Empire, 1998
neon sign, mirrored steel
dimensions 500 x 50 cm
installed in Brunswick Street, Glasgow
commissioned by Visual Arts Projects for the Merchant City Civic Society, Glasgow

A Souvenir of Non-Existence, 1993
framed letter, envelope and b/w photograph
64 x 120 cm
private collection, Zürich

Dead Line in Space, 1997
b/w photographic documentation
exhibition view Villa Minimo, Hannover, 1997

Trust Me, 1993
photographic documentation
exhibition view *Walter Benjamin's Briefcase*, Porto, 1993

From God to Nothing, 1996
wall text and 3 lightbulbs at head height, heart height, genital height
typeface Bembo
dimensions variable
collection FRAC Languedoc-Roussillon, Montpellier
exhibition view *Légende de CRAC*, Sète, 1998

Black and White (Babylon), 1996
video installation (b/w), 2 screens (dimensions variable), mastered on Betacam SP from 16 mm original
duration 00.47.29.00 loop (left); 00.47.26.18 loop (right)
edition 2
private collection, New York; collection L. Declerck, Belgium
exhibition view Galerie Micheline Szwajcer, Antwerpen, 1997

Bootleg (Stoned), 1996
video installation (b/w), 2 screens (300 x 400 cm each), mastered on Betacam SP from VHS copy from 16 mm original
duration 00.30.00.00 loop
edition 2
Museum für Gegenwartskunst, Zürich; private collection, Antwerpen
exhibition view *Close your eyes*, Museum für Gegenwartskunst, Zürich, 1996

Bootleg (Bigmouth), 1996
video installation (colour), wall projection (dimensions variable), mastered on Betacam SP from VHS copy from VHS original
duration 00.19.44.23 loop
edition 2
collection Museum für Gegenwartskunst, Zürich
exhibition view *Close your eyes*, Museum für Gegenwartskunst, Zürich, 1996

Bootleg (Cramped), 1995
video installation (colour), wall projection (dimensions variable), mastered on Betacam SP from VHS copy from VHS original
duration 00.48.21.09 loop
edition 2
collection Museum für Gegenwartskunst, Zürich; private collection, New York
exhibition view *Close your eyes*, Museum für Gegenwartskunst, Zürich, 1996

A Divided Self I and II, 1996
video installation (colour), monitor, mastered on Betacam SP from S-VHS original
duration 00.14.00.00 loop (I); 00.15.00.19 loop (II)
edition 2 of each
collection Fondazione Re Rebaudengo-Sandretto, Torino (A Divided Self I and II);

private collection, London (A Divided Self I); private collection, New York (A Divided Self II)

Letter 1, 1991
typeface Bembo and Courier

Between Darkness and Light (After William Blake), 1997
video installation (b/w and colour), single screen (dimensions variable), double image projection, images generated from commercially available VHS copies
both films in endless repetition
exhibition view *Skulptur Projekte*, Münster, 1997

Painting No 73 Carl Andre (series), 1991
black enamel on gloss 18c39 on canvas
166 x 100 cm
private collection, New York

Painting No 106 Christo (series), 1991
black enamel on acrylic bs 14c39 on canvas
100 x 166 cm
private collection, Chicago

Painting No 74 Carl Andre (series), 1991
black enamel on acrylic 18c35 on canvas
166 x 100 cm
private collection, London

The End (Split-Second Configuration), 1995
scannerchrome on canvas
180 x 240 x 3 cm and 240 x 180 x 3 cm
collection Stedelijk Van Abbemuseum, Eindhoven

Selfportrait as Kurt Cobain, as Andy Warhol, as Myra Hindley, as Marilyn Monroe, 1996
c-print
passport photo size
edition 11

Psycho Hitchhiker, 1993
b/w photograph
46 x 59,5 cm
edition 10

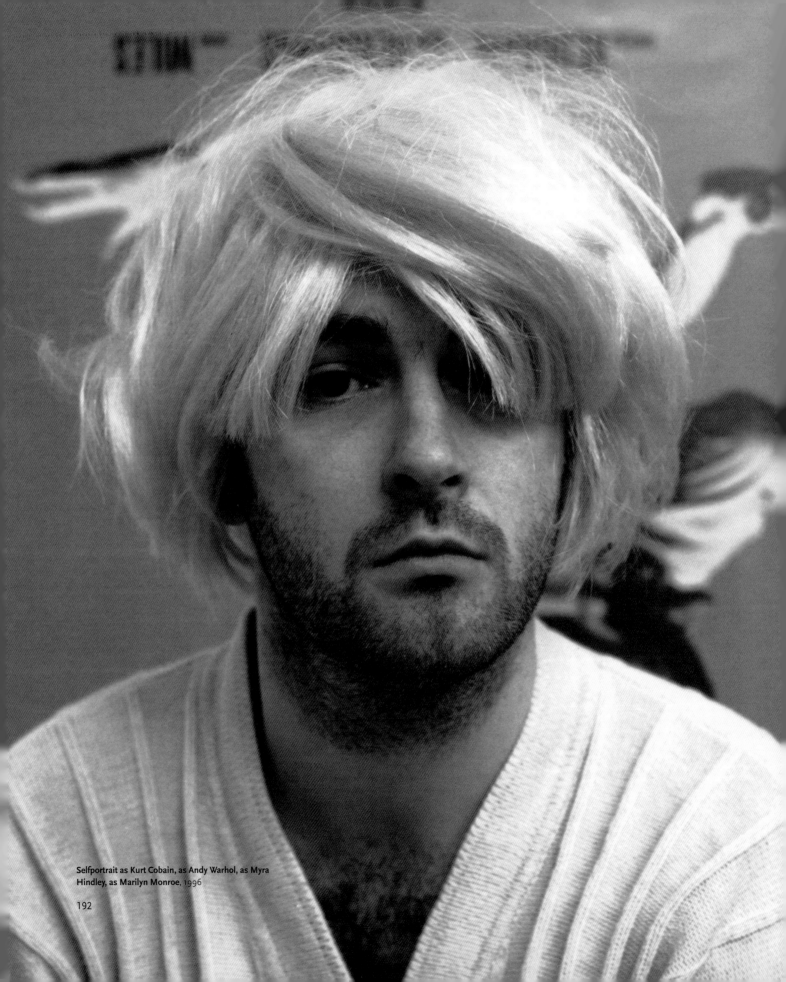

Selfportrait as Kurt Cobain, as Andy Warhol, as Myra Hindley, as Marilyn Monroe, 1996

biography

Douglas Gordon

1966
Born in Glasgow
Lives and works in Glasgow, and...

Education

1984-1988
Glasgow School of Art, Glasgow

1988-1990
The Slade School of Art, London

Prizes and awards

1996
Turner Prize, London, GB
Kunstpreis Niedersachsen, Kunstverein
Hannover, Hannover, D

1997
Premio 2000, Biennale di Venezia, Venezia, I
Daad-Stipendium, Berlin, D

1998
Central Kunstpreis, Kölnischer Kunstverein,
Köln, D
Lord Provost's Award, Glasgow City Council,
Glasgow, GB
Hugo Boss Prize 1998, Guggenheim Museum
SoHo, New York, USA

Solo exhibitions

1987
Transmission Gallery, Glasgow, GB.
In collaboration with Craig Richardson

1991
London Road..., Orpheus Gallery, Belfast, IRL.
In collaboration with Roderick Buchanan

1993
24 Hour Psycho, Tramway, Glasgow, GB;
Kunstwerke, Berlin, D, (Cat)
Migrateur, ARC Musée d'Art Moderne de la
Ville de Paris, Paris, F (Cat)

1994
Lisson Gallery, London, GB

1995
Bad Faith, Künstlerhaus Stuttgart, Stuttgart, D
The End, Jack Tilton Gallery, New York, USA
Jukebox, The Agency, London, GB. In
collaboration with Graham Gussin
Entr'Acte 3, Douglas Gordon, Stedelijk Van
Abbemuseum, Eindhoven, NL (Cat)
Fuzzy Logic, Espace Publique, Sous Sol, Centre

Georges Pompidou, Paris, F (Poster)
Rooseum Espresso, Malmö, S

1996
Douglas Gordon & Rirkrit Tiravanija, FRAC
Languedoc-Roussillon, Montpellier, F
Close your eyes, Museum für Gegenwartskunst,
Zürich, CH (Cat)
Galerie Walcheturm, Zürich, CH
Galleria Bonomo, Roma, I

1997
Bloom Gallery, Amsterdam, NL
Galleri Nicolai Wallner, København, DK
Galerie Micheline Szwajcer, Antwerpen, B
Galerie Mot & Van den Boogaard, Bruxelles, B
Gandy Gallery, Praha, CZ
Over Night #1, Kunstverein Hannover,
Hannover, D
Côté Rue, Galerie Yvon Lambert, Paris, F
Leben nach dem Leben nach dem Leben...
in *Art & Brain II*, Deutsches Museum Bonn
im Wissenschaftszentrum, Bonn, D

1998
Kunstverein Hannover, Hannover, D

Selected group exhibitions

1987
AVE Festival, Arnhem, NL. In collaboration
with Craig Richardson
National Review of Live Art, Riverside Studios,
London. In collaboration with Craig
Richardson and Evan Sutherland

1989
Smith Biennial, Stirling, Scotland, GB
Windfall '89, Bremen, D (Cat)

1990
Sites/Positions, throughout Glasgow, GB
Self Conscious State, Third Eye Centre, Glasgow,
GB (Cat)

1991
Barclays Young Artist Award, Serpentine Gallery,
London, GB (Cat)
Archive Project, APAC Centre d'Art
Contemporain, Nevers, F
Windfall '91, Seaman's Mission, Glasgow, GB
(Cat)
Walk On, Jack Tilton Gallery, New York, USA;
Fruitmarket Gallery, Edinburgh, GB (Cat)
Speed, Transmission Gallery, Glasgow, GB

1992
A Modest Proposal, Milch Gallery, London, GB
Love at First Sight, The Showroom, London, GB

Guilt By Association, Museum of Modern Art,
Dublin, IRL (Cat)
And What Do You Represent?, Anthony
Reynolds Gallery, London, GB
Anomie, Patent House/Andrew Cross, London,
GB
L'U di carte, Café Picasso, Roma, I
Contact, Transmission Gallery, Glasgow, GB
5 Dialogues, Museum of Natural History,
Bergen, N
Il Mistero dei 100 Dollari Scomparsi, Studio
Marconi, Milano, I (Cat)

1993
Left Luggage/Rencontres dans un Couloir,
Maison Hanru, Paris, F. Touring exhibition
Prospekt 93, Frankfurter Kunstverein Schirn
Kunsthalle, Frankfurt, D (Cat)
Douglas Gordon-Simon Patterson, Galerie
Gruppe Grün, Bremen, D
Wonderful Life, Lisson Gallery, London, GB
Viennese Story, Wiener Secession, Wien, A
(Cat)
Walter Benjamin's Briefcase, Moagens
Harmonia, throughout Porto, P
Chambre 763, Hotel Carlton Palace, Paris, F
High Fidelity, Kohji Ogura Gallery, Nagoya, J;
Röntgen Kunst Institut, Tokyo, J
Purpose Built..., Real Art Ways, Hartford,
Connecticut, USA (Cat)
Before The Sound Of The Beep, soundworks
throughout Paris, F

1994
*Stains in Reality: Stan Douglas, Douglas Gordon,
Joachim Koester*, Galleri Nicolai Wallner,
København, DK (Cat)
Wall to Wall, Leeds City Art Gallery, Leeds, GB;
South Bank Centre, London, GB. Touring
exhibition
Something between my mouth and your ear,
Dolphin Gallery, Oxford, GB. Installation for
The Reading Room, a project by Book Works,
London, GB
Rue des Marins, Air de Paris, Nice, F
Modern Art, Transmission Gallery, Glasgow, GB
Gaze: l'Impossible transparence, Carré des Arts,
Parc Floral de Paris, Paris, F
Conceptual Living, Rhizome, Amsterdam, NL
*The Institute of Cultural Anxiety: Works from the
collection*, ICA Institute of Contemporary Arts,
London, GB (Cat)
WATT, Witte de With & Kunsthal, Rotterdam,
NL (Cat)
Some of my friends, Galerie Campbells
Occasionally, København, DK
Points de Vue: Images d'Europe, Centre Georges
Pompidou, Paris, F (Cat)

1995

Eigen + Art: Young British Artists, IAS Independent Art Space, London, GB

Kopfbahnhof/Terminal, Hauptbahnhof Leipzig, Leipzig, D (Cat)

Varje gang jag ser dig/Every Time I See You, Stora Kvarngatan 34, Malmö, S; Galleri Nicolai Wallner, Malmö, S

Take me (I'm yours), Serpentine Gallery, London, GB; Kunsthalle Nürnberg, Nürnberg, D (Cat)

Chez l'un, CHEZ L'AUTRE (1 and 2), Galerie Anton Weller, Paris, F (Cat)

General Release: British Council Selection of Young British Artists, Scuola di San Pasquale, Venezia, I (Cat)

Shift, Stichting De Appel, Amsterdam, NL (Cat)

Arte Inglese d'Oggi, Galleria Civica, Modena, I (Cat)

Aperto 95, FRAC Languedoc-Roussillon, Conqueyrac, F

On Board, Riva San Biagio, Venezia, I

Pulp Fact, Photographers' Gallery, London, GB

Wild Walls, Stedelijk Museum, Amsterdam, NL (Cat)

Am Rande der Malerei, Kunsthalle Bern, Bern, CH (Cat)

Shopping, CAPC Musée d'Art Contemporain, Bordeaux, F

InfoArt: '95 Kwangju Biennale, Kwangju, ROK (Cat)

Perfect Speed, MacDonald Stewart Art Center, Guelph, Canada, CDN; Southern Florida Contemporary Art Museum, Tampa, Florida, USA

Seeing Things, Galeria Antoni Estrany, Barcelona, E

The British Art Show 4, South Bank Centre, London, GB. Touring to Manchester, Edinburgh and Cardiff, GB (Cat)

Over de melancholie, Donia Cieremans, Rotterdam, NL

3e Biennale d'art contemporain de Lyon: installation, cinéma, vidéo, informatique, Musée d'art contemporain; Cité internationale; Palais des Congrès, Lyon, F (Cat)

1996

Turner Prize Exhibition 1996, Tate Gallery, London, GB (Cat)

entre-deux, Rue Antoine Dansaertstraat/ Galerie Mot & Van den Boogaard, Bruxelles, B

Looking Awry, Ambassade Brésilienne, Paris, F

By Night, Fondation Cartier pour l'Art Contemporain, Paris, F (Cat)

21 Days of Darkness, Transmission Gallery, Glasgow, GB

Spellbound, Hayward Gallery, London, GB (Cat)

Traffic, CAPC Musée d'Art Contemporain, Bordeaux, F (Cat)

Hall of Mirrors: Art and Film Since 1945, Museum of Contemporary Art, Los Angeles, USA. Touring exhibition (Cat)

SAWN-OFF, Uppsala Konstmuseum, Uppsala, S (Cat)

Controfigura, Studio Guenzani, Milano, I

Travaux Publics/Public Works, throughout Eindhoven, Stichting Peninsula, Eindhoven, NL (Cat)

Manifesta 1, throughout Rotterdam, NL (Cat)

Auto reverse 2, Le Magasin Centre d'Art Contemporain, Grenoble, F

Propositions, Musée départemental d'art contemporain de Rochechouart, Rochechouart, F (Cat)

Nach Weimar, Ehemaligen Landesmuseum & Schlossmuseum, Weimar, D (Cat)

Scream and Scream Again: Film in Art, Museum of Modern Art, Oxford, GB (Cat)

Perfect, Galerie Mot & Van den Boogaard, Bruxelles, B

Host, OB projects, Amsterdam, NL

Jurassic technologies revenant: 10th Biennale of Sydney, Art Gallery of New South Wales; Artspace; Ivan Dougherty Gallery, Sydney, AUS (Cat)

33 ⅓, Canberra Contemporary Art Space, Canberra, AUS (Cat)

Found Footage: Kunst über Film, Klemens Gasser & Tanja Grünert, Köln, D

Girls High, The Old Fruitmarket, Glasgow School of Art, Glasgow, GB (Cat)

ID. An international survey on the notion of identity in contemporary art, Stedelijk Van Abbemuseum, Eindhoven, NL; Nouveau Musée/Institut d'Art Contemporain, Villeurbanne, F (Cat)

Life/Live, Musée d'Art Moderne de la Ville de Paris, Paris, F; Centro Cultural de Belém, Lisboa, P (Cat)

Full House: Junge Britische Kunst/Young British Art, Kunstmuseum Wolfsburg, Wolfsburg, D (Flyer)

1997

The Lost Ark: Animal, CCA Centre for Contemporary Arts, Glasgow, GB

Wish you were here too, 83 Hill Street, Glasgow, GB

Gothic, ICA Institute of Contemporary Art, Boston, USA (Cat)

XLVII Esposizione Internazionale d'Arte: Passato, Presente, Futuro, Biennale di Venezia, Venezia, I (Cat)

Skulptur Projekte, throughout Münster, D (Cat)

Material Culture: The Object in British Art in the 80's and 90's, Hayward Gallery, London, GB

Letter and Event, Apex Art CP, New York, USA

Hiroshima Art Document '97: Urban Mirage, Old Factory of Army Clothes, Hiroshima, J

Douglas Gordon, Hlynur Hallsson, Petra Kaltenmorgen, Silke Schatz, Villa Minimo, Hannover, D

Quelques motifs de déclaration Amours, Fondation Cartier pour l'Art Contemporain, Paris, F (Cat)

Follow Me: Britische Kunst an der Unterelbe/British Art on the Lower Elbe, Billboards between Buxtehude and Cuxhaven, D (Cat)

Künstlerinnen: 50 Positionen, Kunsthaus Bregenz, Wien, A

Pictura Britannia, Museum of Contemporary Art, Sydney, AUS. Touring exhibition

Flexible, Museum für Gegenwartskunst, Zürich, CH (Cat)

Art from the UK, Sammlung Goetz, München, D (Cat)

4e Biennale d'art contemporain: l'autre, Lyon, F (Cat)

Infra-slim Spaces, Soros Contemporary Art Gallery SCCA, Kiev, UA

Private Face-Urban Space: A New Generation of Artists from Britain, Hellenic Art Galleries Association, Athena, GR (Cat)

1998

Nettverk-Glasgow, Museet for Samtidskunst, Oslo, N (Cat)

Mary Boone Gallery, New York, USA

Close echoes, City Gallery, Praha, CZ; Kunsthalle Krems, Krems, A

Dimensions Variable: New Works from the British Council Collection. Touring exhibition through Eastern Europe

Tuning up #5, Kunstmuseum Wolfsburg, Wolfsburg, D (Cat)

So Far Away, So Close, Encore, Bruxelles, B

Crossings, Kunsthalle Wien, Wien, A (Cat)

Eight People from Europe, Museum of Modern Art, Gunma, J (Cat)

Wounds: Between Democracy and Redemption in Contemporary Art, Moderna Museet, Stockholm, S (Cat)

Hugo Boss Prize Exhibition, Guggenheim Museum SoHo, New York, USA (Cat)

bibliography

Publications including work by the artist

1991
The Missing Text, Chance Books, London.
Edited by Marysia Lewandowska

1992
'Colours for Identification...', *Frieze*, Vol. 1,
No. 2, pp. 14-15. In collaboration with Simon
Patterson

1993
Migrateur, Les Amis du Musée d'Art Moderne
de la Ville de Paris, Paris. A short story
'Telephone Conversation', on cassette
The Speaker Project, ICA Institute of
Contemporary Art, London. Spoken text
'Paris Mémoires: 3 Minute Soundwork', on
cassette *Before The Sound Of The Beep*, Galerie
Giles Peyroulet, Paris. Spoken text
'A Bad Trip', in *Prospekt 93*, Kunsthalle
Frankfurt, Frankfurt. A short story
'In Love in Vienna', in *Viennese Story*, Wiener
Secession, Wien. Edited by Jérôme Sans and
Karin Schorm. Also published in *Kunst &
Museumjournaal*, Vol. 6, No. 5, pp. 59-60.
A short story

1994
'Lost, then found, then lost again; a true story,
after Samuel Beckett', *Witte de With Cahier*,
No. 2 (June), pp. 179-183. A short story

1995
'Wall Drawing', in *Wall to Wall*, Leeds City Art
Gallery, Leeds. A short story
'Berlin visit', in *Kopfbahnhof/Terminal*,
Hauptbahnhof Leipzig, Leipzig. A short story
'2 days in spring', in *On Board*, Riva San
Biagio, Venezia. Edited by Jérôme Sans.
A short story
'Grim: Les Infos du Paradis', *Parkett*, No. 44,
pp. 197-201. In collaboration with Liam Gillick
'Project', *Index* (Stockholm), No. 3-4, pp. 54-63
'Textwork', in *Itinerant texts*, Book Works,
London. Multiple

1997
'Sailing Alone Around the World', *Parkett*,
No. 49, pp. 73-76. A correspondance between
Douglas Gordon and Liam Gillick
'Signature. April 1997', *Parkett*, No. 49,
pp. 82-83. Edition for Parkett
Point d'Ironie, No. 3 (November). Art
publication commissioned by Agnès b and
Hans Ulrich Obrist, edited by Carrie Pilto.
A short story
Art Calls, CD, curated by Jacob Fabricius,
co-production with Galleri Nicolai Wallner,
København. Spoken text

Books and catalogues solo exhibitions

1993
24 Hour Psycho, Tramway, Glasgow. Text:
S. Morgan
The Sociable Art of Douglas Gordon, Tramway,
Glasgow. Text: R. Sinclair

1995
Entr'Acte 3, Douglas Gordon, Stedelijk Van
Abbemuseum, Eindhoven. Text: S. Klein Essink
Fuzzy Logic, Espace Public, Sous Sol, Centre
Georges Pompidou, Paris. Text: C. van Assche

1997
Close your eyes, Museum für Gegenwartskunst,
Zürich. Texts: R. Wolfs, F. McKee

Selected catalogues group exhibitions

1989
Windfall '89, Bremen

1990
Self Conscious State, Third Eye Centre, Glasgow

1991
Barclays Young Artist Award, Serpentine Gallery,
London. Texts: M. Allthorpe-Guyton,
M. Gooding
The Bellgrove Station Billboard Project,
Bellgrove, Glasgow. Texts: A. Dunn, F. McKee,
N. Rolfe
Windfall '91, Seaman's Mission, Glasgow.
Texts: R. Sinclair, G. Piacentini
Walk On, Jack Tilton Gallery, New York;
Fruitmarket Gallery, Edinburgh. Text:
M. Macdonald

1992
Guilt by Association, Museum of Modern Art,
Dublin. Texts: T. Lawson, R. Sinclair
Il Mistero dei 100 Dollari Scomparsi, Studio
Marconi, Milano. Text: L. Gillick

1993
Prospekt 93, Frankfurter Kunstverein Schirn
Kunsthalle, Frankfurt. Text: P: Weiermair
Viennese Story, Wiener Secession, Wien
High Fidelity, Ogura Gallery, Nagoya.
Text: J. Roberts

1994
Stains in Reality, Galleri Nicolai Wallner,
København. Text: S. Sheike
Wall to Wall, South Bank Centre, London.
Touring exhibition. Texts: L. Gillick, M. Paley
*The Institute of Cultural Anxiety: Works from the
Collection*, ICA Institute of Contemporary Arts,
London. Text: F. McKee

WATT, Witte de With Cahier, No. 2, Witte de
With, Rotterdam/Richter Verlag, Düsseldorf.
Text: D. Gordon
Points de Vue: Images d'Europe, Centre Georges
Pompidou, Paris. Texts: C. van Assche,
S. Moisdon

1995
Kopfbahnhof/Terminal, Hauptbahnhof Leipzig,
Leipzig. Text: G. Stimmrich
Take me (I'm yours), Serpentine Gallery,
London; Kunsthalle Nürnberg, Nürnberg.
Text: H.U. Obrist
Guilt by Association, Irish Museum of Modern
Art, Dublin. Text: T. Lawson
Chez l'un, CHEZ L'AUTRE, Éditions Anton
Weller, Paris
*General Release: British Council Selection of
Young British Artists*, Scuola di San Pasquale,
Venezia. Text: J. Roberts
Shift, Stichting De Appel, Amsterdam.
Text: J. Florizoone
Arte Inglese d'Oggi, Galleria Civica, Modena;
Mazzotta, Milano
Wild Walls, Stedelijk Museum, Amsterdam.
Texts: L. Coelewij, M. van Nieuwenhuyzen,
D. Gordon
Am Rande der Malerei, Kunsthalle Bern, Bern.
Text: M. Newman
*3e Biennale d'art contemporain de Lyon:
installation, cinéma, vidéo, informatique*, Lyon.
Texts: T. Raspail, T. Prat
The British Art Show 4, South Bank Centre,
London. Texts: T. Lawson, R. Cork, R. Finn
Kelcey

1996
Traffic, CAPC Musée d'Art Contemporain,
Bordeaux. Text: N. Bourriaud
By Night, Fondation Cartier pour l'Art
Contemporain, Paris
Spellbound: Art and Film, Hayward Gallery;
South Bank Centre, London.
Texts: P. Dodd, I. Christie, A. Taubin
Art and Film since 1945. Hall of Mirrors,
Moca/Monacelli, Los Angeles
Propositions, Musée départemental d'art
contemporain de Rochechouart,
Rochechouart. Text: S. Moisdon-Trembley
Nach Weimar, Ehemaligen Landesmuseum &
Schlossmuseum, Weimar; Cantz Verlag,
Ostfildern
Artisti Britannici a Roma, Umberto Allemandi &
Co., Torino. Text: M. Codognato
SAWN-OFF, Uppsala Konstmuseum, Uppsala.
Text: S. Arrhenius
Manifesta 1, Rotterdam
Scream and Scream Again: Film in Art,
Museum of Modern Art, Oxford. Text: C. Iles
*ID. An international survey on the notion of
identity in contemporary art*, Stedelijk Van

Abbemuseum, Eindhoven; Nouveau Musée/
Institut d'Art Contemporain, Villeurbanne.
Text: S. Moisdon
33 1/3, Canberra Contemporary Art Space,
Canberra
The Turner Prize 1996, Tate Gallery, London.
Text: V. Button
Life/Live, ARC Musée d'Art Moderne de la Ville
de Paris, Paris; Centro Cultural de Belém,
Lisboa

1997

Quelques motifs de déclaration d'amour,
Fondation Cartier pour l'Art Contemporain,
Paris
*Follow Me: Britische Kunst an der Unterelbe;
British Art on the Lower Elbe*,
Landschaftsverband Stade, Stade
Art from the UK, Sammlung Goetz, München.
Text: N. Spector
4e Biennale d'art contemporain: l'autre, Lyon.
Text: H. Szeemann
*Private Face-Urban Space,: A new generation
of artists from Britain*, Hellenic Art Galleries
Association, Athena. Text: K. Gregos
Flexible, Museum für Gegenwartskunst,
Zürich. Texts: R. Wolfs, D. Bosshart

1998

Nettverk-Glasgow, Museet for Samtidskunst,
Oslo. Text: K.J. Brandtzaeg
*Eight People from Europe: The Museum of
Modern Art-The Contemporary Art Wing
Inaugural Exhibition*, Museum of Modern Art,
Gunma, Japan. Texts: S. Moison, N. Spector
Tuning Up #5, Kunstmuseum Wolfsburg,
Wolfsburg. Text: G. van Tuyl
*Wounds: Between Democracy and Redemption
in Contemporary Art*, Moderna Museet,
Stockholm. Text: N. Östlind

Selected articles and reviews

1989

L. Gillick, 'Windfall', *Artscribe*
E. McArthur, 'Windfall', *Variant*
S.N. 'Future Dread', *The List*, December 22 -
January 11

1990

E. McArthur, 'Sites/Positions: Glasgow',
Artscribe, No. 82 (Summer), pp. 77-78

1991

E. MacArthur, 'Windfall', *Variant*, No. 9
(Autumn), pp. 36-41
L. Gillick, 'The Placebo Effect: Some Art in
Britain', *Arts Magazine*, Vol. 65, No. 9 (May),
pp. 56-59
M. Slotover, 'Northern Lights', *Frieze*, Vol. 1,
No. 1, pp. 37-40
M. Macdonald, 'Glasgow: Bellgrove Station
Project', *Artscribe*, No. 87 (Summer), p. 66
E. Newhall, 'Reviews: Walk On', *Art News*,
Vol. 90, No. 9 (December)
D. Bate, 'Books 3: The Missing Text?',
Art Monthly, No. 152 (December-January),
pp. 27-28

1992

D. Lillington, 'Dairy produce', *Time Out*, p. 39
E. Troncy, 'London Calling', *Flash Art*, Vol. XXV,
No. 165 (Summer), pp. 86-89
M. Archer, 'Anomie: Michel Archer defects a
shift of sensibility from the art of the 80s',
Art Monthly, No. 157 (June), pp. 11-13

1993

S.N. 'High Fidelity', *Pia*, Vol. 220, (March),
p. 22
T. Lawson, 'Hello, it's me: Douglas Gordon
interviewed by Thomas Lawson', *Frieze*, No. 9
(March-April), pp. 14-17
S. N., 'High Fidelity', *Studio Voice*, Vol. 220,
(April)
B. Colin, 'Speed Freak', *The List*, April
S. Villiers, 'Psycho with Surreal Touch',
Glasgow Herald, May
R. Sinclair, 'Douglas Gordon: 24 Hour Psycho',
Art Monthly, No. 167 (June), pp. 22-23
A. Renton, 'Reviews: Douglas Gordon,
Tramway', *Flash Art*, Vol. XXVI, No. 172
(October), p. 92
J. Cassim, 'Low Frequency breeds High
Fidelity', *The Japan Times*, October 17
R. Harada, 'From London', *Bijutsu Techo
Monthly Art Magazine*, Vol. 45, No. 678,
pp. 148-149
H. Fricke, 'August Rezension', *Texte zur Kunst*,
Vol. 3, No. 12 (November), pp. 174-178
A. Wilson, 'A Pasta de Walter Benjamin/Walter
Benjamin's Briefcase', *Art Monthly*, No. 172
(December-January), pp. 31-32

1994

J. Roberts, 'Out in the Real World', *Bijutsu
Techo Monthly Art Magazine*, Vol. 46, No. 688,
pp. 36-39
D. van den Boogerd, D. Lillington, 'It's Real
But Very Fucked Up: Een gesprek over WATT',
Metropolis M, Vol. 15, No. 2 (April), pp. 34-38
T. Godfrey, 'Wall to wall', *Untitled*, No. 5
(Summer)
M. Archer, 'Collaborators', *Art Monthly*,
No. 178 (July-August), pp. 3-5
S.N., 'Douglas Gordon', *The Guardian*,
December 10
N. Drake, 'Douglas Gordon', *The Standard*,
December 16
R. Cork, 'Douglas Gordon', *The Times*,
December 31
A. Wilson, 'Slowly All Around You Will Pass
Away', *Paletten*, Vol. 4, No. 219, pp. 16-19
J. Roberts, 'Douglas Gordon', *Paletten*, Vol. 4,
No. 219, pp. 22-25

1995

S. Kent, 'Douglas Gordon', *Time Out*, No. 1273
(January 11-18), p. 44
R. Cork, 'The Naked and the Undying',
The Times, January 3
I. Blazwick, 'Douglas Gordon', *Art Monthly*,
No. 183 (February), pp. 34-36
H. Hanru, 'Une élégante menace', *Omnibus*,
No. 8 (February)
W. Feaver, 'Douglas Gordon', *Artnews*, Vol. 94,
No. 3 (March), p. 144
R. Millard, 'Beware of the hungry artist',
The Daily Telegraph, March 18
A. Kingston, 'Douglas Gordon: Lisson Gallery,
London', *Frieze*, No. 21 (March-April),
pp. 60-61
E. Sandbach, 'London: "Take me (I'm yours)"
in der Serpentine Gallery', *Das Kunst-Bulletin*,
No. 4 (April), p. 48
M. Newman, 'Au-delà de l'object perdu: de la
sculpture au film et à la vidéo/Beyond the Lost
Object: from Sculpture to Film and Video',
Art Press, No. 202 (May), pp. 45-50
S. Curtis, 'Take me (I'm yours)', *World Art*,
No. 3 (Summer), p. 98
T. Godfrey, 'Venice Biennale Report', *Untitled*,
(Summer), pp. 4-5
M. Archer, 'Home and Away', *Art Monthly*,
No. 188 (July-August), pp. 8-10
S. Kent, 'Sound and Vision', *Time Out*,
No. 1306 (August 30-September 6), pp. 24-27
T. Wulffen, 'Take me (I'm yours)', *Kunstforum
International*, No. 131 (August-October),
pp. 362-363
T. Wulffen, 'Kopfbahnhof/Terminal',
Kunstforum International, No. 131 (August-
October), pp. 364-366
P. Tegenbosch, 'Van fictie naar feit en dan
weer terug', *Het Parool*, September 21
R. Roos, 'Douglas Gordon rekt kleine
momenten op tot oncomfortabele
gebeurtenissen', *Trouw*, September 22

G. Muir, 'Douglas Gordon-Lisson Gallery-Londres', *Blocnotes*, No. 8 (Winter), p. 107

S.N., 'Agitate', *Tate Magazine*, No. 7 (Winter), p. 9

J. Florizoone, 'Douglas Gordon: Life or Death', *Metropolis M*, Vol. 16, No. 5 (October), pp. 30-31

A. Tilroe, 'Luisteren in de baarmoeder', *NRC Handelsblad*, October 6

W. Sütö, 'Gordon zet de toon maar gunt ieder zijn eigen melodie', *de Volkskrant*, October 12

J. Braet, 'Vertraagde beweging: video-installaties van Douglas Gordon in "Entr'Acte" van het Van Abbemuseum', *Knack*, October 25, p. 97

M. Gibbs, 'Wild Walls, Stedelijk Museum', *Art Monthly*, No. 191 (November), pp. 30-32

E. Gerber, 'Bern: Am Rande der Malerei in der Kunsthalle Bern', *Das Kunst-Bulletin*, No. 11 (November), pp. 33-34

R. Bevan, 'Home-made youth', *The Art Newspaper*, No. 53 (November), p. 12

R. Steenbergen, 'Melancholie', *NRC Handelsblad*, November 27

P. Migeat, 'Douglas Gordon à l'Écran', *Beaux Arts*, No. 140 (December), p. 31

A. Barak, 'Douglas Gordon: L'Art de la Décélération. The Art of Slowing Down', *Art Press*, No. 208 (December), pp. 45-49

R. Dorment, 'Anything but boring', *The Daily Telegraph*, December 30

R. Garnett, 'The British Art Show 4', *Art Monthly*, No. 192 (December-January), pp. 27-29

1996

J. Fargier, 'L'immobilité hypnotique de Douglas Gordon', *Le Monde*, January 6

S. Moisdon-Trembley, 'Douglas Gordon, Attraction-répulsion', *Blocnotes*, No. 11 (January-February), pp. 46-53, 109-115

S. Moisdon-Trembley, 'Biennale de Lyon', *Blocnotes*, No.11 (January-February), p. 80

M. Dalla Bernardina, '3e Biennale de Lyon', *Art Monthly*, No. 193 (February), pp. 27-28

S.N., 'Spellbound at the Hayward Gallery', *The Art Newspaper*, No. 56 (February), p. 10

R. Dorment, 'Mixed media caught on camera', *The Daily Telegraph*, February 28

S. Morrissey, 'Art & Film', *Untitled*, No. 10 (Spring), p. 3

A. Crabtree, 'Biennale de Lyon', *Untitled*, No. 10 (Spring), p. 16

Y. Abriuox, 'Douglas Gordon, Pompidou Centre, Paris & Lyon Biennale', *Untitled*, No. 10 (Spring), pp. 18-19

M. Sladen, 'Spellbound: Art and Film', *Art Monthly*, No. 195 (April), pp. 25-27

M.E. Feldman, '21 Days of Darkness', *Art Monthly*, No. 195 (April), pp. 38-40

S.N., 'De Appel Curator League Tables', *The Crap Shooter*, No. 1 (April), p. 4

J. Sans, 'Douglas Gordon, Centre Georges Pompidou', *Artforum*, Vol. XXXIV, No. 8 (April), pp. 109-110

P. Cecchetto, 'Douglas Gordon', *Juliet*, No. 77 (April-May), pp. 34-35

J. Lowry, 'Spellbound', *Creative Camera*, (April-May), pp. 40-41

I. Hunt, 'Vide Video', *Art Monthly*, No. 196 (May), pp. 3-7

K.M. Brown, 'Sawn-Off', *Art Monthly*, No. 196 (May), pp. 40-43

F. Gennari, 'Oltre Manica alla moda', *Il Manifesto*, May 30

J. Findlay, 'Glaswegian Goods: Interviews with art professionals in Glasgow', *Flash Art*, Vol. XXIX, No. 188 (May-June), p. 64

L. Gillick, 'The Corruption of Time: Looking back at future art', *Flash Art*, Vol. XXIX, No. 188 (May-June), pp. 69-70

M. Glover, 'Spellbound: Art and Film', *Artnews*, Vol. 95, No. 6 (June), pp. 158-159

N. Houghton, 'Of Shadows, Shadows, Angelmakers and Ciberflash', *Mute*, No. 5 (Summer), pp. XIV-XIV

B. Hare, 'Motion and Emotion: Walking a Tightrope', *Contemporary Art*, Vol. 4, No. 4 (Summer), pp. 42-45

B. Colin, 'The man they couldn't hang', *The Scotsman Weekend Supplement*, August 17, pp. 20-23

C. Elwes, 'The Big Screen', *Art Monthly*, No. 199 (September), pp. 11-16

R. Cork, 'Playing to the Gallery', *The Times Magazine*, October 19, pp. 38-42

C. van Assche, 'Six questions to Douglas Gordon', *Parachute*, No. 84 (October-December), pp. 16-19

J. Jones, 'Douglas Gordon Confessions of a Justified Sinner', *Untitled*, No. 12 (Winter), pp. 10-11

R. Beil, 'From the moment you hear these words, untill you kiss someone with blue eyes', *Kunst-Bulletin*, No. 12 (December), pp. 16-21

1997

L. Buck, *Moving targets: A user's guide to British art now*, Tate Gallery Publishing, London, pp. 24, 39-41, 112, 126, 130, 145, 150, 156, 157, 163, 164, 172, 173, 175, 181, 186

M. Sanders, 'Next stop Barbados', *Dazed & Confused*, (January), pp. 54-60

O. van den Boogaard, 'Schuld wordt zichtbaar in de spiegel', *NRC Handelsblad*, January 24

M. de Brugerolle, 'Douglas Gordon: Museum für Gegenwartskunst, Zürich', *Parachute*, No. 85 (January-March), pp. 47-48

R. Perrée, 'Bij Douglas Gordon wordt de kijker voyeur', *Kunstbeeld*, No. 2 (February), pp. 23-25

J. Seijdel, 'Mediakunst: vertrouw Douglas Gordon', *Het Financieele Dagblad*, February 10

G. Worsdale, 'Morality bites', *Artists Newsletter*, (February), pp. 14-16

S. Kyriacou, 'The Rise and Rise of British Video', *Contemporary Visual Arts*, No. 14

J.M. Prévost, 'Rochechouart. Musée départemental d'art contemporain', *Revue Louvre Musées de France*, No. 47 (April), pp. 107-108

S. Sheikh, 'Et interview med billedkunstneren Douglas Gordon', *Ojeblikkett*, No. 31 (Spring)

I. Blom, 'Slow motion, Douglas Gordon finds emotional solace', *Siksi (The Free Supplement)*, Vol. XII, No. 1 (Spring), pp. 20-21

R. Flood, '24 Hour Psycho', *Parkett*, No. 49, pp. 37-41

T. Bezzola, 'De Spectaculis. Or Who is Kim Novak Really Playing?', *Parkett*, No. 49, pp. 46-52

R. Fergusson, 'Divided Self', *Parkett*, No. 49, pp. 59-64

I. Blazwick, 'In Arcadia', *Art Monthly*, No. 209 (September), pp. 7-10

K. Tieke, 'Douglas Gordon: Rückblick', *Mitgliederzeitschrift Kunstverein Hannover*, No. 2 (October), p. 17

Television

1993

'The late show', BBC Scotland, (May)

1996

'Ex-S 24 Hour Psycho', BBC Scotland (November 18)

'The Turner Prize', Channel 4 (November 28)

1997

'Slow Motion: The Conceptual Art of Douglas Gordon', ARTE & WDR Television (October)

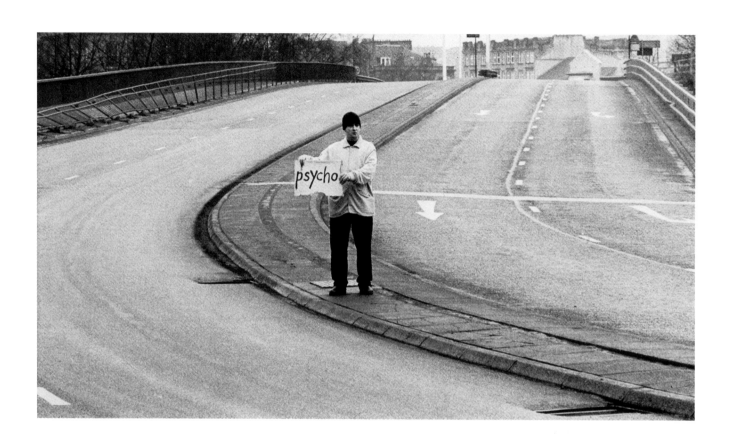

Psycho Hitchhiker, 1993

colophon

concept
Marente Bloemheuvel, Arlette Brouwers,
Jan Debbaut, Douglas Gordon

text and annotations
Jan Debbaut, Douglas Gordon, Francis McKee

editing
Marente Bloemheuvel

design
Arlette Brouwers, Amsterdam/Emst
in collaboration with Douglas Gordon

copy editing
Solange de Boer, Mari Shields

biography/bibliography
Diana Franssen

photography
Oladele Bamgboye, London
Otto Berchem, Amsterdam
Manon de Boer, Amsterdam/Bruxelles
Don Brown, London
Adam Chodzko, London
Peter Cox, Eindhoven
Mike Fear, London
Hlynur Hallsson, Hannover
Heidi Kosaniuk, Edinburgh
Galerie Yvon Lambert, Paris
Marcus Leith, London
Bruno Mancia, Zürich
Roman Mensing, Münster
Georges Meguerditchian, Centre Georges
Pompidou, Paris
Anders Nilsson, Wien
Patrick Painter Editions, Vancouver
João Penalva, London
John Riddy, London
Simon J. Starling, Glasgow
Stedelijk Museum, Amsterdam
Tate Gallery, London
Larry Thall
US National Archives
Galleri Nicolai Wallner, Copenhagen
Stephen White, London

typeface
FFScala, FFScalaSans
MBembo

paper
Westminster, 130 grams

dtp
Arlette Brouwers, Amsterdam/Emst
Anja Nerrings, Amsterdam

printing
Lecturis bv, Eindhoven

acknowledgements
Bloom Gallery, Amsterdam; Galeria Bonomo,
Roma; Book Works, London; Lucy Byatt, Visual
Art Projects Glasgow; Galeria Estrany-de la
Motta, Barcelona; Russell Ferguson, Los
Angeles; Gagosian Gallery, New York;
Guggenheim Museum, New York; Hlynur
Hallsson, Hannover; Galerie Hauser & Wirth
II, Zürich; Kunstverein Hannover; Galerie Yvon
Lambert, Paris; Thomas Lawson, Los Angeles;
Lisson Gallery, London; Galerie Mot & Van den
Boogaard, Bruxelles; Museum für
Gegenwartskunst, Zürich; Patrick Painter
Editions, Vancouver; Parkett, Zürich; Galerie
Micheline Szwajcer, Antwerpen; Tate Gallery,
London; Galleri Nicolai Wallner, København;
Westfälisches Landesmuseum, Münster

Douglas Gordon wishes to thank
Marente Bloemheuvel, Amsterdam; Arlette
Brouwers, Amsterdam/Emst; Jan Debbaut,
Eindhoven/Temse; the Gordon family,
Dumbarton and London; Tanya Leighton,
Glasgow; Francis McKee, Glasgow; Koos van
der Meer, Emst; Bert Ross, Glasgow; all staff at
the Stedelijk Van Abbemuseum, Eindhoven;
Astrid Vorstermans, Amsterdam; the Webster
family, Glasgow

publisher
Stedelijk Van Abbemuseum, Eindhoven

distribution
NAI Publishers, Rotterdam

Available in North, South and Central America
through D.A.P./Distributed Art Publishers Inc,
155 Sixth Avenue 2nd Floor, New York,
NY 10013-1507, Tel. 212 627.1999
Fax 212 627.9484

Available in the U.K. and Ireland through Art
Data, 12 Bell Industrial Estate 50 Cunnington
Street, London W4 5HB, Tel. 181 747.1061,
Fax 181 742.2319